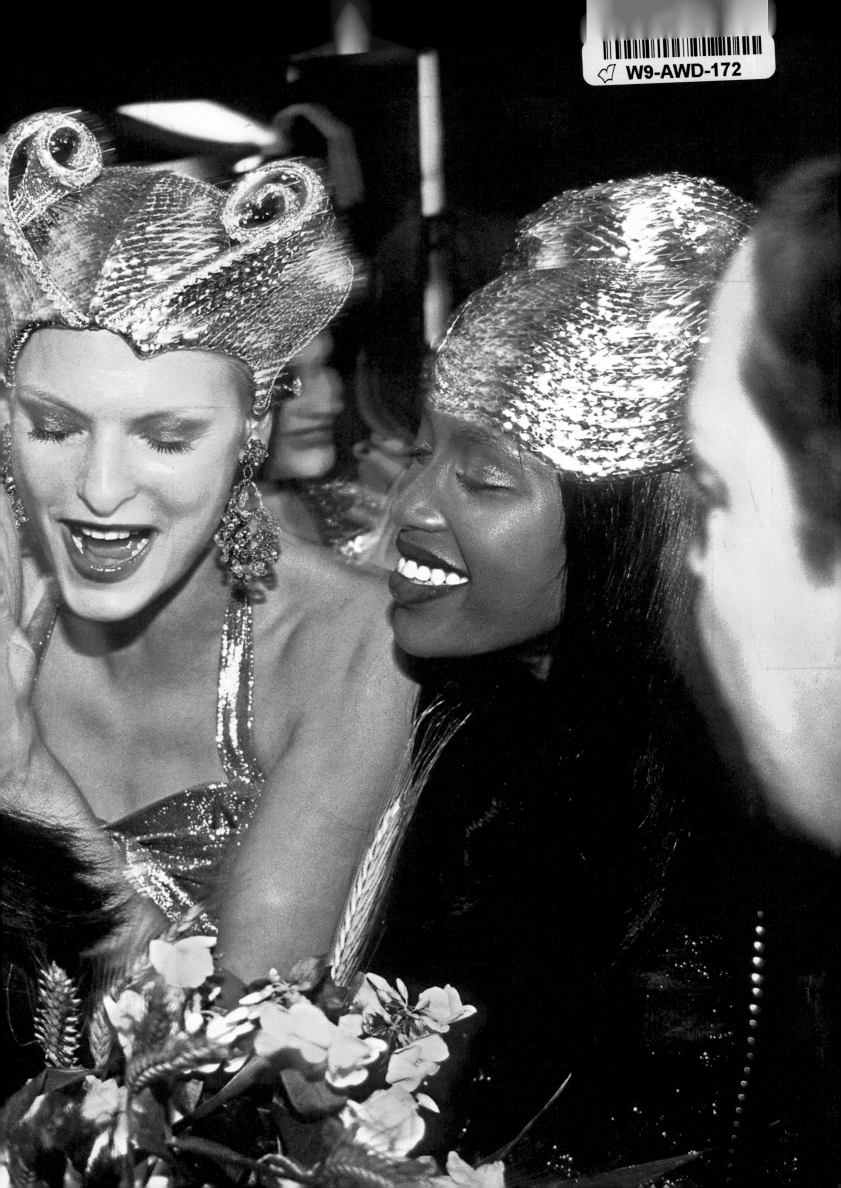

INTENTS

oo,

Dam Mallis

xx

Patrick Mc Mullan

IN ASSOCIATION WITH

OLYMPUS®

MADE POSSIBLE BY

TEN ON SIXTH

DESIGNED BY PENTAGRAM

A PORTION OF THE AUTHOR'S AND PUBLISHER'S PROCEEDS OF THIS BOOK ARE BEING DONATED TO

National Colorectal Cancer
RESEARCH ALLIANCE™
An Entertainment Industry Foundation Program

INTENTS

**Photography by
Patrick McMullan**

Foreword by Katie Couric

*Introduction by
Fern Mallis*

*powerHouse Books
New York, NY*

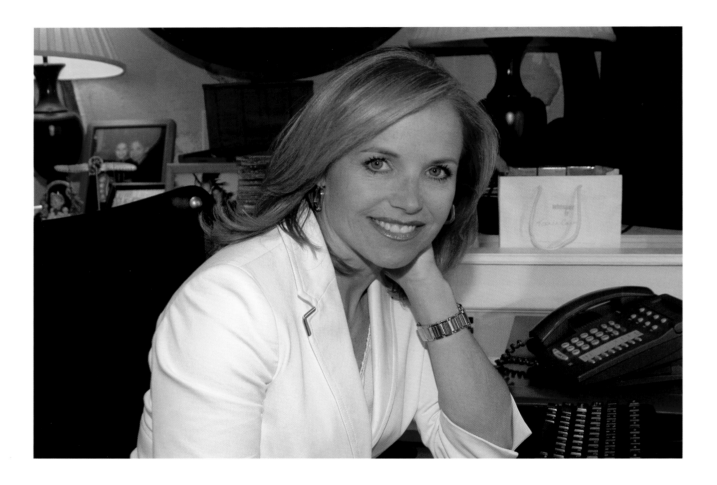

Katie Couric at her office at NBC's "Today Show," June 2004

COVER

Anna Sui, Linda Evangelista, Naomi Campbell, and Roxanne Lowitt at the Anna Sui show, November 1994

DEAR READER,

WITH YOUR PURCHASE OF *INTENTS*, PATRICK MCMULLAN'S LATEST AND GREATEST PHOTOGRAPHIC PEEK INSIDE THE WORLD OF FASHION, YOU ARE SUPPORTING A PROJECT THAT HAS SPECIAL SIGNIFICANCE FOR ME.

AFTER LOSING MY 42-YEAR-OLD HUSBAND, JAY MONAHAN, TO COLON CANCER IN 1998, I WORKED WITH THE ENTERTAINMENT INDUSTRY FOUNDATION TO ESTABLISH THE NATIONAL COLORECTAL CANCER RESEARCH ALLIANCE (NCCRA). THIS DISEASE IS ONE OF THE DEADLIEST FORMS OF CANCER IN THE U.S., BUT IS HIGHLY PREVENTABLE WHEN DETECTED EARLY. FINANCIAL SUPPORT FOR THE NCCRA IS CRUCIAL TO OUR ONGOING RESEARCH AND PUBLIC SERVICE INITIATIVES THAT, ULTIMATELY, SAVE LIVES.

AS A CANCER SURVIVOR HIMSELF, PATRICK MCMULLAN HAS, ALONG WITH PUBLISHER POWERHOUSE BOOKS, GENEROUSLY OFFERED TO DONATE A PORTION OF THE ROYALTIES FROM *INTENTS* TO THE NCCRA. COLLECTIVELY, WE CAN CONTINUE TO RAISE AWARENESS ABOUT THIS VERY REAL CANCER THREAT AND GET PEOPLE SCREENED.

PATRICK MCMULLAN IS ONE OF FASHION'S MOST INFLUENTIAL INSIDERS. FOLLOWING ON THE SUCCESSES OF *MEN'S SHOW* AND *SO80S*, *INTENTS* OFFERS A BEHIND-THE-SCENES LOOK AT TEN YEARS OF ONE OF THE MOST EAGERLY ANTICIPATED FASHION EVENTS IN AMERICA — NEW YORK'S FASHION WEEK AT THE BRYANT PARK TENTS. I'VE BEEN BACK-STAGE AND ON THE FRONT ROW AT FASHION WEEK, AND HAVE SEEN ITS EXCITEMENT FIRST HAND. IN THIS BOOK, PATRICK HAS MADE THAT WORLD ACCESSIBLE TO FASHION LOVERS WHO MIGHT NOT HAVE HAD THE CHANCE TO EXPERIENCE THE TENTS THEMSELVES. AND, MOST IMPORTANT TO ME, IT HELPS A VERY IMPORTANT CAUSE.

TAKE A LOOK INSIDE, AND ENJOY!

KATIE COURIC

I CAN'T REMEMBER WHEN I FIRST MET PATRICK MCMULLAN. IT SEEMS AS IF I'VE KNOWN HIM MY WHOLE LIFE. HE'S EVERYWHERE I GO. BUT I DO REMEMBER WHEN 7TH ON SIXTH WAS FORMED, AND WHY WE BEGAN ORGANIZING FASHION SHOWS IN TENTS IN THE MIDDLE OF MIDTOWN MANHATTAN, AND THE ROLE PATRICK PLAYED IN THAT INCREDIBLE JOURNEY.

IN THE SPRING OF 1991 I BECAME THE EXECUTIVE DIRECTOR OF THE COUNCIL OF FASHION DESIGNERS OF AMERICA (CFDA) WHERE I THOUGHT MY JOB WAS TO WORK WITH AMERICA'S LEADING DESIGNERS ON SEVERAL MAJOR CHARITABLE INITIATIVES, COMING UP WITH PROGRAMS AND OPPORTUNITIES FOR YOUNG DESIGNERS, AND TO GENERALLY RUN AN INDUSTRY NOT-FOR-PROFIT TRADE ASSOCIATION. MY JOB DESCRIPTION CHANGED WITH JUST ONE FASHION SHOW A FEW WEEKS AFTER MY HIRE.

IN A LOFT SPACE ON WEST 24TH STREET AS MICHAEL KORS WAS PRESENTING HIS FALL COLLECTION, PIECES OF PLASTER BEGAN FALLING FROM THE CEILING ON NAOMI, CINDY, LINDA, AND CHRISTY AS THEY WALKED DOWN THE RUNWAY. ALTHOUGH THE GIRLS DIDN'T MISS A BEAT AND KEPT THEIR STRIDES, THE PLASTER LANDED ON THE LAPS OF JOURNALISTS SUZY MENKES OF THE *INTERNATIONAL HERALD TRIBUNE* AND CARRIE DONOVAN OF *THE NEW YORK TIMES* WHO WERE SITTING IN THE FRONT ROW. THE NEXT DAY'S HEADLINES TOOK THE AMERICAN FASHION INDUSTRY TO TASK. SUZY SAID "WE MAY LIVE FOR FASHION…BUT WE DON'T WANT TO DIE FOR IT." IT WAS THE SHOT HEARD "ROUND THE WORLD" AND THE CFDA HAD A NEW MISSION.

AMERICAN DESIGNERS WERE ALWAYS GREAT AT WORKING TOGETHER…AS LONG AS IT WAS FOR CHARITY. THE IDEA OF SHARING SPACES AND AMORTIZING COSTS FOR THE BIANNUAL WEEKS OF FASHION SHOWS WAS AN ENTIRELY FOREIGN CONCEPT. ONCE WE CONVINCED THEM THAT AN ORGANIZED, CENTRALIZED, AND MODERNIZED WEEK COULD WORK, WE NEEDED TO FIND A LOCATION. AFTER WEEKS AND MONTHS OF LOOKING AT EVERY EMPTY PARKING LOT, UNFINISHED OFFICE BUILDING, AND LARGE GARAGE COMPLEX IN THE CITY AND NEGOTIATING WITH THE BRYANT PARK RESTORATION CORPORATION, THE MAYOR AND VARIOUS NYC AGENCIES GAVE US THE GO AHEAD WE NEEDED. NOW THE ONLY THING LEFT TO DO WAS RAISE THE MONEY. SPONSORS SIGNED ON FROM DOWNTOWN TO DETROIT WITH EVIAN WATER AND *VOGUE* MAGAZINE THE FIRST TO COME ONBOARD, FOLLOWED QUICKLY BY MORE MAGAZINES, HAIR, COSMETIC, AND AUTOMOTIVE COMPANIES, AND IN THE FALL OF 1994 7TH ON SIXTH WAS LAUNCHED. WE MOVED 7TH AVENUE — THE GENERIC NAME AND REAL HOME OF ALL OF THE MAJOR FASHION SHOWROOMS — TO BRYANT PARK ON SIXTH AVENUE. I CAN STILL REMEMBER THAT FIRST SEASON, THE FIRST SOUND CHECK, AND THE FIRST TIME THE LIGHTS CAME UP AND THE MODELS WALKED OUT ON OUR RUNWAYS. IT STILL GIVES ME GOOSE BUMPS. IT ALL BECAME SO REAL. WHAT WE HAD ONLY ENVISIONED WAS NOW A REALITY. NOW IN 2004, AS OLYMPUS FASHION WEEK, NO ONE CAN REMEMBER A TIME WHEN FASHION SHOWS TOOK PLACE ANYWHERE ELSE.

FASHION SHOWS ARE A VITAL ELEMENT OF OUR INDUSTRY'S BUSINESS. IN JUST TWENTY MINUTES, DESIGNERS PRESENT THEIR VISION FOR THE SEASON WITH THE WIDEST AUDIENCE OF FASHION INDUSTRY LEADERS, STYLE-MAKERS, AND INFLUENCERS WHO WILL ULTIMATELY DECIDE WHAT THE WORLD WILL BE WEARING IN THE NEXT SIX MONTHS. THE SHOWS ARE WILD, SEDATE, SERIOUS, AND EXUBERANT. THEY HAVE BECOME THE SPORTS STADIUM AND THE THEATER OF THE 90S AND THE MILLENNIUM AND THERE IS NO END IN SITE. THE FASHION SHOW IS WHERE THE MOST CREATIVE FORCES COME TOGETHER — BOTH BACKSTAGE AND IN THE FRONT ROW. IT IS THE ROMAN AMPHITHEATER OF SOCIETY.

ALL OF THE ACTION SURROUNDING THE SHOWS IS DOCUMENTED BY HUNDREDS OF PHOTOGRAPHERS EACH SEASON, BUT NONE MORE NOTABLE THAN PATRICK MCMULLAN, WHO HAS BEEN WITH US SINCE THE BEGINNING. AFTER TRAVELING TO MOSCOW ONE WEEKEND IN 1992 TO CELEBRATE THE OPENING OF A DISCO NAMED MANHATTAN EXPRESS, AND LAUGHING FOR FOUR DAYS BECAUSE PATRICK BECAME THE TRIP'S OFFICIAL PHOTOGRAPHER, I KNEW HE WOULD ALWAYS BE IN MY LIFE.

WHEN WE FORMED 7TH ON SIXTH, I KNEW WE NEEDED TO DOCUMENT IT, AND I KNEW OF NO ONE WHO COULD DO IT WITH MORE HUMOR, GOOD SPIRIT, AND ENERGY THAN PATRICK. HE WAS THE FIRST PHOTOGRAPHER TO HAVE AN ALL-ACCESS PASS TO THE TENTS AND TO THIS DAY CONTINUES TO COVER ALL OF THE ACTION, DESIGNERS, CELEBRITIES, AND SOCIALITES WITH THE SAME ENERGY AND ENTHUSIASM AS HE DID ELEVEN YEARS AGO. HIS COMMITMENT TO THE TENTS AND THIS PROJECT HAS BEEN UNWAVERING. OVER THE YEARS WE HAVE SHARED A DREAM OF ONE DAY SEEING ALL OF HIS IMAGES OF THE TENTS MADE INTO A BOOK AND I NOW HOPE YOU ENJOY THE JOURNEY AS MUCH AS WE HAVE.

FERN MALLIS
EXECUTIVE DIRECTOR OF THE COUNCIL OF FASHION DESIGNERS

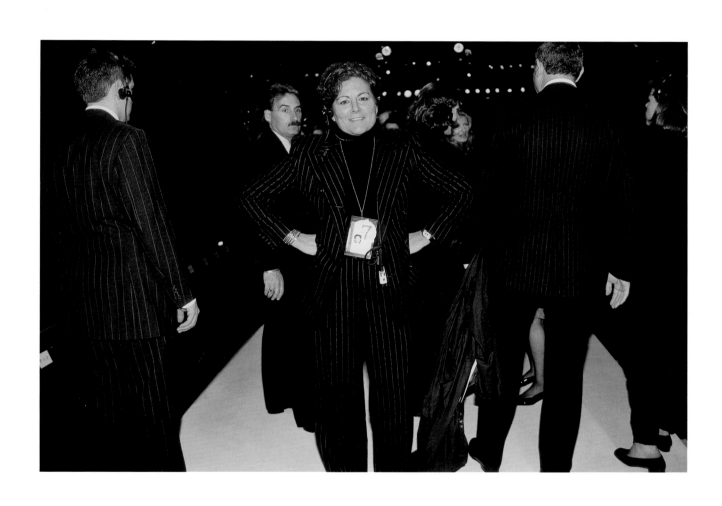

Fern Mallis at the Ralph Lauren show, November 1995

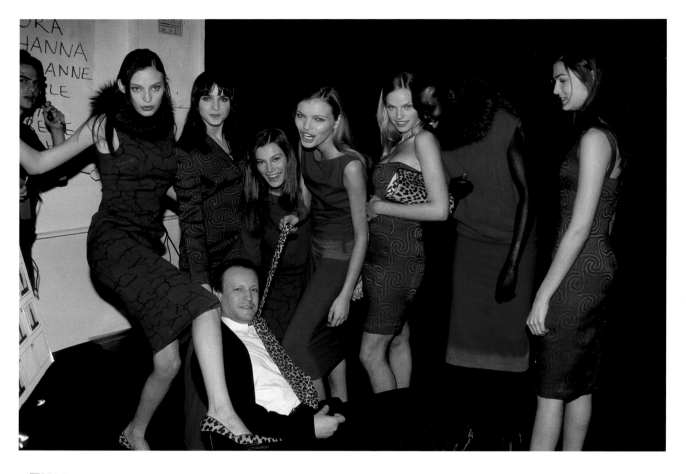

THIS BOOK IS DEDICATED TO THE LEGENDARY FASHION EDITOR, LIZ TILBERIS, WHO DIED OF OVARIAN CANCER; MY GODMOTHER, PHYLLIS ROGERS, WHO SURVIVED COLORECTAL CANCER; AND TO MY MOTHER, CONNIE MCMULLAN, WHO IS HAPPILY AND JOYFULLY ALIVE.

Patrick McMullan with models backstage at the Nicole Miller show, March 1998

I AM NOT REALLY SURE WHERE MY INTEREST IN FASHION FIRST STARTED, I KNOW IT WASN'T ON THOSE SHOPPING SPREES WITH MOM TO ROBERT HALL AND MACY'S, AND GOD KNOWS WHERE ELSE WE WOULD BE DRAGGED. SEEING THE FOLKS ALL DRESSED UP, THOUGH, ON THEIR WAY TO A FUN PARTY WAS MORE EXCITING. OH, AND HOW I LOVED GETTING OUT OF BED WHEN ONE OF THOSE WILD PARTIES WAS HAPPENING AT HOME.

MY FIRST FASHION SHOW WAS DEFINITELY BETSEY JOHNSON AND IT WAS ON ROLLER SKATES. ALL I REALLY REMEMBER THOUGH WAS BETSEY. WOW, DID SHE HAVE CHARISMA. THE NEXT WAS AT THE RITZ — EVERYONE WAS GOING TO SEE STEPHEN SPROUSE'S SHOW, SO OF COURSE I WENT, I WAS A NIGHTCLUB/PARTY PHOTOGRAPHER AND IT WAS AT A NIGHTCLUB AND IT WAS STEPHEN SPROUSE. SO, HEY, WHY NOT. IT WAS COOL, VERY COOL INDEED.

FAST FORWARD TO 1992, I WAS INVITED ON A TRIP TO MOSCOW, AND WAS AMONG THE MANY GUESTS THAT DAVID RABIN AND WILL REGAN HAD INVITED AND FLOWN TO THE NIGHTCLUB OPENING OF MANHATTAN EXPRESS. THE CLUB WAS FINE BUT THE TRIP ITSELF WAS SO MUCH FUN. I MADE SOME VERY LASTING FRIENDSHIPS ON THAT TRIP, ESPECIALLY FERN MALLIS. FERN, WHO HAS A WONDERFUL SENSE OF HUMOR, SORT OF GOT ME RIGHT AWAY AND WE LAUGHED AND LAUGHED OUR WAY THROUGH MOSCOW. WE ALL BONDED, AND AFTER THE TRIP FERN TOLD ME THAT SHE HAD A PROPOSITION. SHE WAS STARTING UP THIS WHOLE FASHION THING (7TH ON SIXTH) AND COULD USE A PHOTOGRAPHER TO DOCUMENT ALL THE PARTS OF THESE TENTS THAT WERE BEING CONSTRUCTED. WAS I INTERESTED? THERE WAS NO PAYMENT BUT THEY WOULD GIVE ME ALL THE ACCESS I WANTED, AND HELP ME WITH FILM EXPENSES. I IMMEDIATELY SAID SURE. WHICH WAS THE BEGINNING OF MY LOVE AFFAIR WITH FASHION.

AFTER A WHILE, I MET LIZ TILBERIS THROUGH MY FRIEND SUSAN MAGRINO. LIZ WAS A WARMHEARTED, KIND, AND GENEROUS WOMAN WHO HAD A GREAT SENSE OF HUMOR AS WELL AS GREAT SENSE OF STYLE. SHE ALSO WAS THE EDITOR IN CHIEF OF *HARPER'S BAZAAR* AND WANTED TO SEE ALL THE PICTURES I WAS TAKING BECAUSE SHE SAW ME EVERYWHERE. WELL, SHE LOVED WHAT SHE SAW AND OFFERED ME A JOB. WELL, LOTS HAS CHANGED AND LIKE ALL LOVE AFFAIRS, THEY ARE OFTEN LOVE/HATE. LOVE THE CLOTHES. HATE THE HAIR. LOVE THE MODELS. HATE THE WEATHER. LOVE STAYING OUT LATE/HATE WAKING UP EARLY. I THINK YOU ALL GET THE PICTURE.

WELL, I DO OF COURSE HAVE LOTS OF PICTURES NOW AND ALSO LOTS OF HELPERS AS WELL. I NO LONGER DO IT ALL, BECAUSE I HAVE DONE IT ALL, AND SEEN IT ALL, BUT I KEEP COMING BACK FOR MORE.

PATRICK MCMULLAN

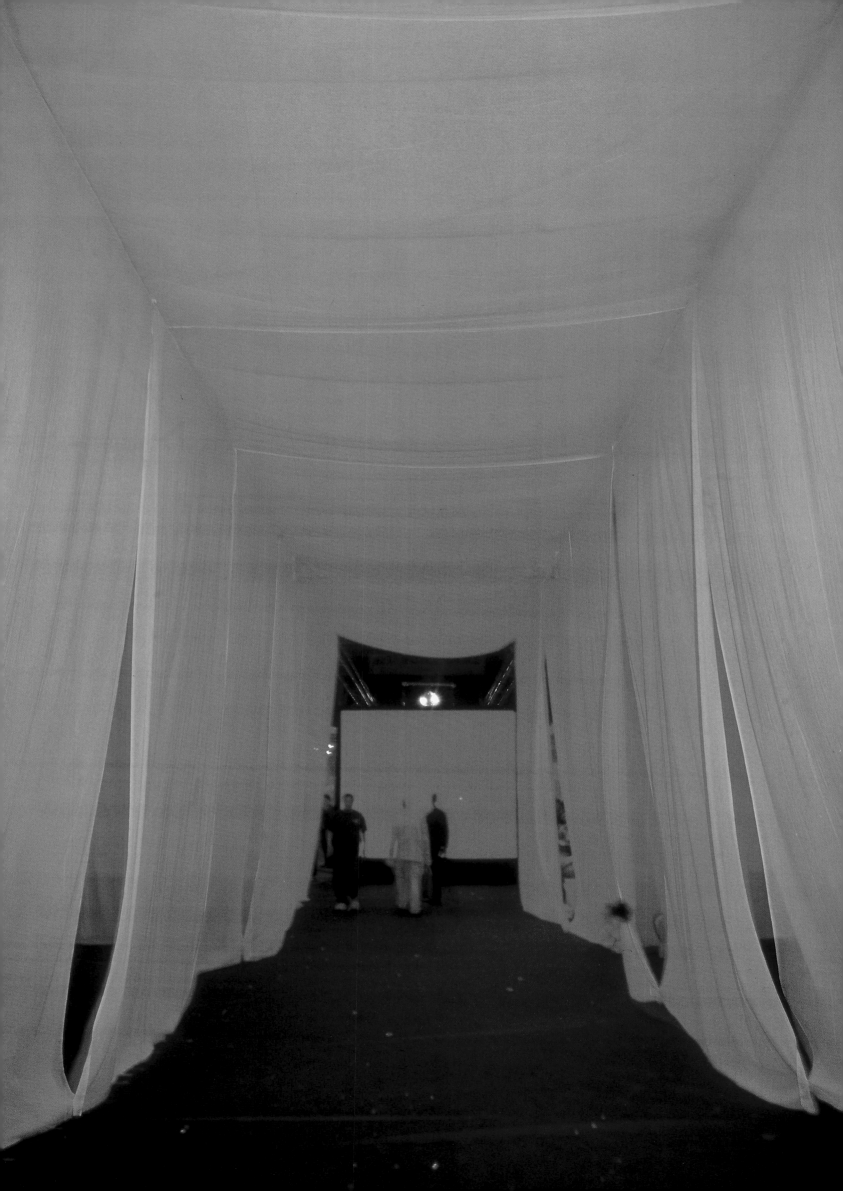

I WOULD LIKE TO THANK ALL OF THE DESIGNERS AND COMPANIES THAT HAVE INVITED ME SHOOT THEIR SHOWS AT THE 7TH ON SIXTH TENTS AT BRYANT PARK OVER THE LAST TEN YEARS. I WOULD LIKE TO THANK MANY OF THE PEOPLE WHO HAVE HELPED ME WITH THIS BOOK AND TEN YEARS OF SHOOTING IN THE TENTS. FIRST OF ALL, EVERYONE WHO APPEARS IN THESE PHOTOS AND THOSE BEHIND THE SCENES, ESPECIALLY THE TECHNICIANS, THE SECURITY, THE STAFF, AND VOLUNTEERS AT 7TH ON SIXTH WHO HELPED IN SO MANY WAYS. I GIVE SPECIAL THANKS TO STAN HERMAN, DAVID CARUSO, AND ESPECIALLY FERN MALLIS, WHO GAVE ME MY FIRST ALL-ACCESS PASS, WHICH ALLOWED ME TO BEGIN ON MY GREAT, TEN-YEAR JOURNEY DOCUMENTING THE HAPPENINGS AT THE TENTS IN BRYANT PARK.

I WOULD ALSO LIKE TO EXPRESS MY GRATITUDE TO THE WONDERFUL AND GIFTED EDITOR WHO GAVE ME MY FIRST REGULAR JOB SHOOTING FASHION, THE LATE LIZ TILBERIS. AS EDITOR OF *HARPER'S BAZAAR*, LIZ'S BELIEF IN MY PHOTOGRAPHY HELPED TO INSPIRE MY ENDLESS ENERGY IN COVERING EACH AND EVERY ASPECT OF THE SHOWS, ALONG WITH JENNIFER JACKSON ALFANO. AND THANKS TO THE MAGAZINES AND EDITORS THAT HAVE BEEN MY ALLIES DURING THIS TEN-YEAR JOURNEY: AT *ALLURE*, LINDA WELLS AND JEFFREY SLONIM; *AMERICAN PHOTO*, DAVID SCHONAUER, RICHARD RABINOWITZ, BETH LUSKO; *GOTHAM*, JASON NIXON, JASON BINN; *HARPER'S BAZAAR*, GLENDA BAILEY, MARY ALICE STEPHENSON, KRISTINA O'NEALL; *INTERVIEW*, INGRID SISCHY, SANDY BRANT; *NEW YORK* MAGAZINE, CAROLINE MILLER, AMY LAROCCA, SHYAMA PATEL, DEBORAH SCHOENEMAN; MOST ESPECIALLY *OCEAN DRIVE*, GLENN ALBIN, ERIC NEWELL, AND THE GANG; *PEOPLE*, MARTHA NELSON; *US WEEKLY*, BRITTAIN STONE; *STAR*, BONNIE FULLER; STYLE.COM, CANDY PRATTS PRICE; *VOGUE*, ANNA WINTOUR, ANDRÉ LEON TALLEY; *VANITY FAIR*, GRAYDON CARTER, ELIZABETH SALTZMAN, DAVID FRIEND, DANA BROWN; *W*, PATRICK MCCARTHY. THE "FULL FRONTAL FASHION" GANG, ESPECIALLY JUDY LICHT AND THE GANG IN THE VAN.

I WOULD LIKE TO THANK MY PUBLISHER, POWERHOUSE BOOKS: DANIEL POWER, CRAIG COHEN, SARA ROSEN AND THE DESIGN TEAM BEHIND *INTENTS*, PENTAGRAM DESIGN: MICHAEL BIERUT, KERRIE POWELL.

AND TO EVERYONE WHO CONTRIBUTED A QUOTE, THANK YOU FOR YOUR MEMORIES OF THE TENTS!

AND SPECIAL THANKS TO THE SPONSORS AND THE PEOPLE WHO MADE *INTENTS* POSSIBLE: 7TH ON SIXTH/IMG: FERN MALLIS, JACQUIE KELLEHER, LEIGH BOKSER, MELISSA MCCARTHY, ANNE WATERMAN; CFDA: STAN HERMAN, PETER ARNOLD; OLYMPUS: CHRISTOPHER SLUKA; MVPG: CHAD THOMPSON; AVEDA: CHRIS MOLINARI, JESSICA BARLOW; THE DIAMOND INFORMATION CENTER: SALLY MORRISON; COACH: REED KRAKOFF, RAINA PENCHANSKY, HEATHER FEIT; AND ESTEE LAUDER: TERUCA RULLAN, ANNA DELUCA.

THE PMC *INTENTS* GANG: ART AND EDITORIAL: JASON CRANTZ AND ALISON MOORE; SPONSORSHIP AND PROMOTION: ANITA ANTONINI AND SAM BOLTON; THE WHOLE PATRICK MCMULLAN COMPANY, ESPECIALLY MY NIECE CANDI MCCARTHY, JULIA RISH, ANITA SARKO AND KATHY DENTON.

THE PMC PHOTOGRAPHERS: JIMI CELESTE, BILLY FARRELL, GANDALF GAVAN, MARIE HAVENS, DAN HERRICK, GREG KESSLER, MICHAEL LOCCISANO, STEPHEN LOVEKIN, JAMIE MCCARTHY, RICHARD ORJIS, NICK PAPANANIAS, P.J. RANSONE, THOS ROBINSON, AND PERRIE WARDELL.

LASTLY TO MY SON LIAM MCMULLAN, FRIEND MARGIE BECK, SISTER SHARON SHALINSKI, TONY SHALINSKI, AND ALANNA SHALINSKI, AND MOM CONNIE MCMULLAN WHO TAUGHT ME TO LAUGH AT MISFORTUNE AND ALWAYS TRY MY BEST. MY BEST TO ALL WHO LOOK THROUGH THESE PAGES AND TRY TO FIGURE JUST WHAT IS *IN* FASHION.

PATRICK MCMULLAN

A "pink" tent interior, September 2001

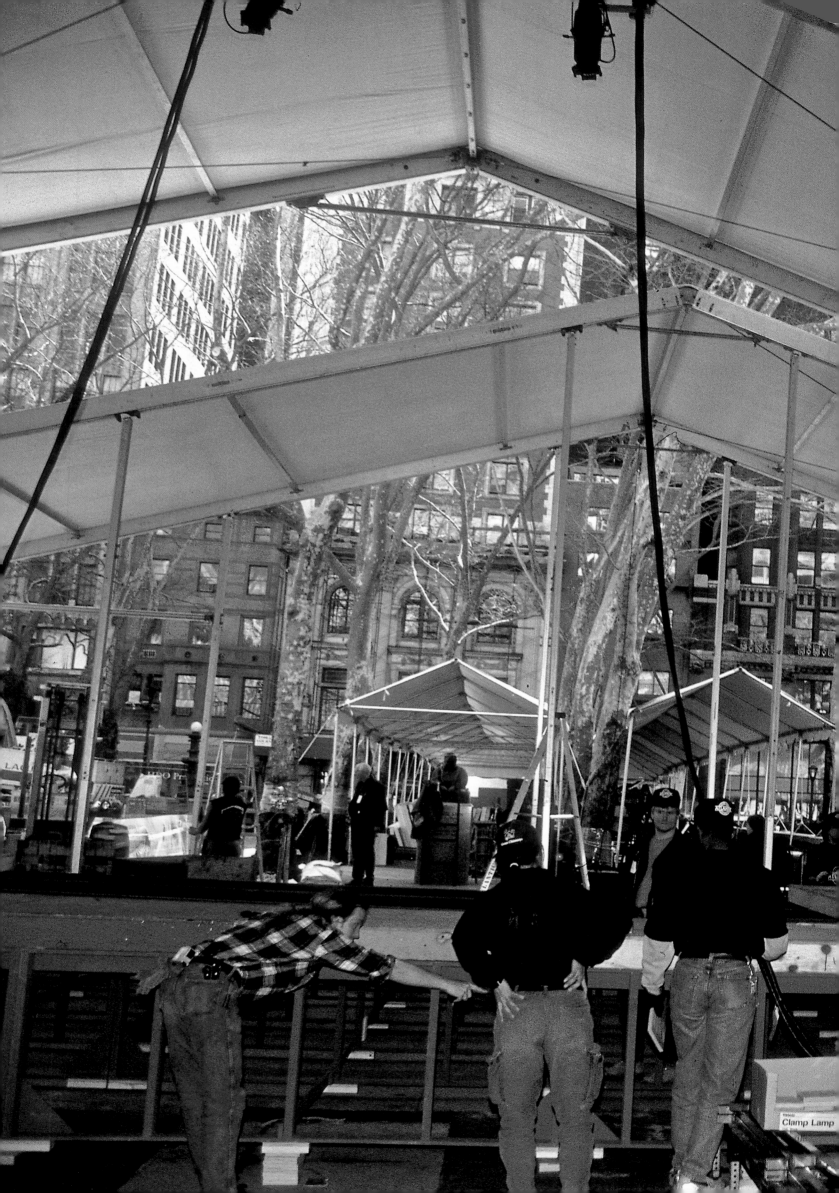

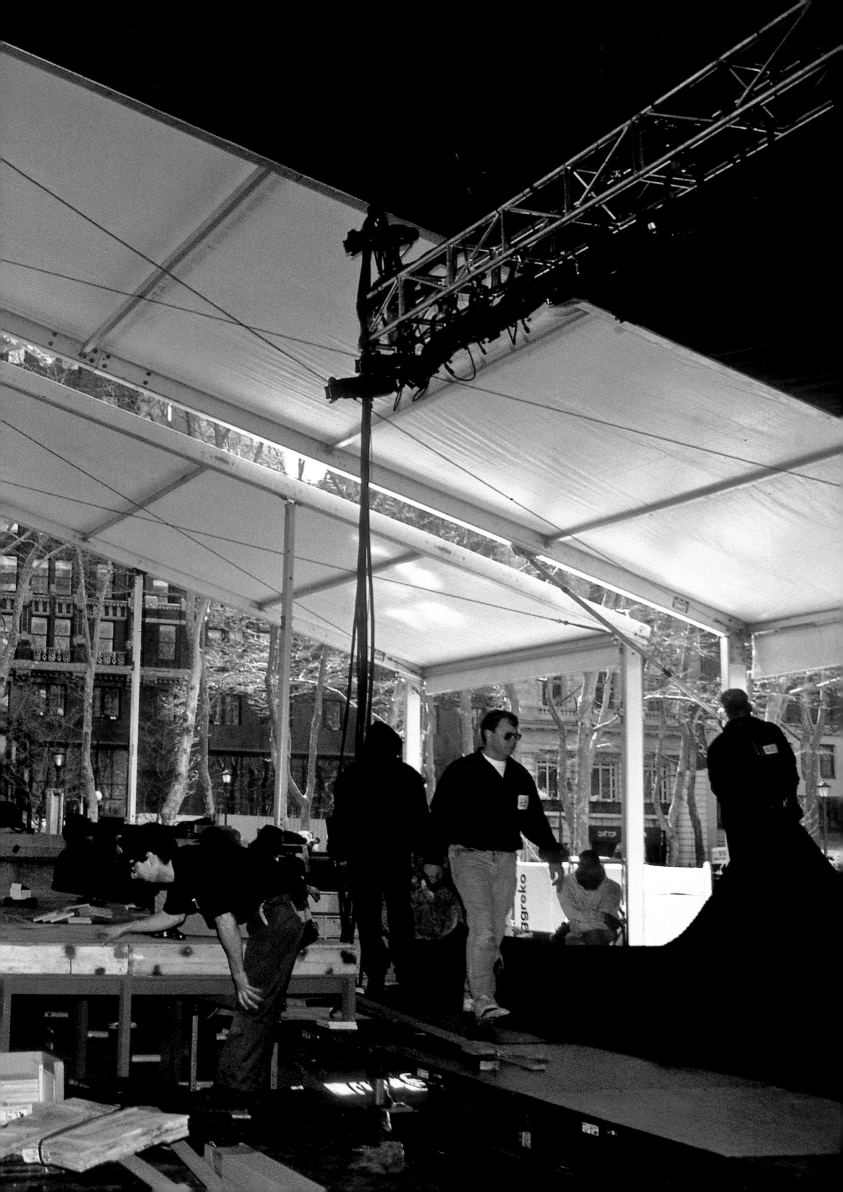

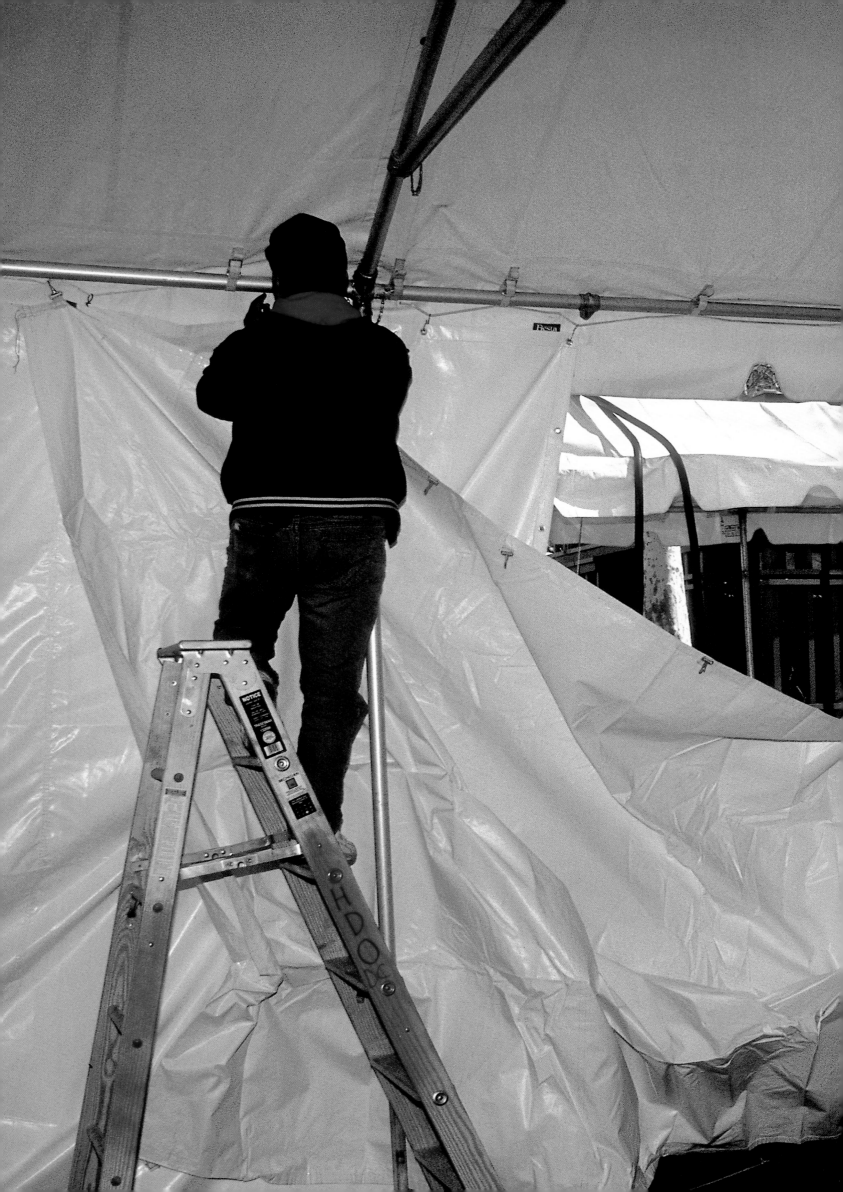

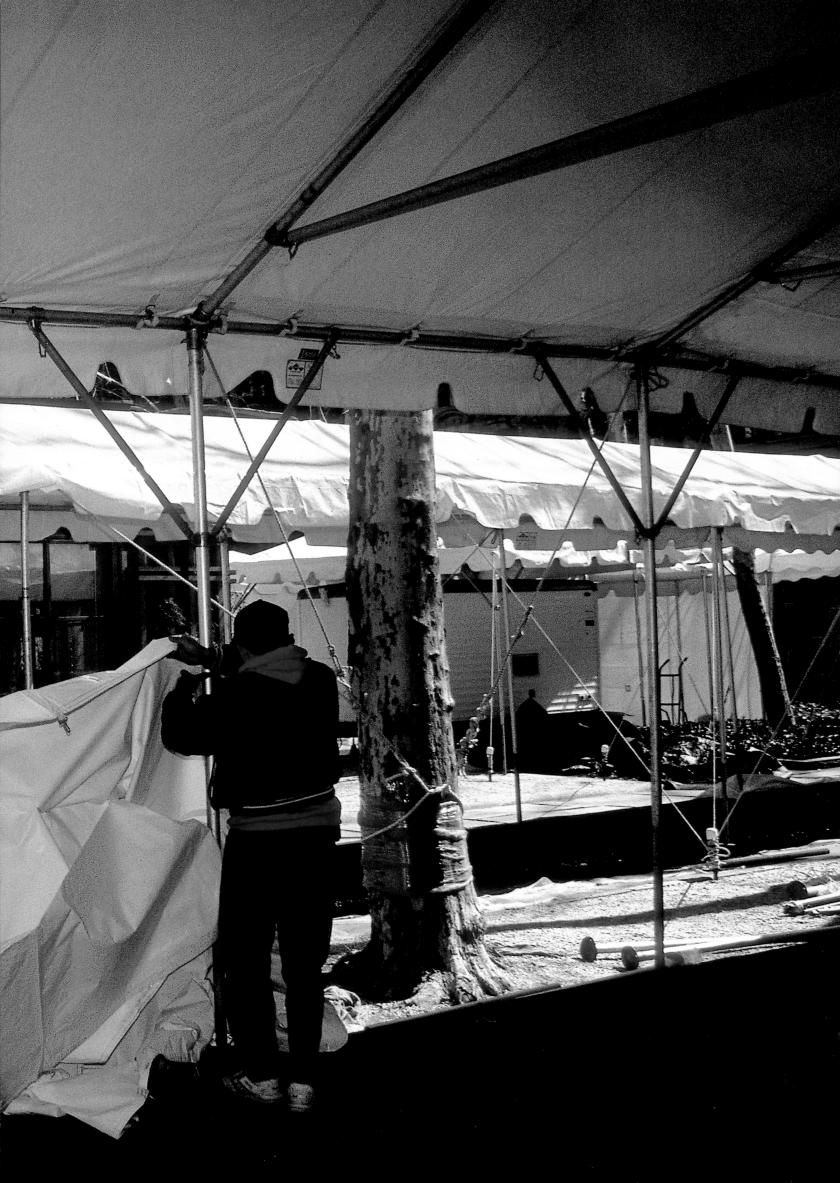

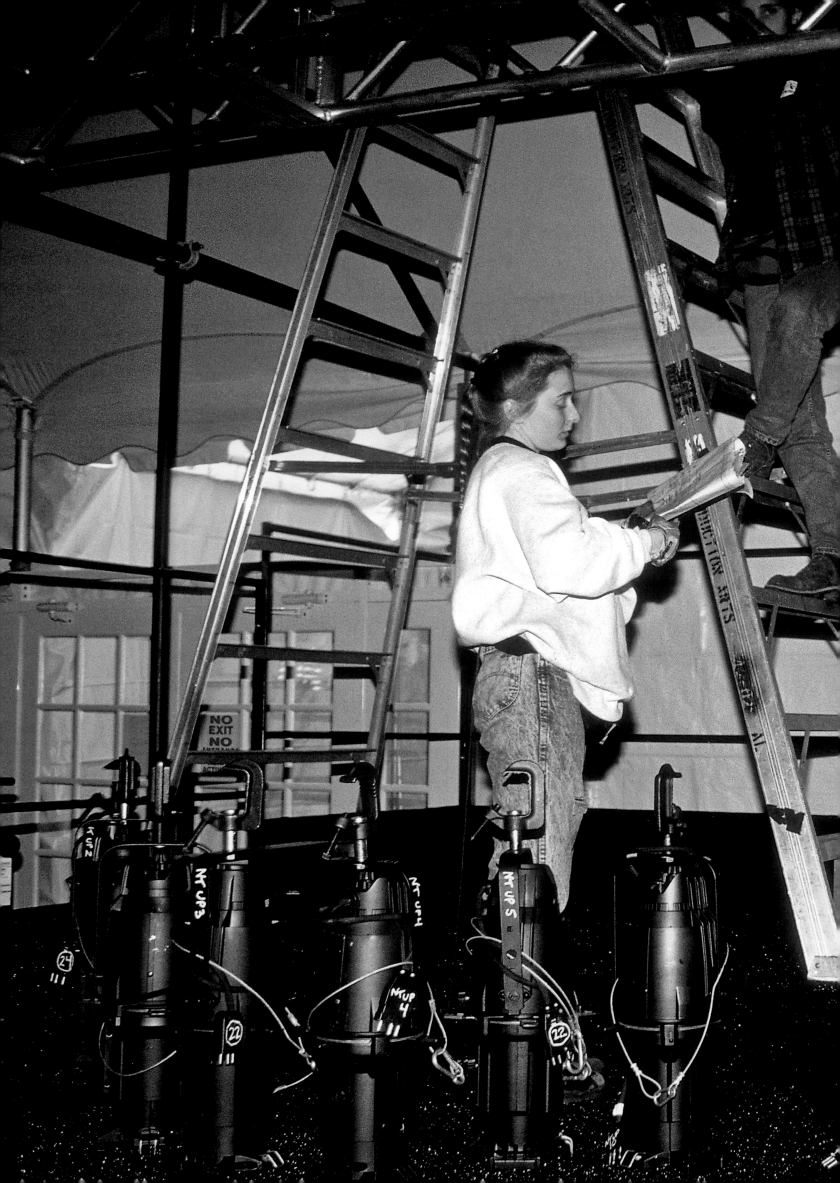

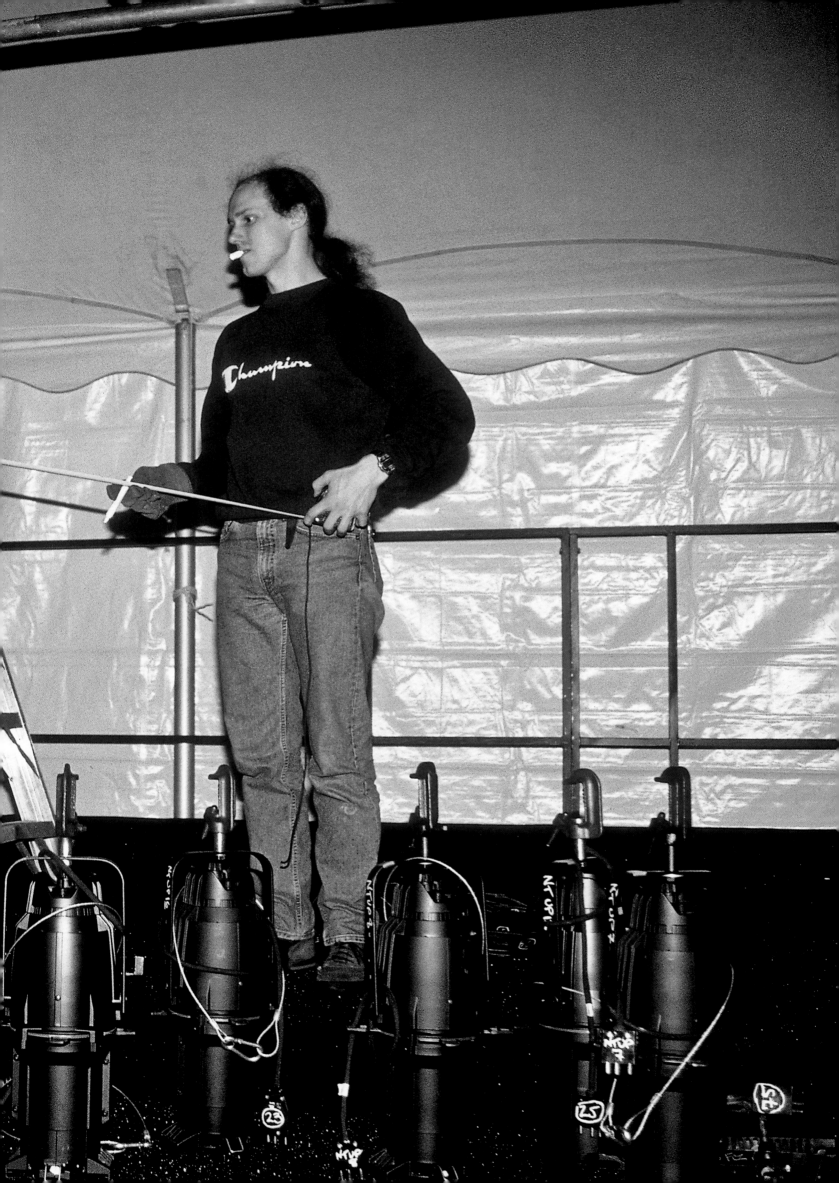

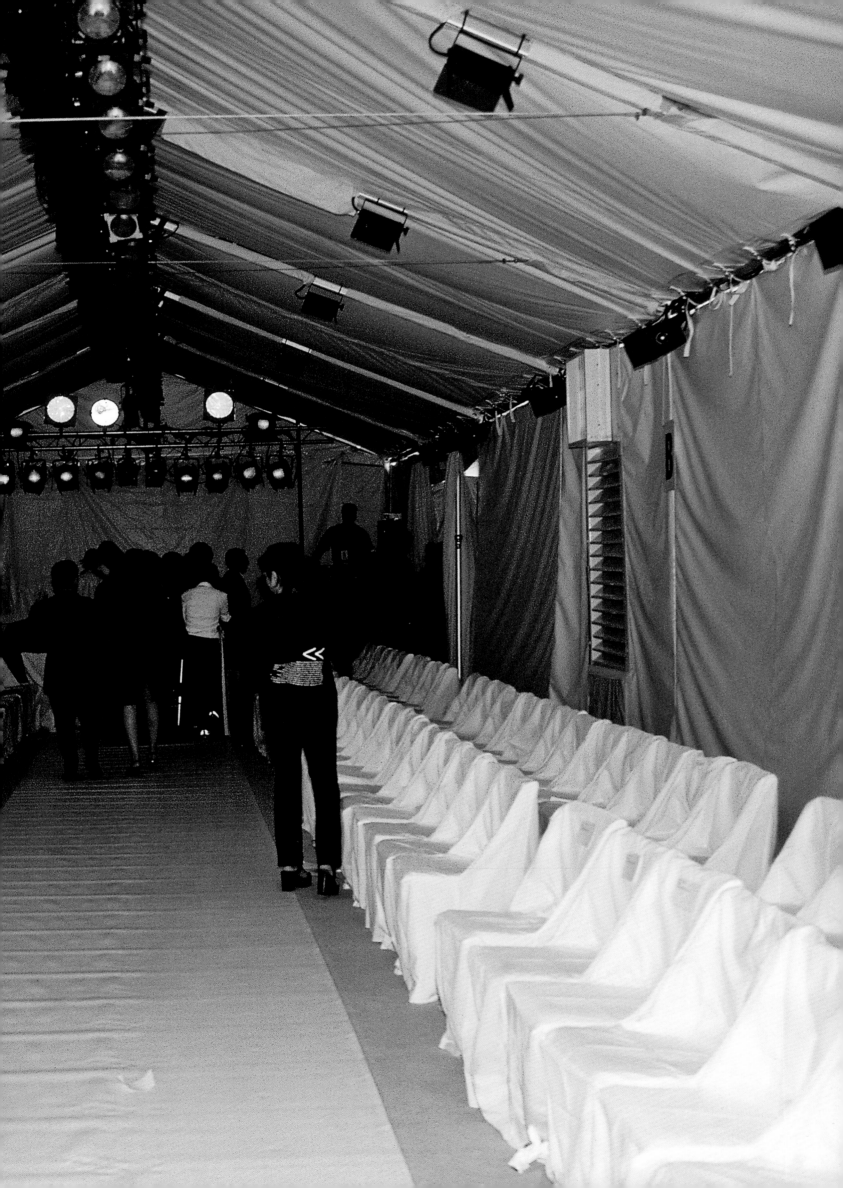

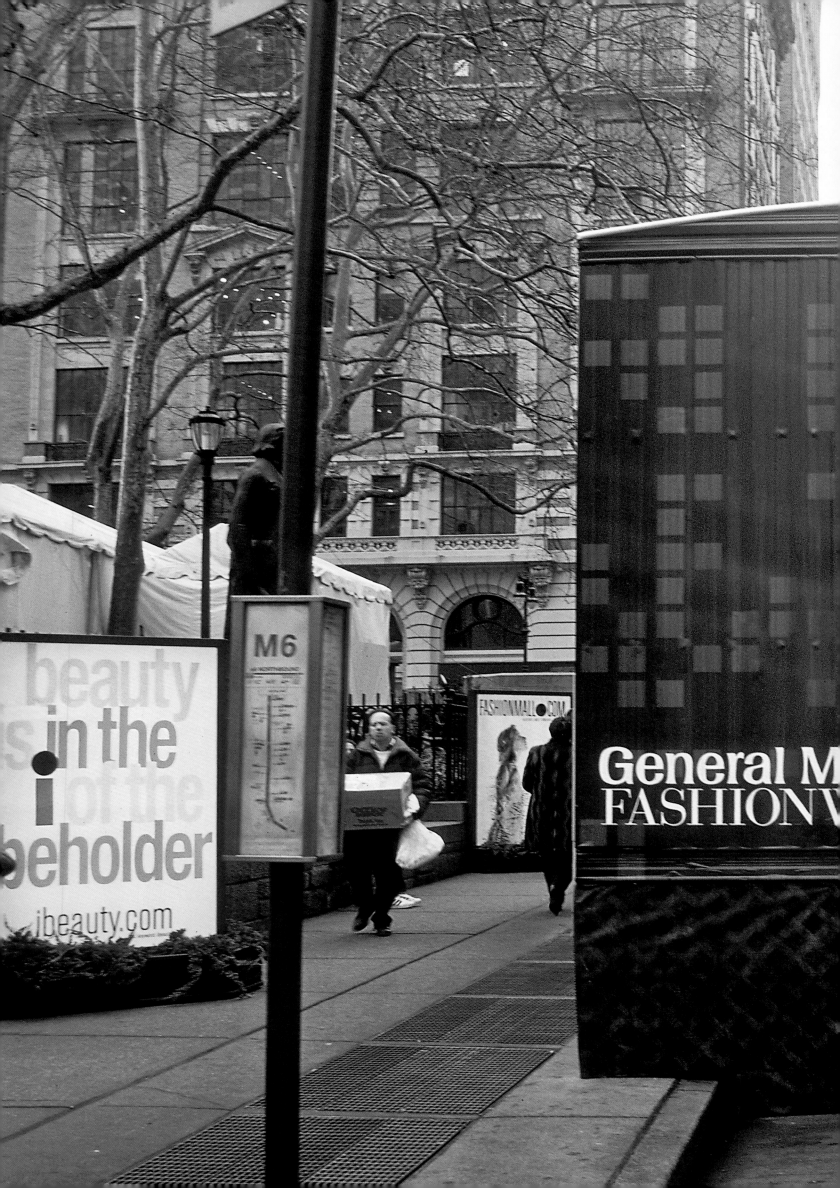

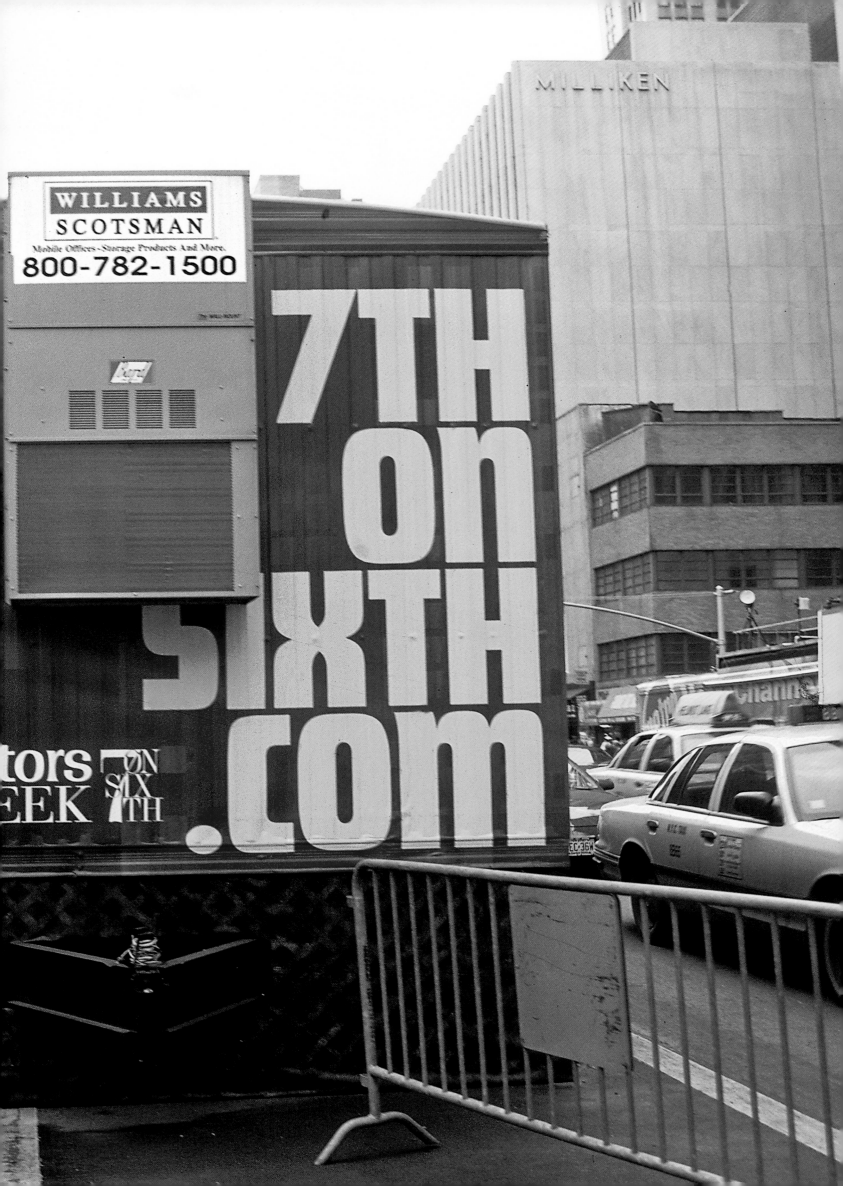

PAGES 12–17

Tents being set up in Bryant Park, April 1994

PAGES 18–19

Preparing for the Isabel Toledo show, March 1998

PAGES 20–21

7th on Sixth "Command Center" outside of Bryant Park, February 2000

PAGES 22–23

Waiting on line to get into a show at Bryant Park, April 1997

ADJACENT

From top, left to right:
Clothing steamer at the Susan Lazar show, February 1999
Fern Mallis overseeing the setup of Fashion Week, October 1995
Hairstylist Garren and designer Anna Sui at her show, February 2003
Pushing a clothing rack backstage at the Todd Oldham show, April 1997
Clothing racks at the BCBG Max Azria show, September 2002
Naomi Campbell's garment bag at the Anna Sui show, Fall 2003
Fern Mallis opening the New York Times photographer Bill Cunningham's photography exhibit
outside of the Tents at Bryant Park, September 2003
Fashion show producer Alexandre de Betak and designer John Bartlett at the John Bartlett show, July 1996
Helena Christensen and Naomi Campbell at the Badgley Mischka show, April 1994
The Ground Crew's Audrey Smaltz at the JOOP! show, September 2000
The Gertrude Stein statue "styled" for the show inside of the eponymous Gertrude Tent, April 1995
Fashion show producer Kevin Krier and Jonathan Reed at the Badgley Mischka show, September 2003
Mannequins being set up, November 1997
Backstage at the Luca Luca show, February 2003
Reviewing the seating chart at the Anna Sui show, April 1994
Designer Wolfgang Joop and fashion show producer Kevin Krier at the JOOP! show, February 2000
Runway rehearsal at the Lloyd Klein show, September 2003
Serena Bass's catering crew backstage at the Tommy Hilfiger show, September 2002

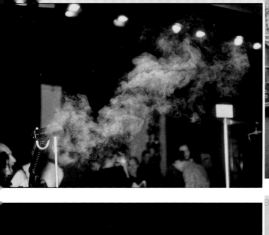
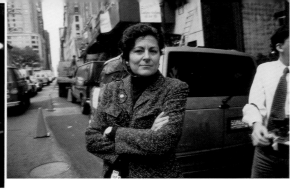
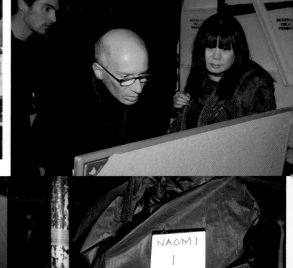
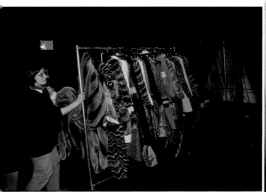

BCBG MAXAZRIA
COLLECTION

CANDICE

11. LILAC SILK SLIP DRESS
CITRON COTTON SKIRT
CITRON COTTON CAMI
GOLD LEATHER PUMP
MULTI RUFFLED PURSE

#11

31. MULTI JERSEY SKIRT
CHALK ¾ SLV BLOUSE
GOLD BRAIDED BELT

NAOMI
1

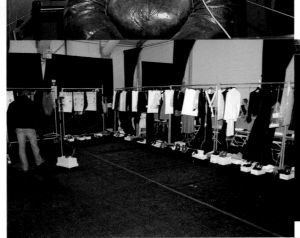
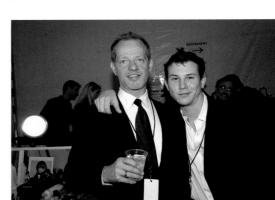

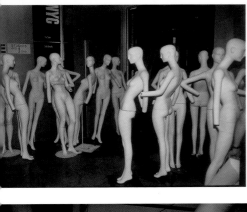

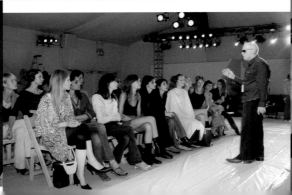

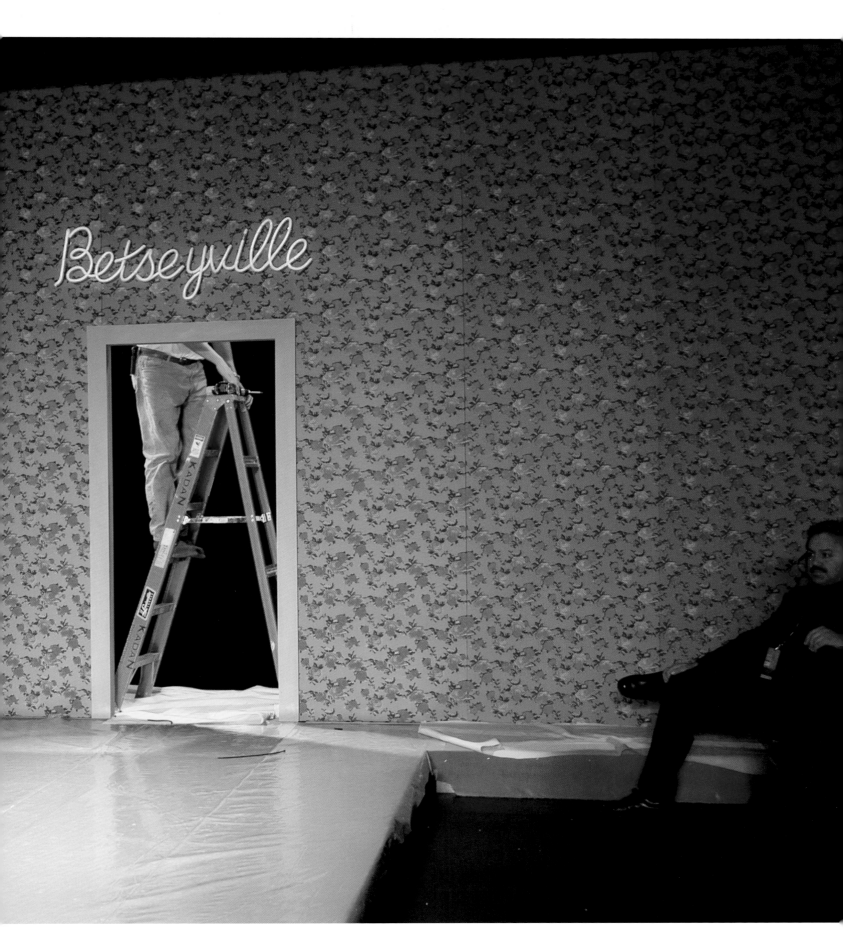

Setting up at the Betsey Johnson show, September 2003

Preshow runway at the Matthew Williamson show, February 2003

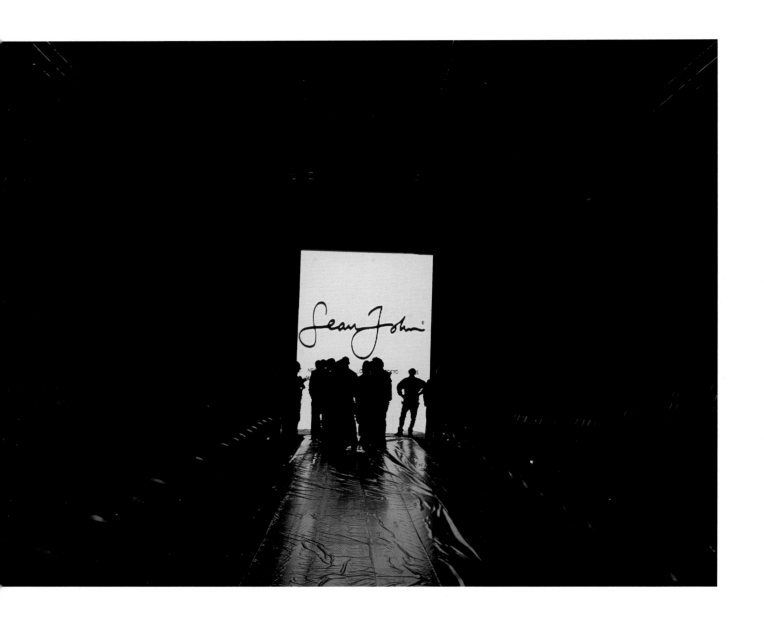

Preshow runway at the Sean John show, February 2000

Preshow runway at the Anna Sui show, September 1999

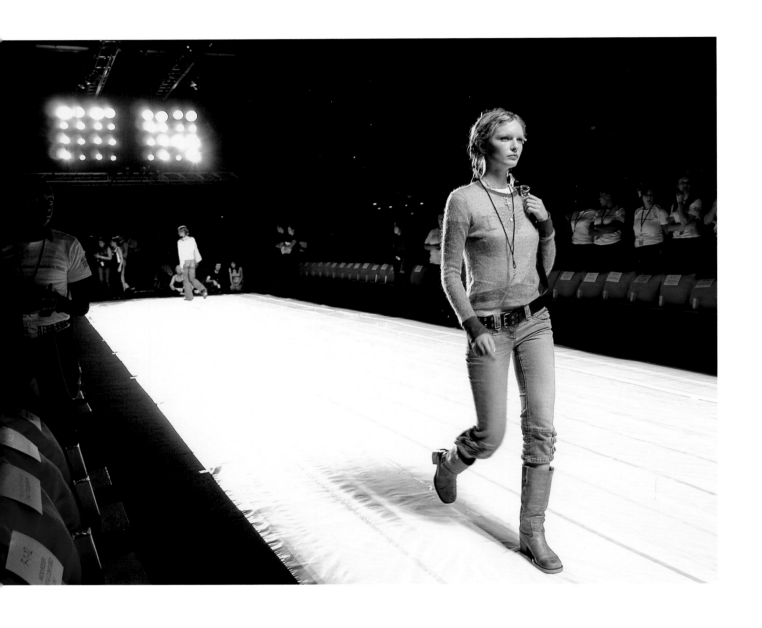

Runway rehearsal at the Lacoste show, September 2003

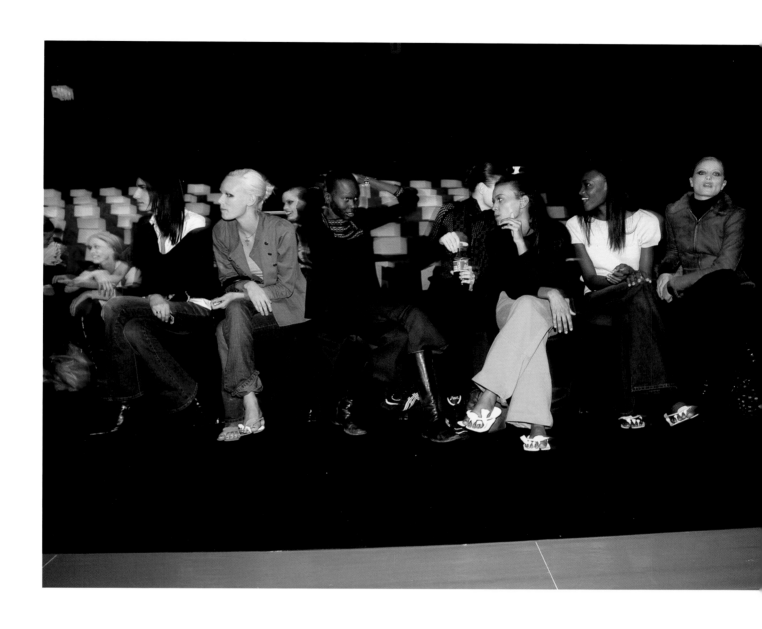

Models, preshow, at the Luca Luca show, February 2003

THE TENTS IN BRYANT PARK WERE AN IDEA WHOSE TIME HAD ARRIVED, AND I FEEL PRIVILEGED TO HAVE BEEN A PART OF THEIR BIRTH. IT WAS A TIME WHEN FASHION IN NEW YORK STEPPED INTO THE INTERNATIONAL SPOTLIGHT. TENTS IN THE PARK, IN THE HOT CENTER OF MIDTOWN MANHATTAN — DEFINITELY A WATERSHED MOMENT IN AMERICAN FASHION HISTORY. I HAVE WALKED THOSE TENTS FOR ALL THEIR ELEVEN YEARS AND I STILL GET CHILLS WHEN I SEE THE FIRST PLATFORM BEING SET, THE FIRST WALL RISE AND THE RUSH OF ENERGY GENERATED BY OUR MOST TALENTED DESIGNERS. I HAVE GREAT FONDNESS REMEMBERING THE ORIGINAL TENTS. SUPPORTED BY POLES LIKE A CIRCUS WITH OBSTRUCTED VIEWS. IT WAS LIKE PUTTING ON SUMMER STOCK IN THE CATSKILLS AND FINDING YOUR SHOW HAD BROADWAY QUALITY. NOW IT IS THE LONGEST RUN ON BROADWAY.

STAN HERMAN
FORMER PRESIDENT, CFDA

Alek Wek at the Matthew Williamson show, February 2002

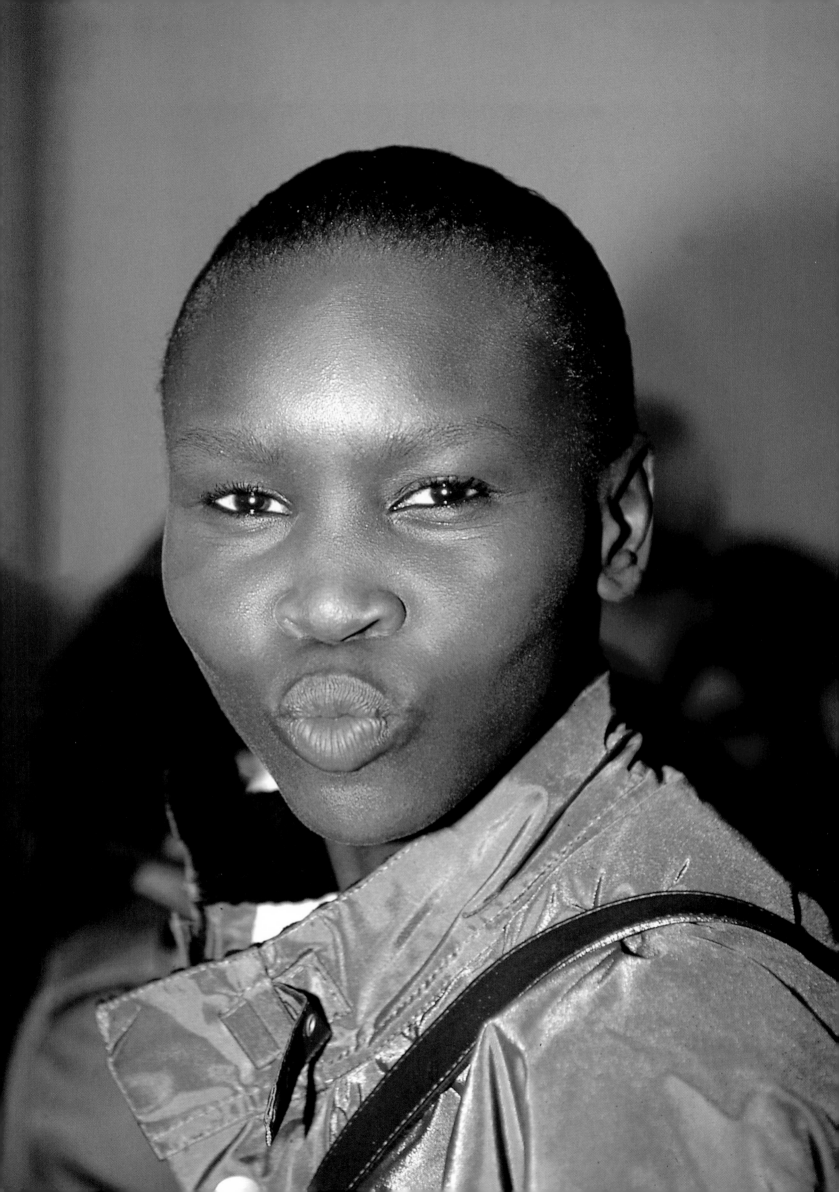

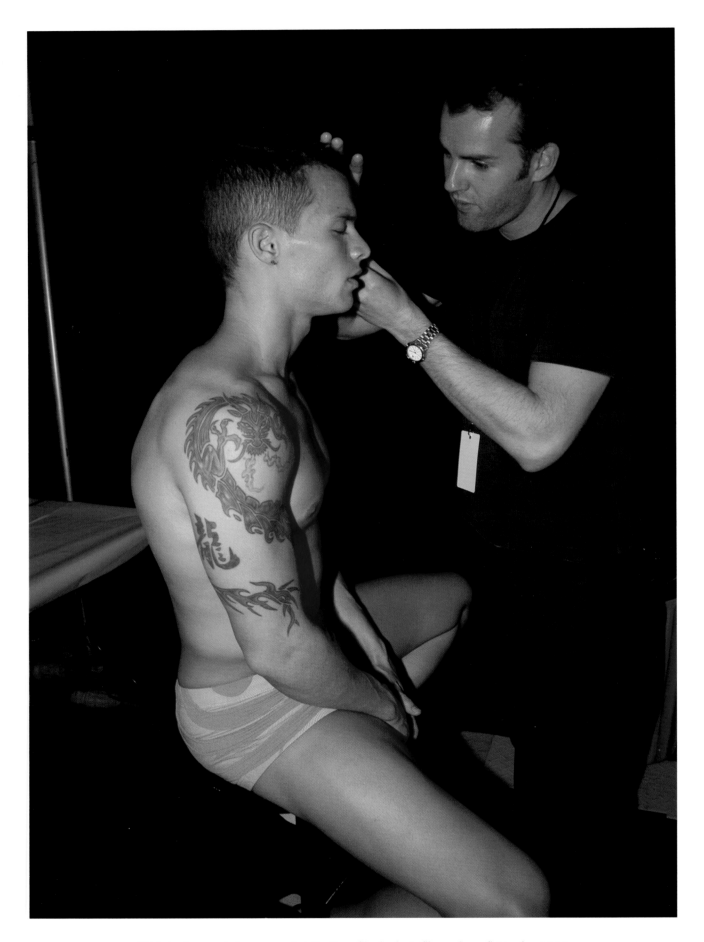

Nicholas Lemons being groomed at the Rosa Cha by Amir Slama show, September 2003

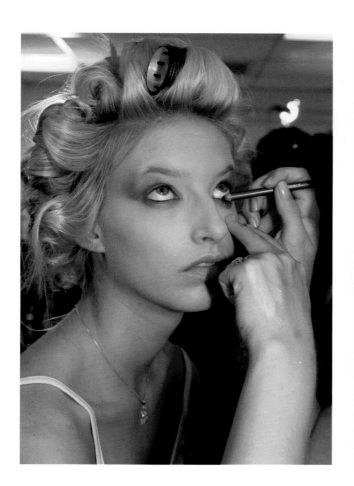

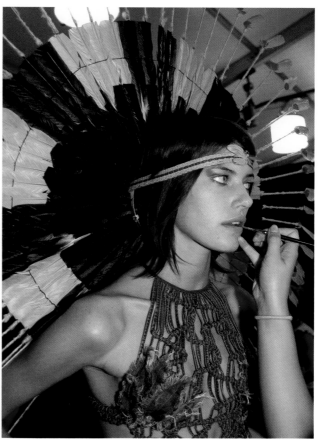

Beauty at the House of Field show, September 2002
Beauty at the Carlos Miele show, September 2002

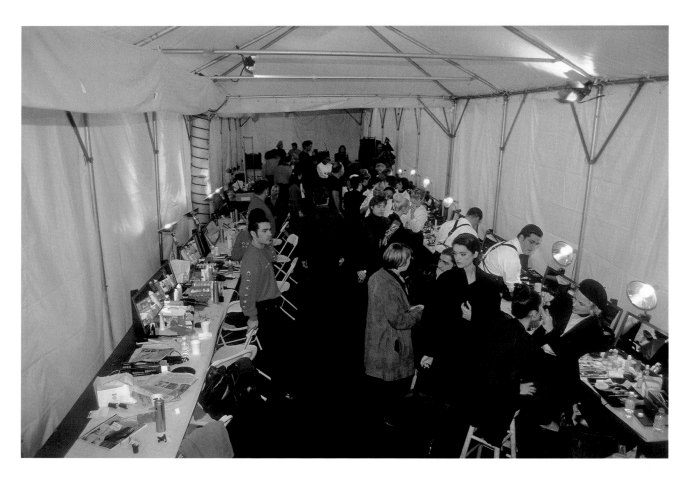

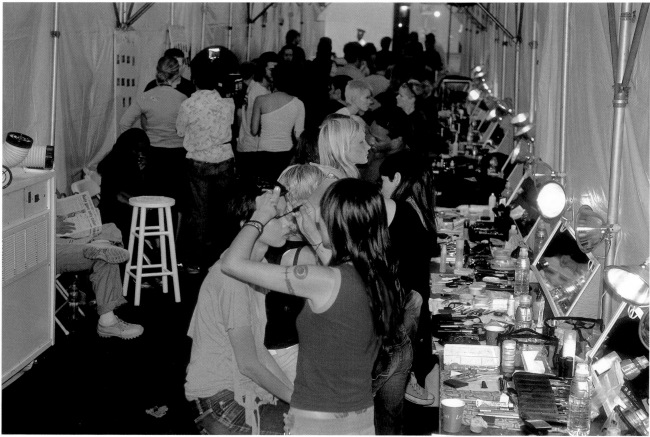

Backstage at the Donald Deal show, November 1995
Backstage at the Kenneth Cole show, September 2001

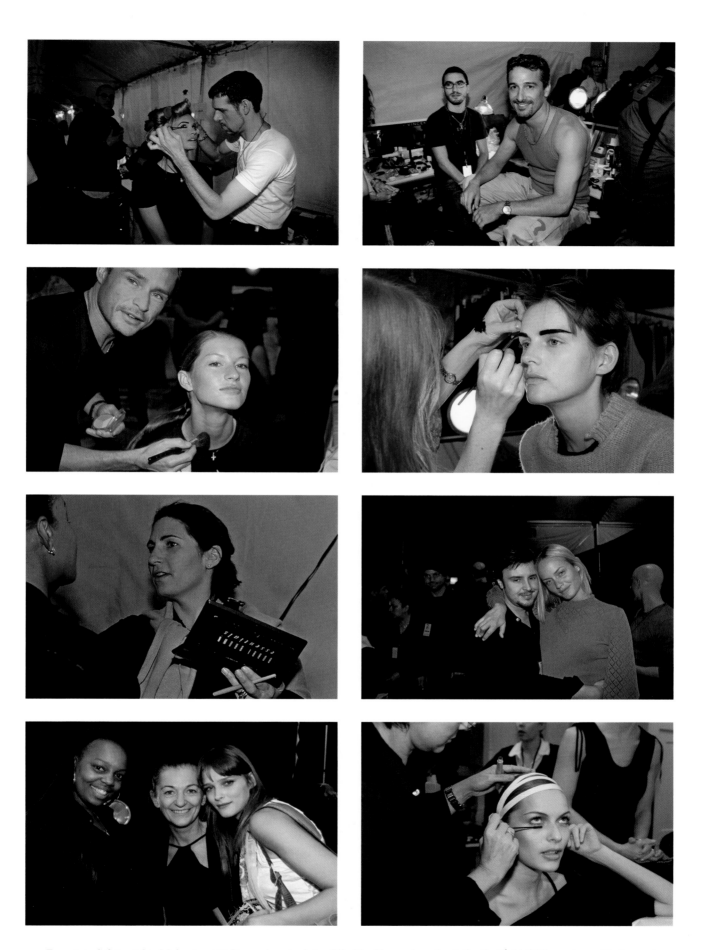

From top, left to right: Makeup artist Kevyn Aucoin doing Elle MacPherson's makeup for the Todd Oldham show, April 1995
Makeup artist Vincent Longo at the Lloyd Klein show, September 2003
Makeup artist Tom Pecheux with Gisele Bundchen at the Ralph Lauren show, September 2000
Stella Tennant at the Luella Bartley show, February 2003
Makeup artist Bobbi Brown at the Bill Blass show, April 1998
Makeup artist François Nars and Amber Valletta at the Anna Sui show, April 1998
Makeup artist Pat McGrath, stylist Brana Wolf, and Carmen Kass at the Anna Sui show, September 2002
Rie Rasmussen at the Bill Blass show, September 2002

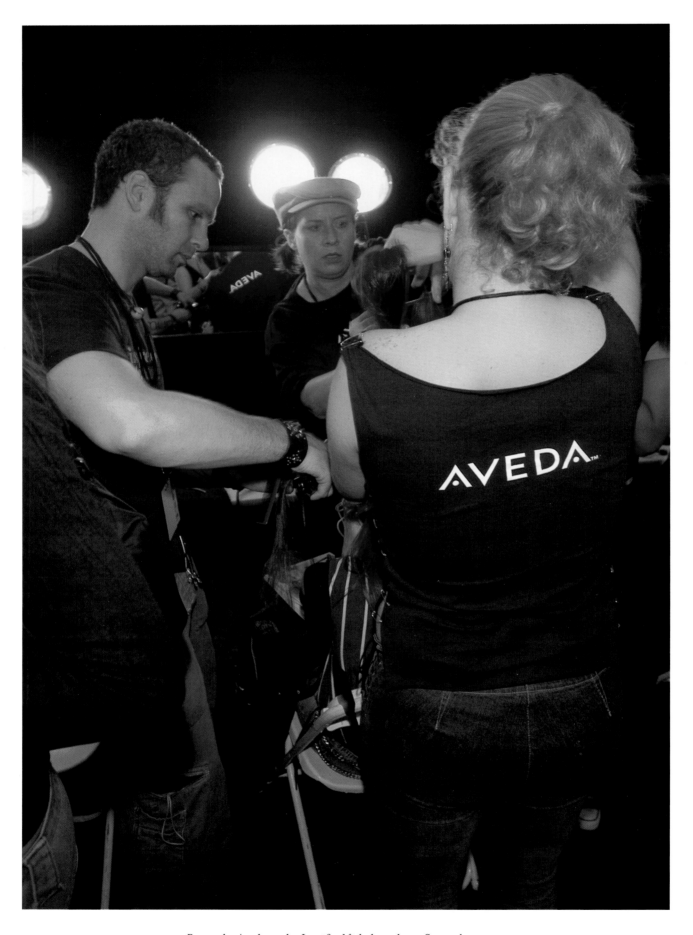

Beauty by Aveda at the Jennifer Nicholson show, September 2003

FASHION SHOWS SET THE STAGE FOR MAKEUP ARTISTS, HAIRSTYLISTS, AND DESIGNERS TO GAIN EXPERIENCE, HAVE FUN, AND CREATE WITHIN A FORUM THAT'S SAFE TO PUSH BUTTONS AND CREATE SHOCK VALUE. TODAY, I THINK MORE EMPHASIS IS PLACED ON SHOCK VALUE RATHER THAN BEAUTY ITSELF. I ALWAYS ENJOYED THE THEATRICAL NATURE OF THE SHOWS, CREATING WILD LOOKS, BUT EVEN IN THE EXTREMES MY WORK WAS ALWAYS BEAUTIFUL AND I MADE ALL THE GIRLS LOOK BEAUTIFUL. I ALWAYS VALUED MY RELATIONSHIPS WITH THE MODELS, WHICH IN ESSENCE CREATED A CHALLENGE TO PLEASE, SINCE ALL THE TOP MODELS AT THE SHOWS WANTED ME TO MAKE THEM UP. FASHION SHOWS ARE VERY MUCH THE PULSE OF THE INDUSTRY AND IT WAS A VERY FUN TIME FOR ME, BUT I'M GLAD THAT I HAVE MOVED ON.

FRANÇOIS NARS

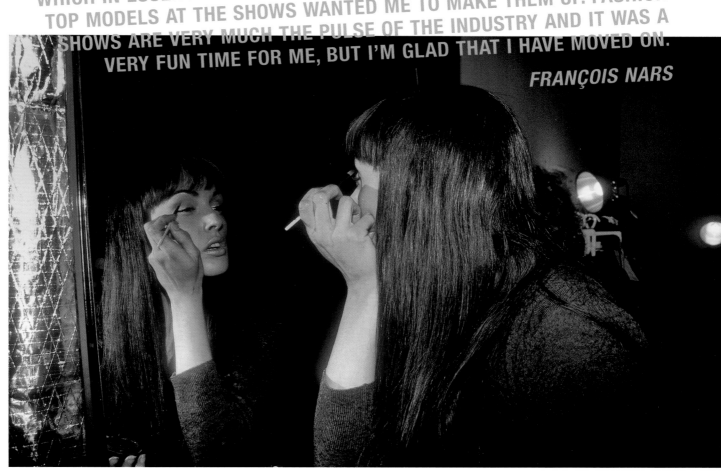

Maureen Gallagher, April 1994

41

FASHION WEEK IN NEW YORK HAS BECOME THE GREATEST SHOW ON EARTH AND LIKE BARNUM AND BAILEY BEFORE IT, THE WEEK HAS EVERYTHING: LIONS, TIGERS, CLOWNS, AND QUITE A FEW WHITE ELEPHANTS. AND THEN THERE ARE THE TRAPEZE ARTISTS WE CALL DESIGNERS, WHO WALK THE TIGHTROPE OF PUTTING ON CLOTHES THAT LOOK GOOD ON A RUNWAY AND CAN ACTUALLY SELL OUT THERE IN DULUTH. MOST FALL, OF COURSE, BUT EVERY ONCE IN A WHILE, A FEW SUCCEED AND REACH THE OTHER SIDE. THAT'S WHEN THE APPLAUSE IS DEAFENING. IT'S BETTER THAN ANY CIRCUS.

PATRICK MCCARTHY

Wig at the Vivienne Tam show, February 2003

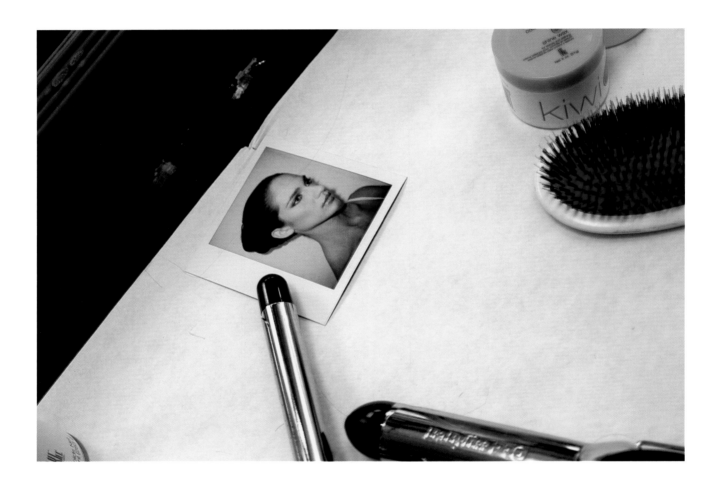

Beauty polaroid at the Badgley Mischka show, February 2003

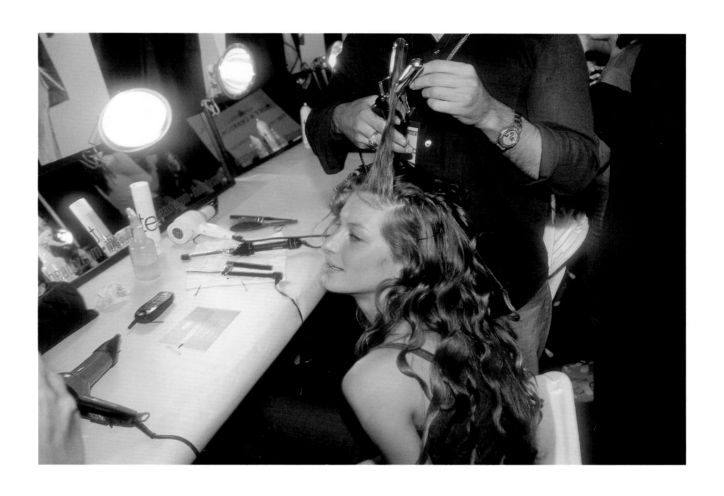

Gisele Bundchen getting her hair done at BCBG Max Azria show, September 1999

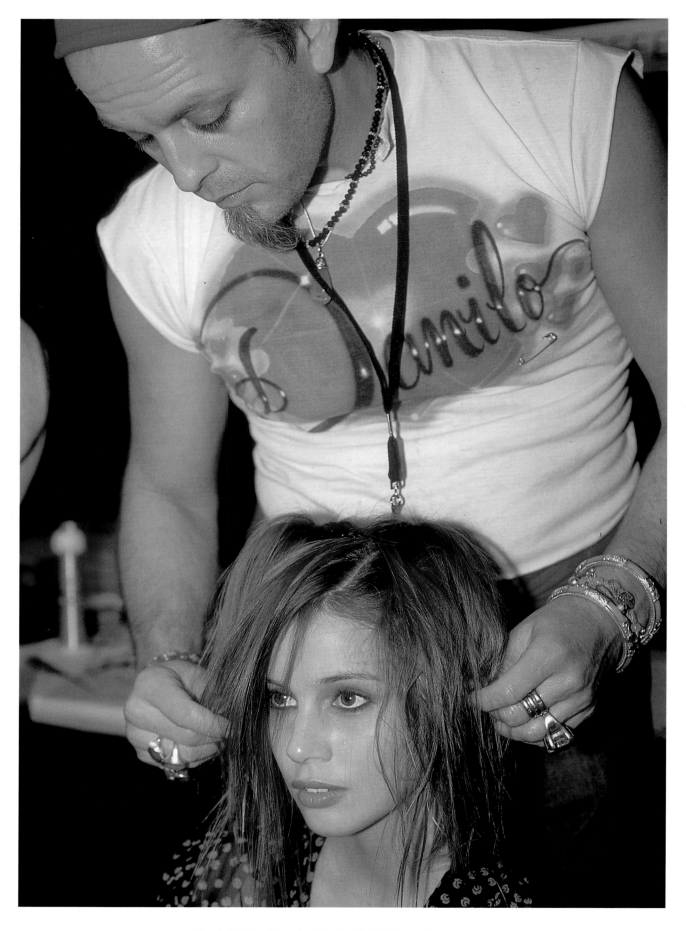

Hairstylist Danilo at the Cynthia Steffe show, February 2001

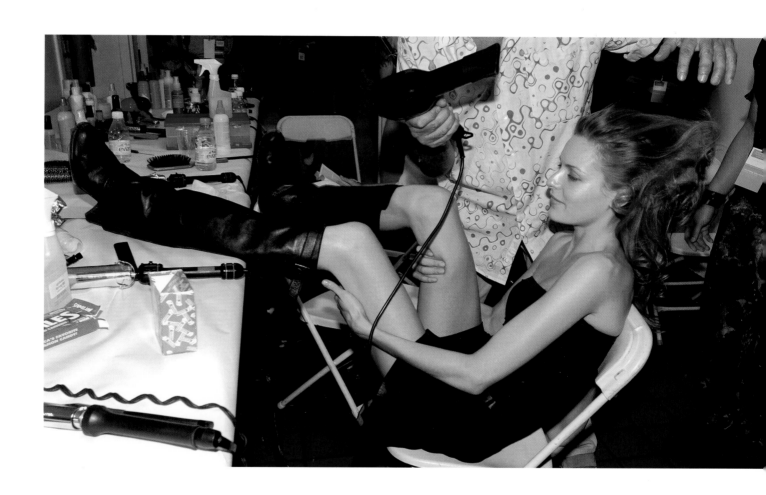

Rie Rasmussen at the Matthew Williamson show, September 2002

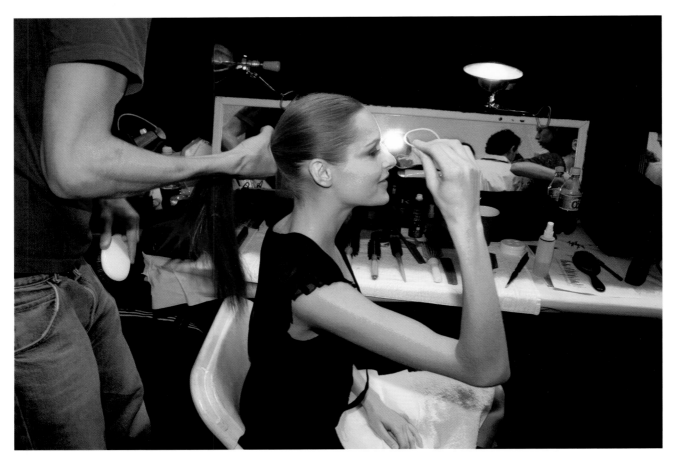

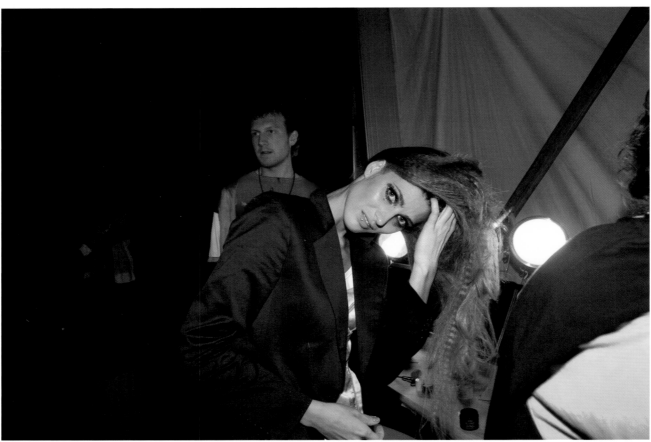

Rie Rasmussen at the Oscar de la Renta show, September 2002
Michelle Alves at the Baby Phat show, September 2003

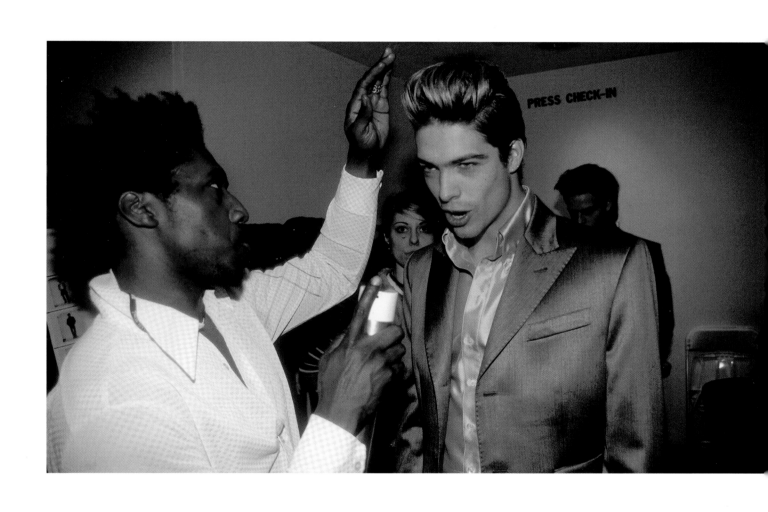

Mike Campbell at the Richard Tyler show, February 1996

Backstage at the Victor Alfaro show, September 2000

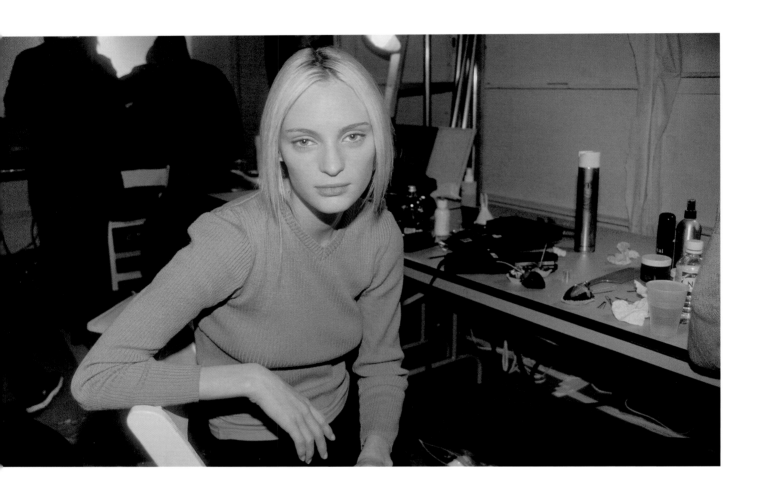

Amy Wesson at the Isaac Mizrahi show, October 1996

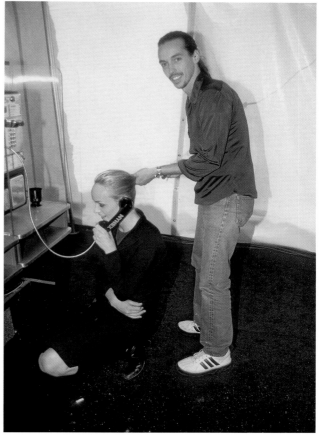

Amber Valletta at the Versace show, October 1995
Hairstylist Orlando Pita fixing Amber's hair at the pay phone, March 1996

Fernanda Tavares at the Bill Blass show, February 2002
Trish Goff at the Oscar de la Renta show, September 2000

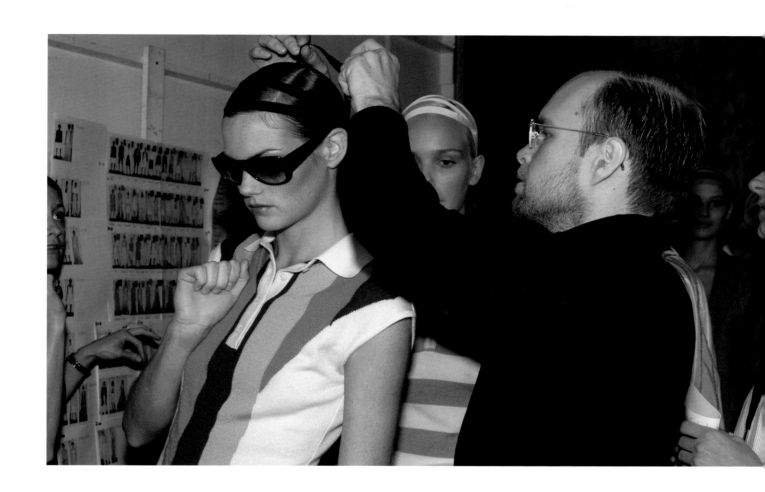

Lars Nilsson adjusting Mini Anden's look before the show at the Bill Blass show, September 2002

IT'S FASHIONABLE CHAOS. LIKE DICKENS WROTE: "IT WAS THE BEST OF TIMES, IT WAS THE WORST OF TIMES." IT'S INCREDIBLY STUNNING FASHION. IT'S A WOMAN STEPPING ON YOUR FOOT IN HER HIGH HEEL BLAHNIKS AS SHE RUSHES TO HER SEAT IN THE FRONT ROW. THE PRESSURE. LOTS OF PRESSURE. WORKING BACKSTAGE WITH HUNDREDS OF CAMERAS — IT JUST AIN'T EASY. BUT THAT'S WHAT MAKES IT FUN. AND EVERY SEASON IS DIFFERENT.

LAUREN EZERSKY

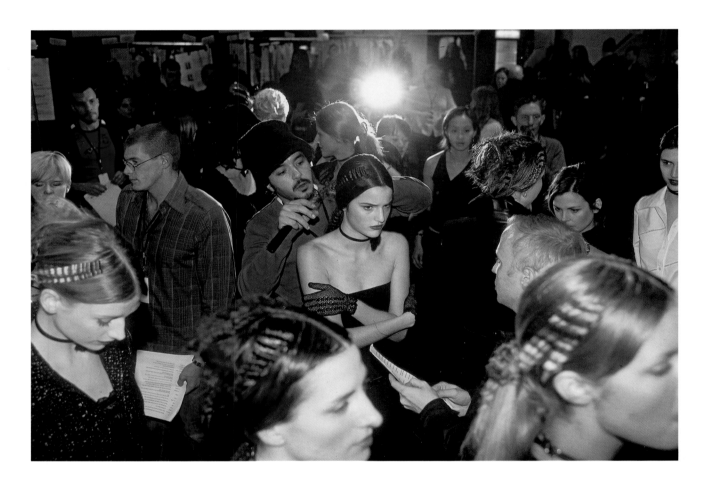

Backstage at the Cynthia Steffe show, February 2002

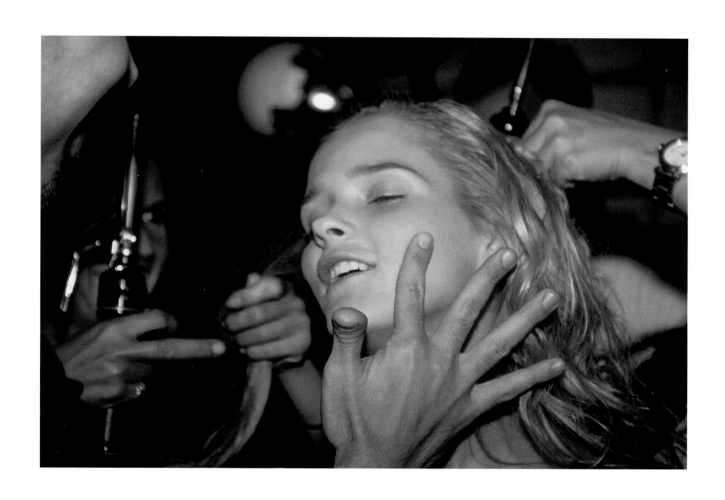

Carmen Kass at the BCBG Max Azria show, September 1999

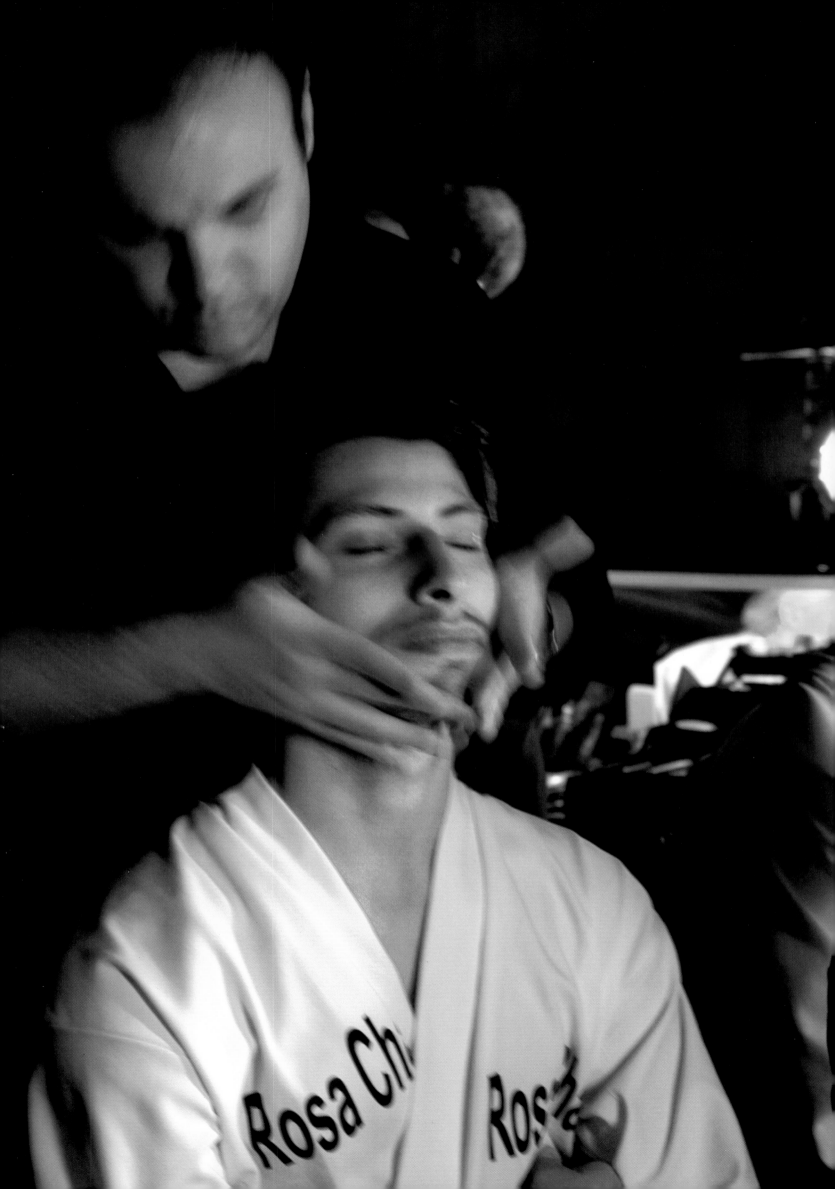

THE TWICE-YEARLY FASHION SHOWS HELD
AT NEW YORK'S TENTS AT BRYANT PARK
ARE A LEGEND WITHIN THE WORLD OF
MAKEUP ARTISTS AND HAIRDRESSERS.
TO WORK BEHIND THE SCENES BACKSTAGE
AT ANY FASHION SHOW IS EXHILARATING,
NERVE-RACKING AND HIGH ENERGY...
YET WHEN ONE "GRADUATES" TO BEING
BOOKED AT A SHOW THAT IS HELD AT
THE TENTS... WELL, THE WHOLE MOOD IS
SUPER CHARGED WITH INTERNATIONAL
FLAVOR, CELEBRITIES, SUPERMODELS, AND
MORE OUTRAGEOUS BACKSTAGE ANTICS.

CHARLIE GREEN

Backstage at the Rosa Cha by Amir Slama show, September 2002

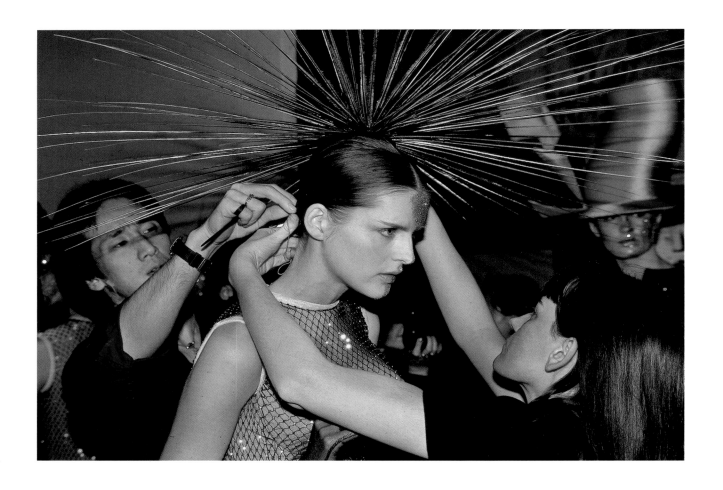

Adjusting the headpiece on Stella Tennant at the Phillip Treacy show, February 1999

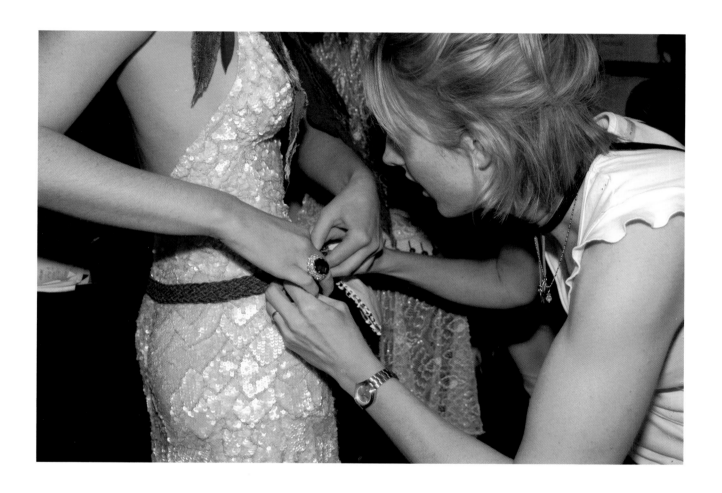

Final adjustments to a dress at the Carlos Miele show, September 2002

Kristen McMenamy at the Isaac Mizrahi show, April 1997

TENTS, FOLDING CHAIRS, AND
PORTAPOTTIES. NEVER THE RIGHT
TEMPERATURE. THE GLAMOUR OF
BACKSTAGE...GOTTA LOVE IT!

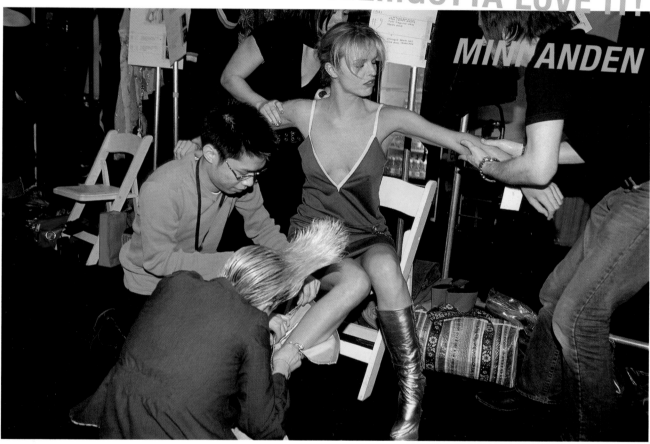

Eva Herzigova being dressed at the Matthew Williamson show, February 2002

A shoe being laced up at the Chaiken show, February 2003

House of Field designer David Dalrymple tweaking a look at the House of Field show, September 2002
Model backstage at the Julien MacDonald show, November 1998

Lining up at the Kenneth Cole show, February 2003

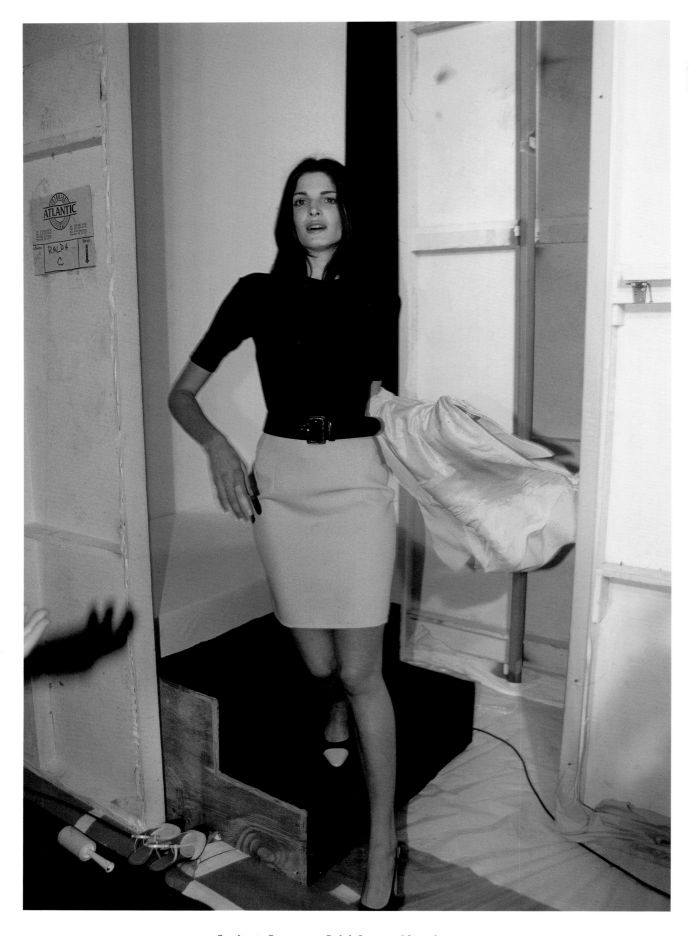

Stephanie Seymour at Ralph Lauren, November 1995

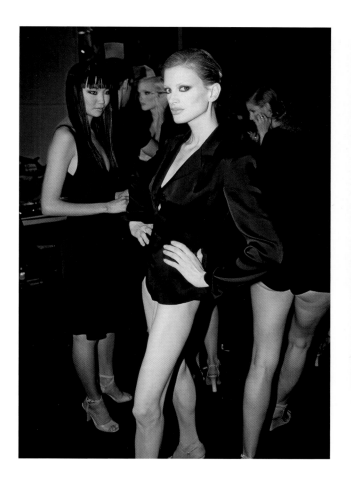
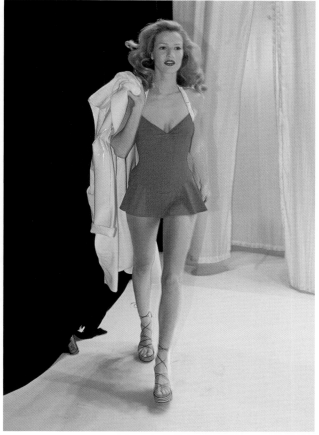

Irina Pantaeva and Kristen McMenamy at the Donna Karan show, November 1994
Karen Mulder at the DKNY show, October 1994

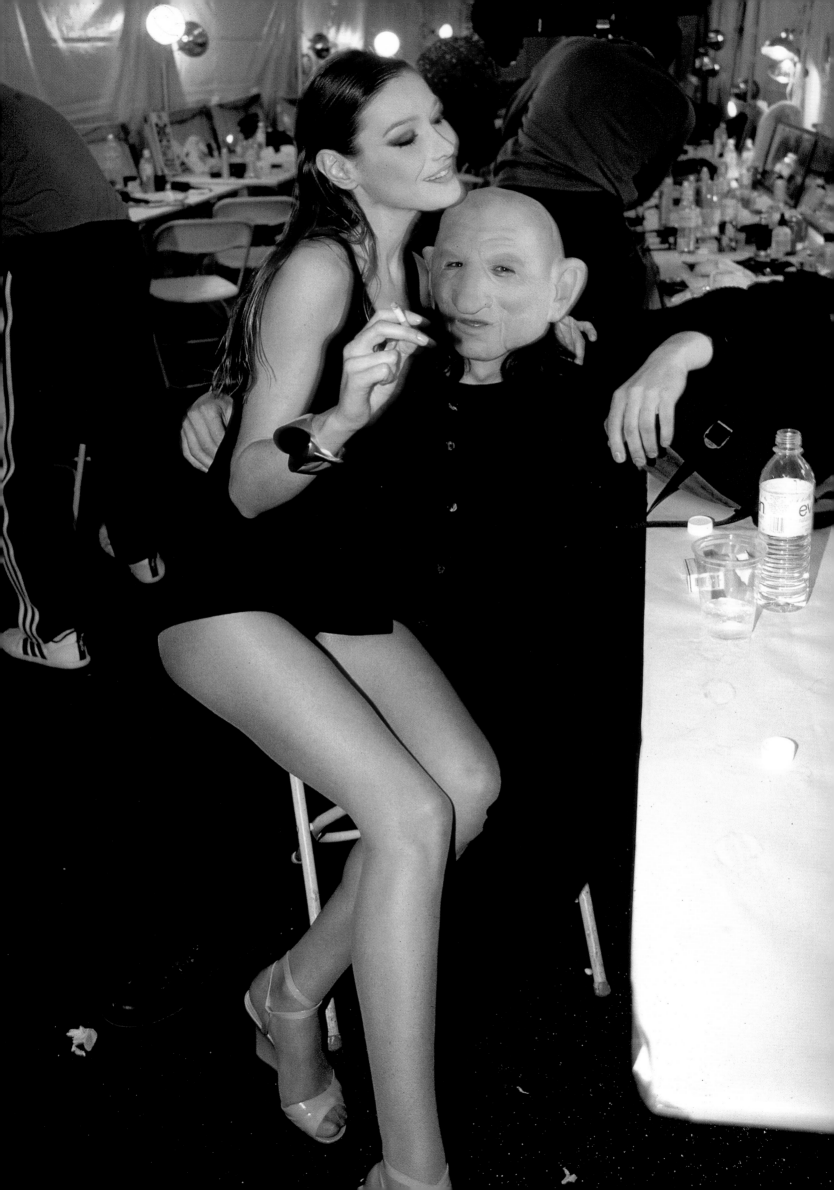

IT IS ENTIRELY APPROPRIATE THAT FASHION WEEK IS SET UNDER THE TENTS, SUGGESTIVE AS IT IS OF A CIRCUS ATMOSPHERE. AND WHAT A GREAT CIRCUS IT IS! NO DOUBT CENTER RING IS THE PAGEANTRY OF THE DESIGNERS AND THEIR COLLECTIONS, THEIR MODELS (STRUTTING ATTITUDE FROM THEIR HIPS), THE CONSTANT SOUND OF CLICKS FROM PHOTOGRA-PHERS' FLASHES, AND THE PULSATING MUSIC THAT ADDS TO THE TENSION AND EXCITEMENT OF THE SHOWS. BUT THERE IS ANOTHER INTERESTING SHOW BEYOND THE "BIG RING." IT IS THE AMALGAMATION OF PEOPLE GATHERED FOR THE EVENT — FASHION EDITORS, FASHIONISTAS, FASHION WANNA-BES, FASHION VICTIMS. THEN THERE ARE THE SO-CALLED "CELEBRITIES" — THOSE IN THE ENTERTAINMENT OR SPORTS WORLDS (OR ANYONE WHO'S SIMPLY NOTORIOUS) — WHO LITTER THE FRONT ROWS TO SEE, BE SEEN, AND MAKE THE SCENE. IT IS PEOPLE WATCHING AT ITS ZENITH, AND ALL IN ALL, IT IS A VISUAL TREAT. BUT MOST OF ALL, IT IS A GREAT CONCOCTION OF FANTASY AND FUN. AND ONE OF THE BEST PARTS OF BEING AMONGST THIS PANOPLY (BESIDES SEEING THE COLLECTIONS), IS VISITING WITH YOUR FRIENDS AS YOU AWAIT THE REAL SPECTACLE TO BEGIN. IT'S MUCH BETTER THAN DOING LUNCH — ANY DAY!

MUFFIE POTTER ASTON

Carla Bruni and masked man at the Donna Karan show, November 1994

Meghan Douglas reading WWD backstage at the Richard Tyler show, October 1994
Model reading at the Tommy Hilfiger show, February 2003

Bridget Hall reading the New York Post at the Michael Kors show, February 2002

Maggie Rizer, backstage at the Carlos Miele show, September 2003

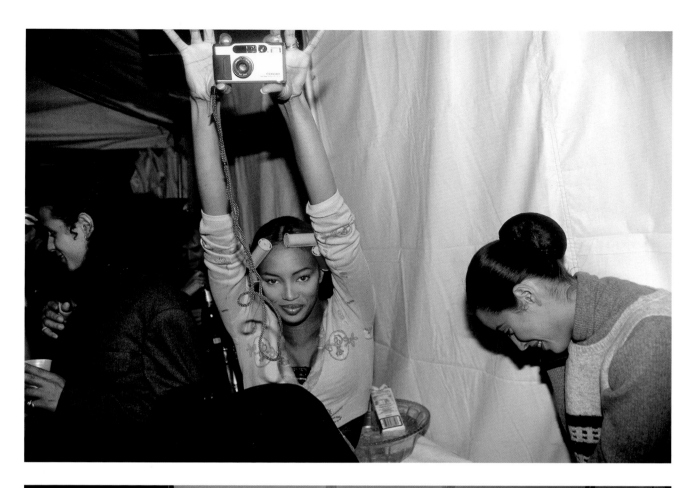

Naomi Campbell backstage, April 1994
Models at the Tuleh show, September 2003

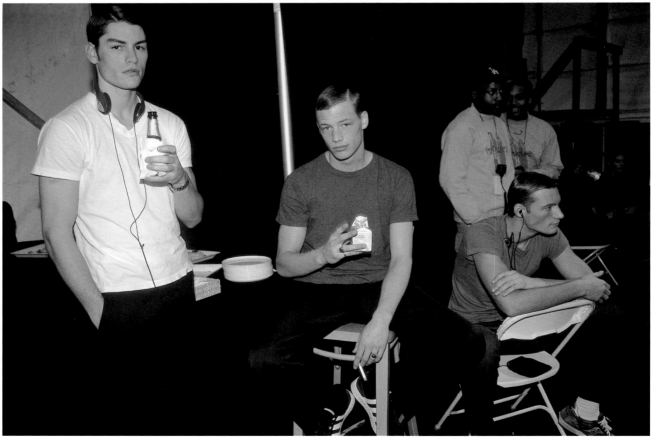

Models eating at the Cynthia Steffe show, February 2003
Tyson Ballou, Ryan Locke, and Gabriel Aubry at the Michael Kors show, February 1999

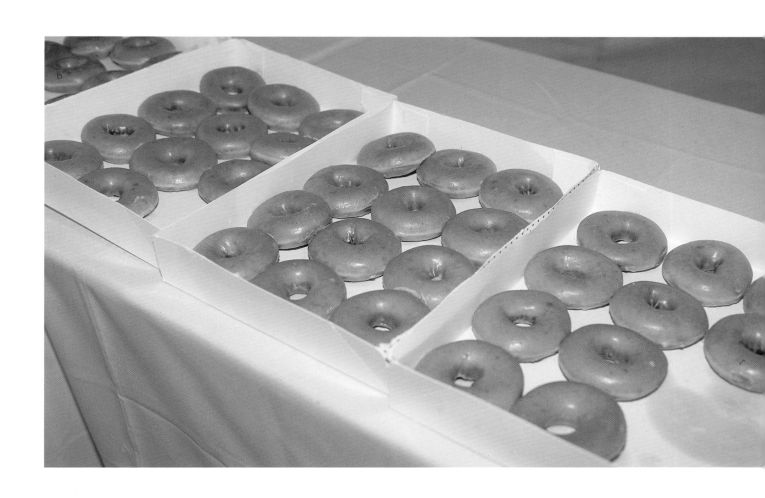

Krispy Kreme donuts backstage at the Kenneth Cole show, September 2001

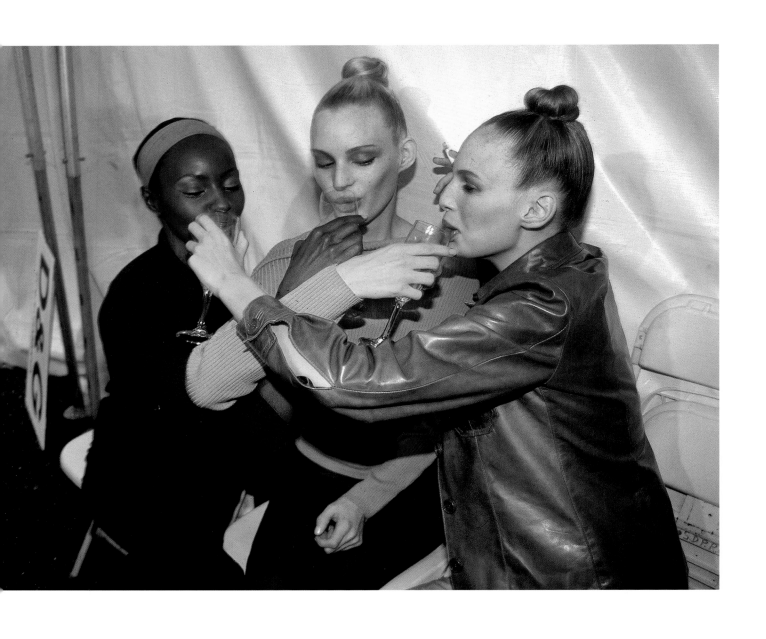

Models sipping champagne at the DKNY show, October 1996

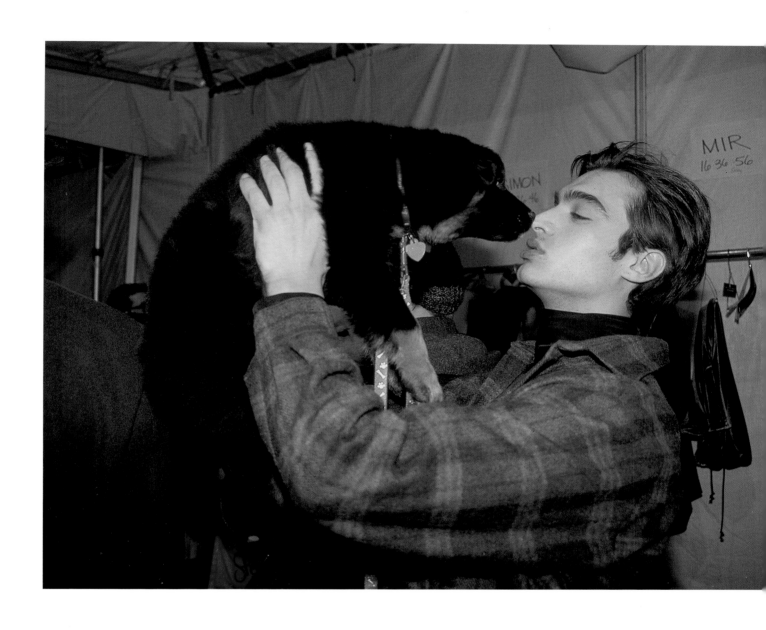

Model and dog at the Ron Chereskin show, February 2000

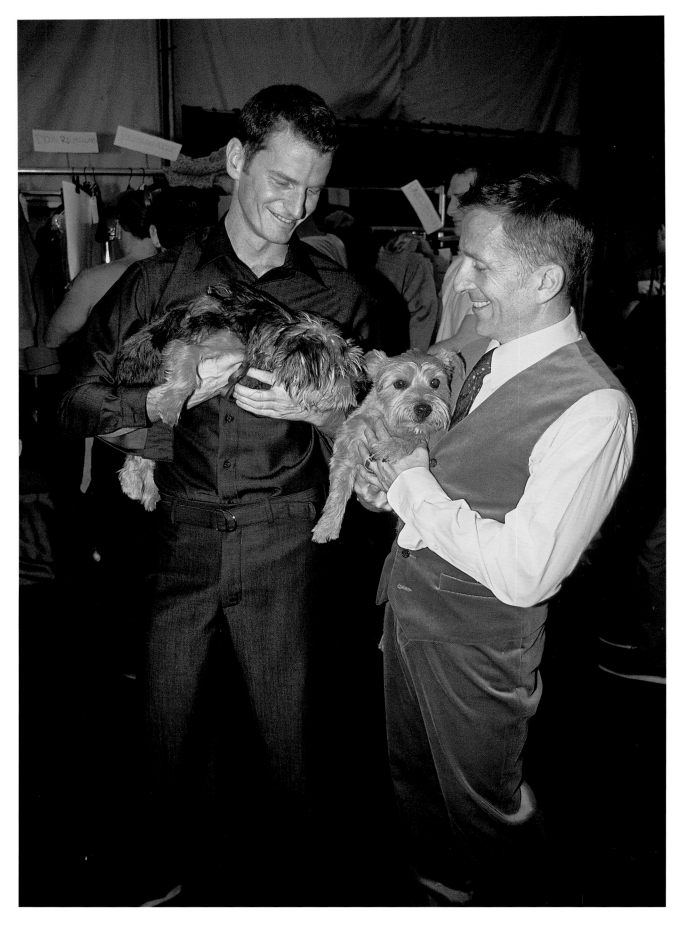

Marc Malkin and Simon Doonan with their dogs at the Perry Ellis show, February 2002

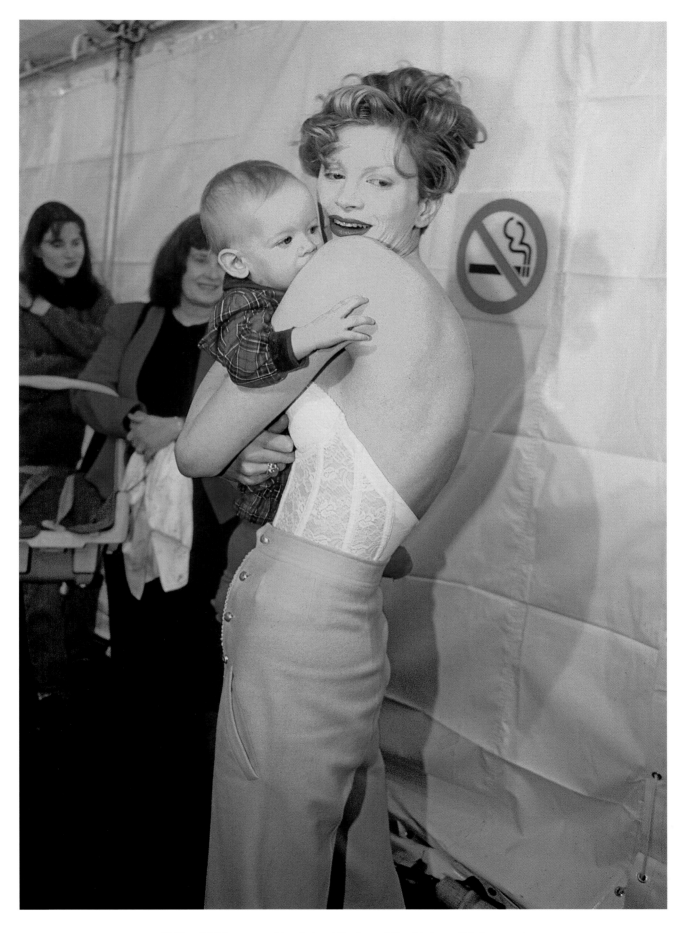

Kristen McMenamy and her baby at the Isaac Mizrahi show, October 1994

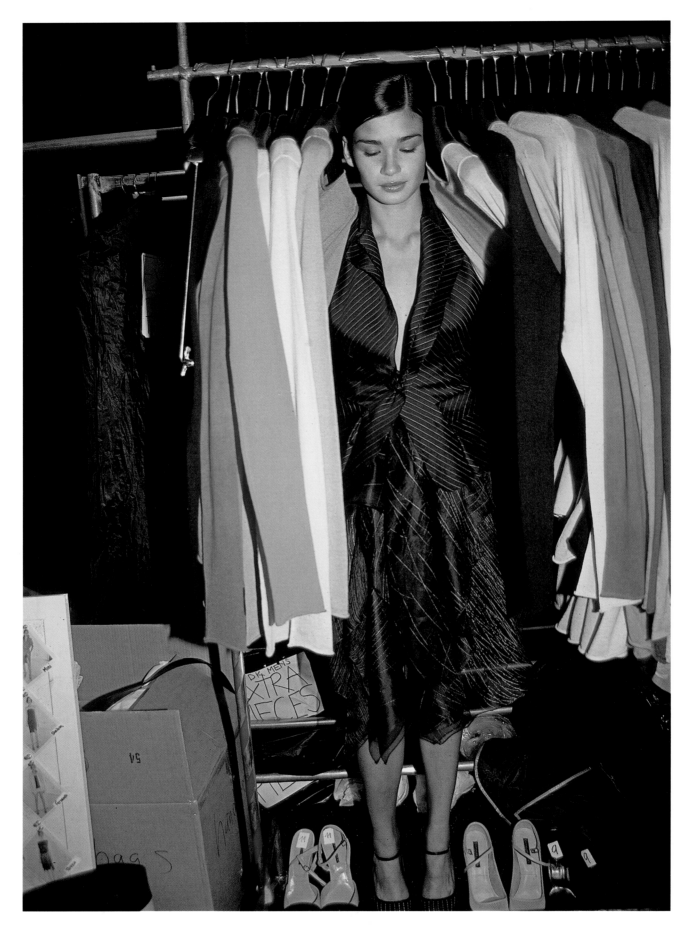

Caroline Ribeiro hiding in the racks at the Donna Karan show, September 2000

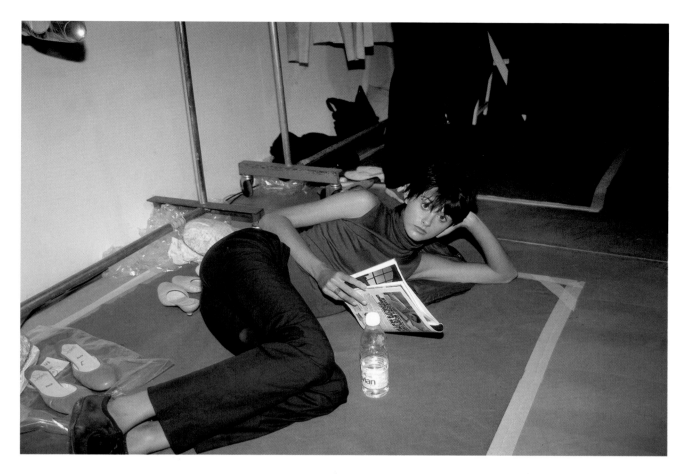

Trish Goff relaxing at the TSE show, September 1999
Model sleeping at the Hong Kong Luxe show, September 2001

Greg Payne outside of the Zang Toi show, September 2000
Tom Lariviere outside of the Lloyd Klein show, September 2003

Models outside of the Y&Kei show, September 2002

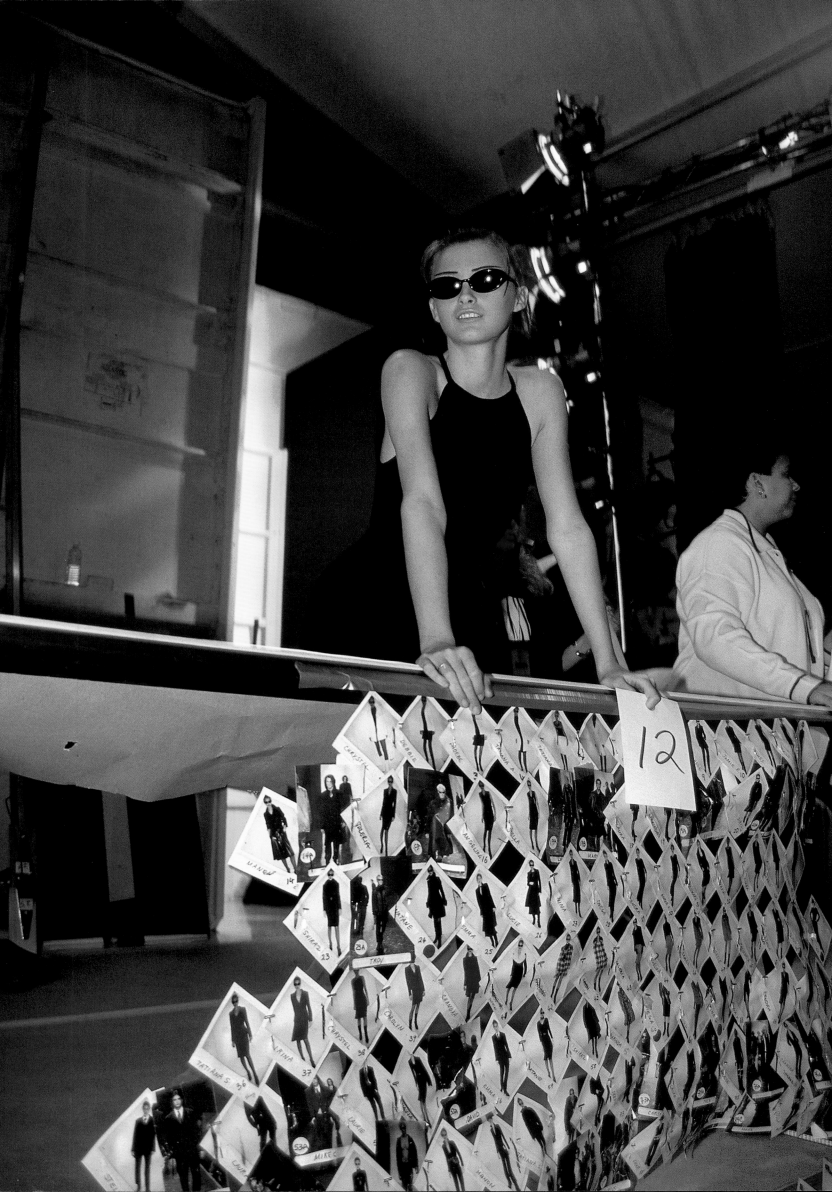

THE SHOWS IN THE BRYANT PARK TENTS HAVE GROWN IN IMPORTANCE OVER THE LAST DECADE. THE INTERNATIONAL PRESS AND BUYERS COME TO SEE WHAT'S HAPPENING IN AMERICAN FASHION.

KAL RUTTENSTEIN
SR. VICE PRESIDENT
FASHION DIRECTION
BLOOMINGDALE'S

I THINK WE FASHION DEVOTEES MUST SURELY BE MASOCHISTS. WHO ELSE WOULD ENDURE 4-5 WEEKS OF ATTENDING SHOWS FROM 9AM TO 10 OR 11PM EVERYDAY; THE WAITING FOR SHOWS TO BEGIN, WITH DELAYS OF ANYWHERE FROM 30 MINUTES TO AN HOUR AND A HALF (THANK YOU MESSIEURS GALLIÁNO AND GAULTIER!) ARE ENOUGH TO DISCOURAGE ANY NORMAL MORTAL FROM EVER ATTENDING ANOTHER FASHION SHOW. BUT EACH SEASON WE KEEP COMING BACK FOR MORE. FASHION IS A DRUG AND THOSE OF US WHO LOVE IT KEEP WAITING FOR THE "HIGH" — THAT MOMENT WHEN YOUR HEART LEAPS BECAUSE YOU KNOW YOU ARE WITNESSING BRILLIANCE OR A NEW TALENT EMERGING TO TAKE HIS OR HER PLACE IN THE FIRMAMENT OF FASHION GREATS.

JOAN KANER
NEIMAN MARCUS

FOR THOSE OF US IN THIS INDUSTRY, THE CONSTRUCTION OF THE TENTS IN BRYANT PARK SIGNALS THE BEGINNING OF THE MOST EXCITING PERIOD FOR FASHION EACH SEASON. THE DISCOVERY OF WHO THE NEW DESIGNER SHOW STOPPERS WILL BE, HOW WILL THE ENTRENCHED DESIGNERS CREATE NEW DIRECTION, WHO IS SITTING WHERE, WHICH MODEL WILL BE DEEMED THE NEW STAR OF THE CATWALK AND WHICH DESIGNER CAN BRING OUT THE MOST STARS TO HIS OR HER SHOW ALL ADD THE EXTRA ELEMENT OF SURPRISE TO THIS SEMI-ANNUAL EVENT. THE SEASONAL FASHION SHOWS HAVE BECOME MAJOR EVENTS UNLIKE A FEW YEARS AGO WHEN MANY DESIGNERS PREFERRED TO SHOW TO A SMALL INDUSTRY CROWD IN THEIR SHOWROOMS. TODAY'S FASHION SHOWS ARE A MEDIA EXTRAVAGANZA. THE TENTS, NOW WITH CORPORATE SPONSORS, TELEVISION COVERAGE, INTERVIEWS WITH INDUSTRY NOTABLES AND MULTIPLE DAILY EDITIONS OF VARIOUS MAGAZINES HAVE ALL MOVED THIS WORK FORUM INTO A MAJOR MEDIA ENTERPRISE. HOWEVER, AS A RETAILER, BELIEVE IT OR NOT, THIS IS WORK.

RON FRASCH
SAKS FIFTH AVENUE

Backstage at the DKNY show, April 1995

Model backstage at the Matt Nye show, September 1999

Model at the Vivienne Tam show, November 1997

IT'S ALWAYS THE SAME — WE HAVE BEEN WORKING ON THE COLLECTION AT OUR STUDIO NON-STOP, SLAVING AWAY UNDER THE FLUORESCENT LIGHTS, AND THEN YOU ARRIVE AT THE TENTS AND THE TRUE GLAMOUR OF FASHION HITS YOU RIGHT BETWEEN THE EYES.

MARK BADGLEY AND JAMES MISCHKA

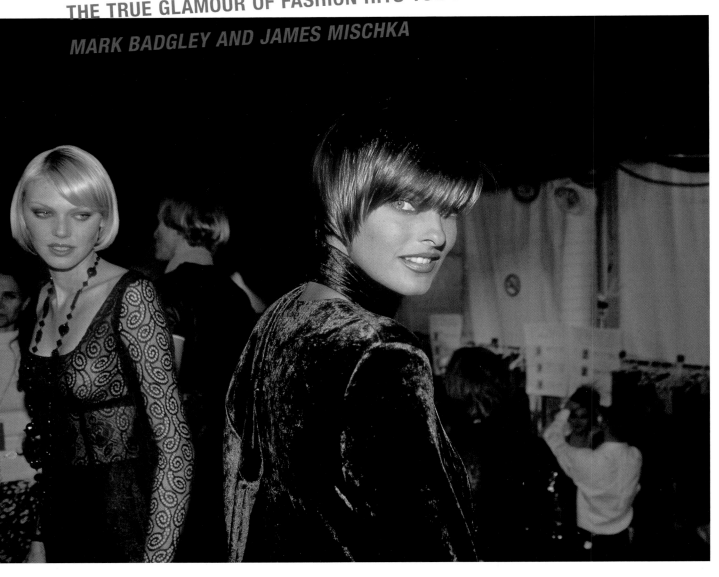

Shirley Mallman and Linda Evangelista at the Anna Sui show, March 1996

Trish Goff at the Bill Blass show, April 1995

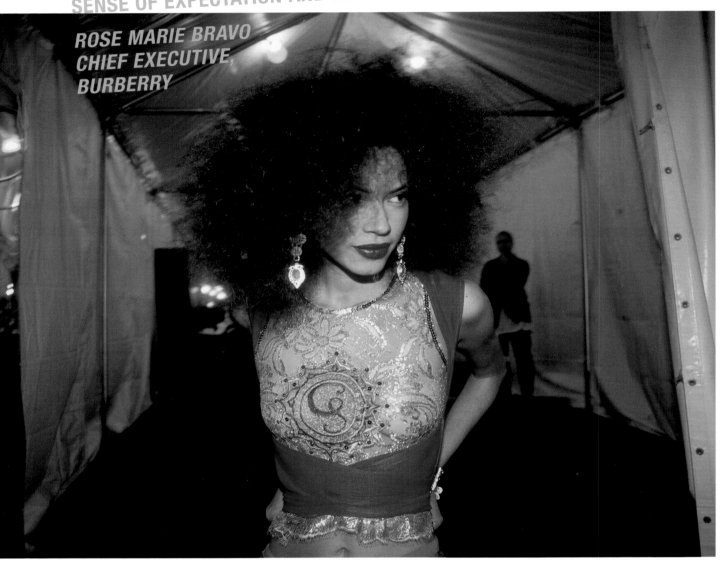

Backstage at the Ghost show, October 1994

Backstage at the Luca Luca show, February 2000

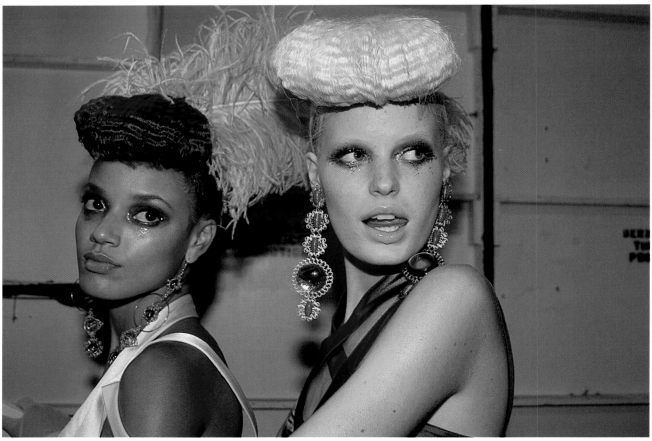

Carmen Kass at the Baby Phat show, September 2003
Selita Ebanks and Caroline Winberg at the Baby Phat show, September 2003

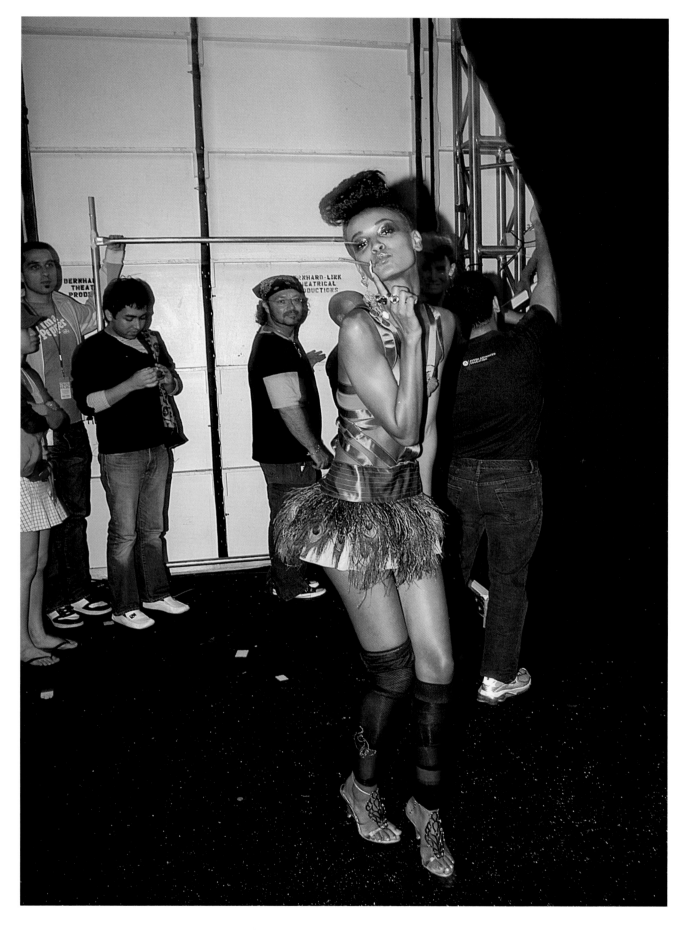

Liya Kebede at the Baby Phat show, September 2003

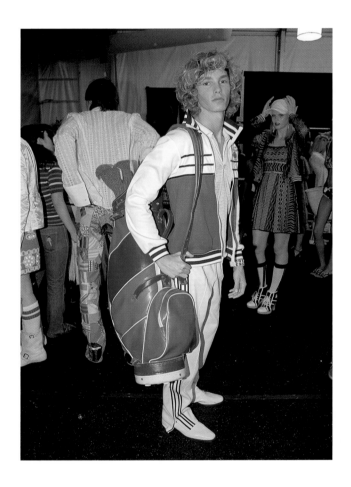 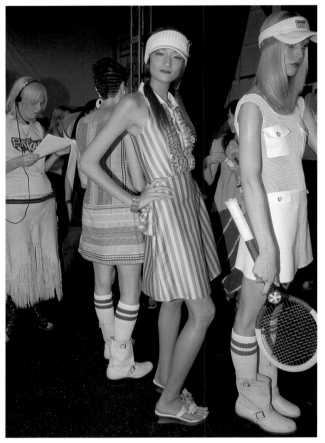

THE MODELS ARE HAVING SUCH A GOOD TIME BACKSTAGE, THEY REALLY SEEM TO ENJOY WEARING THE CLOTHES.

ANNA SUI

Jak at the Anna Sui show, September 2002
Ai Tominaga at the Anna Sui show, September 2002

Kate Moss, Shalom Harlow, and Amber Valletta at the Anna Sui show, November 1995
Michael Loomis at the Anna Sui show, November 1995

THREE MONUMENTAL TIMES
IN HISTORY WHEN TENTS HAVE
MADE A DIFFERENCE:

1 P.T. BARNUM
2 LAWRENCE OF ARABIA
3 THE TENTS AT BRYANT
 PARK ON 42ND STREET

THEY CHANGED THE FACE OF
FASHION IN AMERICA FOREVER.

PAUL WILMOT

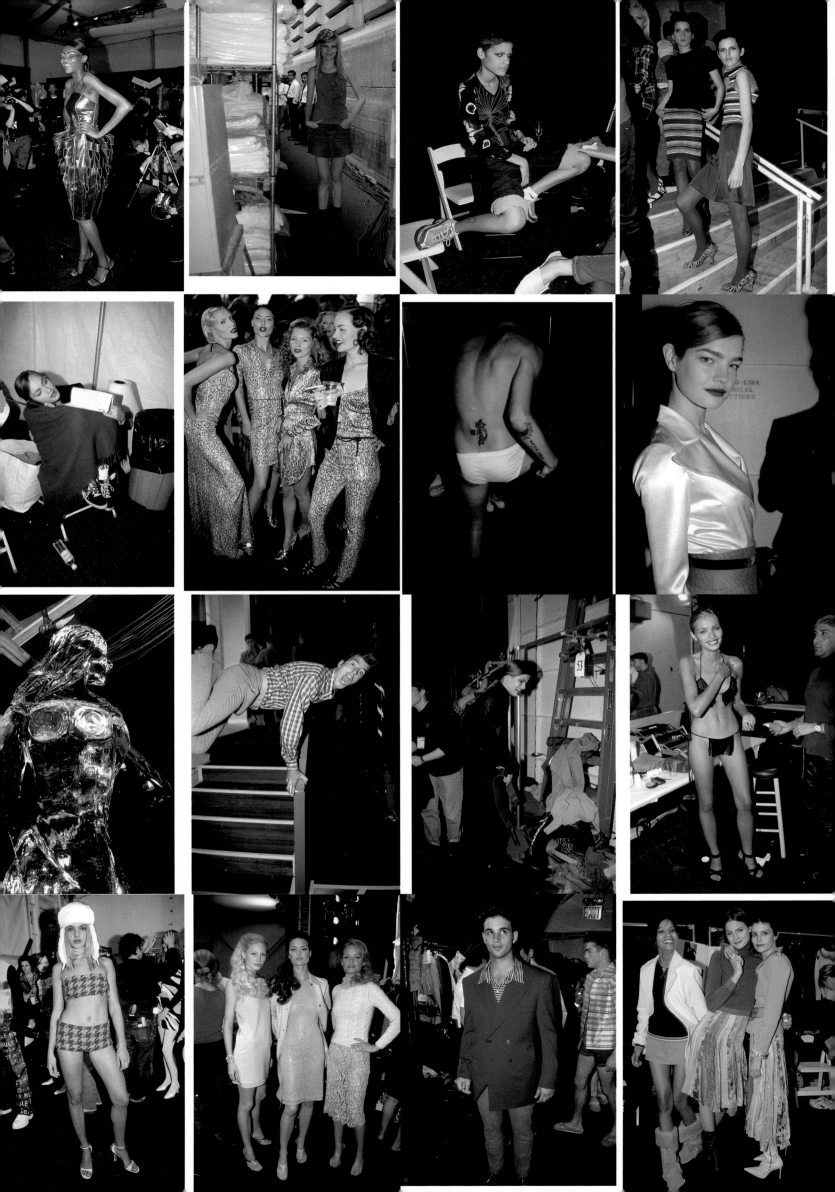

Kate Moss at the Ghost show, November 1994

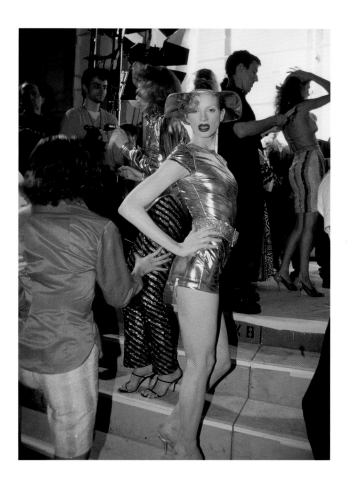

Kristen McMenamy at the Todd Oldham show, October 1994
Cindy Crawford at the Richard Tyler show, November 1994

Eve backstage at the House of Field show, September 2002

WHO DOESN'T LOVE WORKING UNDER THE BIG TOP?
KEVIN KRIER

Karen Elson at the Philip Treacy show, February 1999

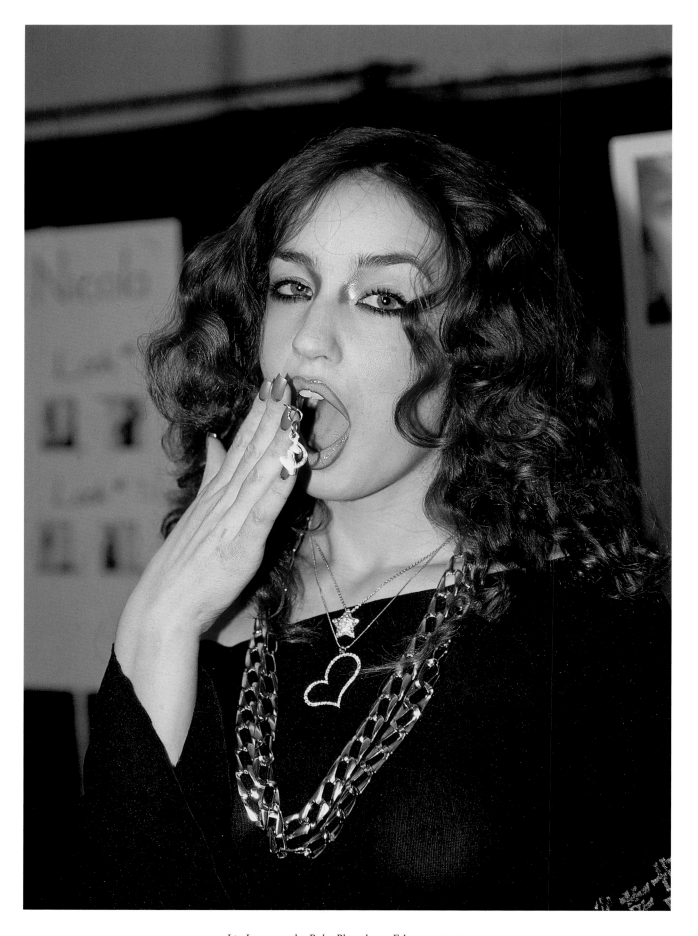

Liz Jagger at the Baby Phat show, February 2002

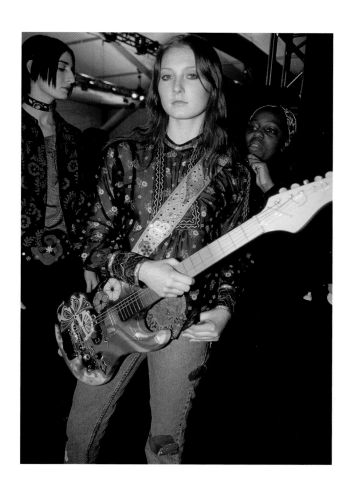

Maggie Rizer with a guitar at the Anna Sui show, February 2002
Sybil Buck at the Betsey Johnson show, October 1994

Heidi Klum at the Victor Alfaro show, September 1999

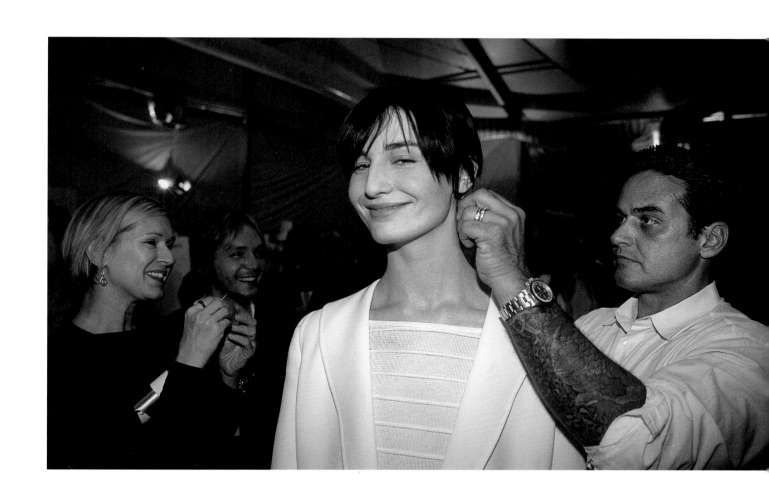

Hairstylist Oribe doing Erin O'Connor's hair at the Oscar de la Renta show, November 1998

LIKE MOST DESIGNERS, I COULDN'T WAIT TO READ THE REVIEWS OF OUR PREVIOUS DAY'S FASHION SHOWS. OUR LIVES CHANGED FOREVER THE NEXT DAY, AND IT WAS MONTHS LATER THAT WE REALIZED THAT WE HAD NEVER READ THEM. OUR SHOW WAS AT 9:00, SEPTEMBER 10, 2001.

KENNETH COLE

I MISS IT AND AT ONCE DO NOT — THOSE TWENTY FLEETING MINUTES TO DANCE BEFORE THE WORLD....I DO MISS THE STAGE AND STATEMENT — TWICE A YEAR — AND ALL THAT HIGH INTENSITY GENERATED BY AN AMALGAM OF AMAZING CREATIVE PEOPLE AT WORK TOGETHER WITH BEAUTIFUL GIRLS, INCREDIBLE LIGHTING, AND THE PHOTOGRAPHY THAT CAPTURED AND SUSPENDED THOSE MOMENTS — I MISS THAT PART, CERTAINLY, BUT I LOOK TOWARD THE NEVER-ENDING CREATIVE JOURNEY — WHILE OFTEN LESS INTENSE THAN IN THE TENTS — CAN STILL BE INTERESTING IN THE STORE AND SHOWROOM.

HAN FENG

From top, left to right:
Linda Evangelista, Amber Valletta, and Shalom Harlow at the Anna Sui show, November 1994
Karolina Kurkova at the Michael Kors show, September 2003
Jeffrey Casciano at the Betsey Johnson show, September 2003
Jamie Rishar at the Marîthé+François Girbaud show, April 1995
Frederique van der Wal rollerblading on the runway at the Ralph Lauren show, October 1994
Greg Payne at the Kenneth Cole show, February 2003
Amber Valletta and Ryan Locke at the Versus show, September 1999
Joel West at the Hugo Boss show, July 1996
Mark Vanderloo on the pay phone during the DKNY show, April 1995
Models hugging at the Gene Meyer show, February 2001
Anouck Lepère at the Jeremy Scott show, February 2002
Kids backstage at the Marîthé+François Girbaud show, April 1995
Gisele Zelauy at the Oscar de la Renta show, November 1994
Models at the Marîthé+François Girbaud show, April 1995
Jodie Kidd at the Betsey Johnson show, November 1997
Jonathan Chick on the runway at the Matsuda show, October 1996

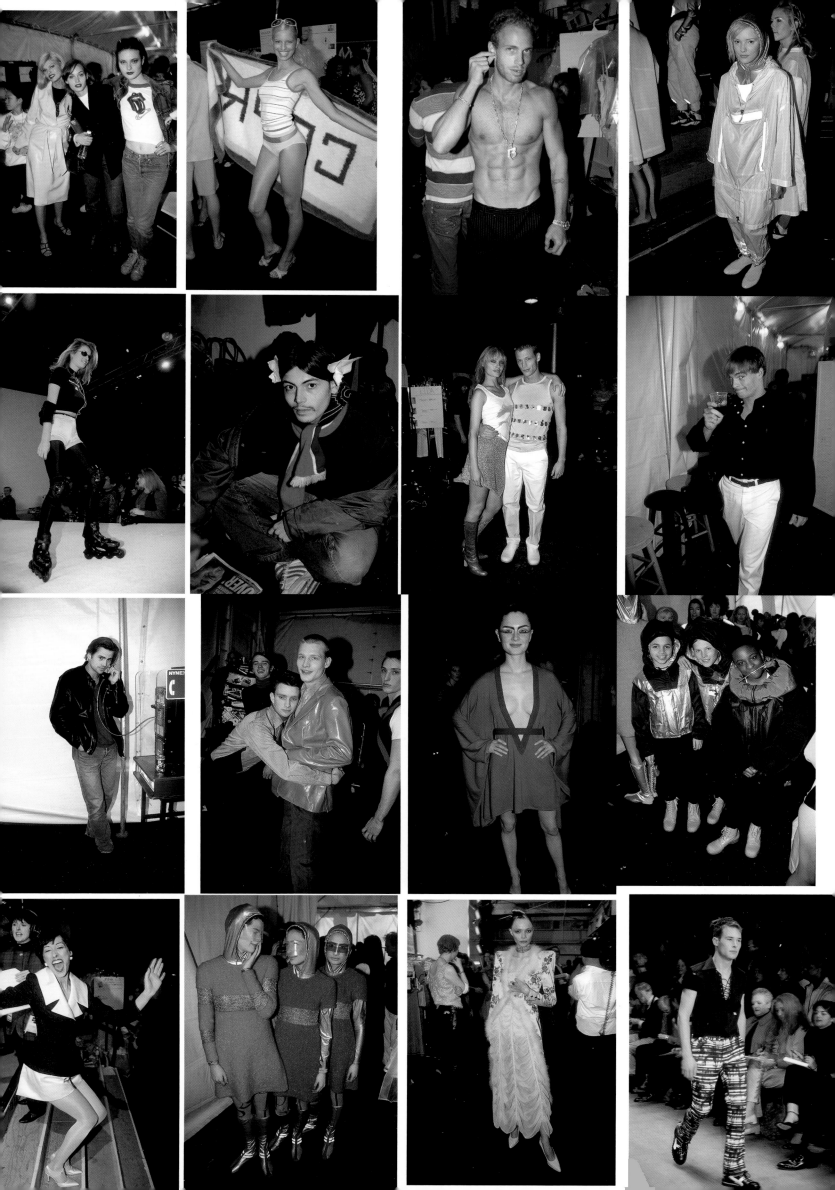

Caleb Lane at the Rosa Cha by Amir Slama show, September 2003

Kelly Rippy getting changed at the Kenneth Cole show, July 1999

Paul Wignall at the BCBG Men's Show, September 2000

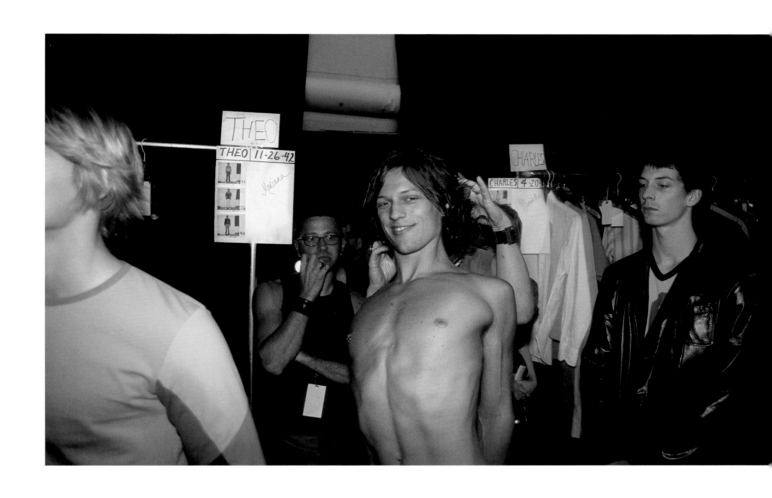

Marcelo Boldrini stretching at the Gene Meyer show, September 2001

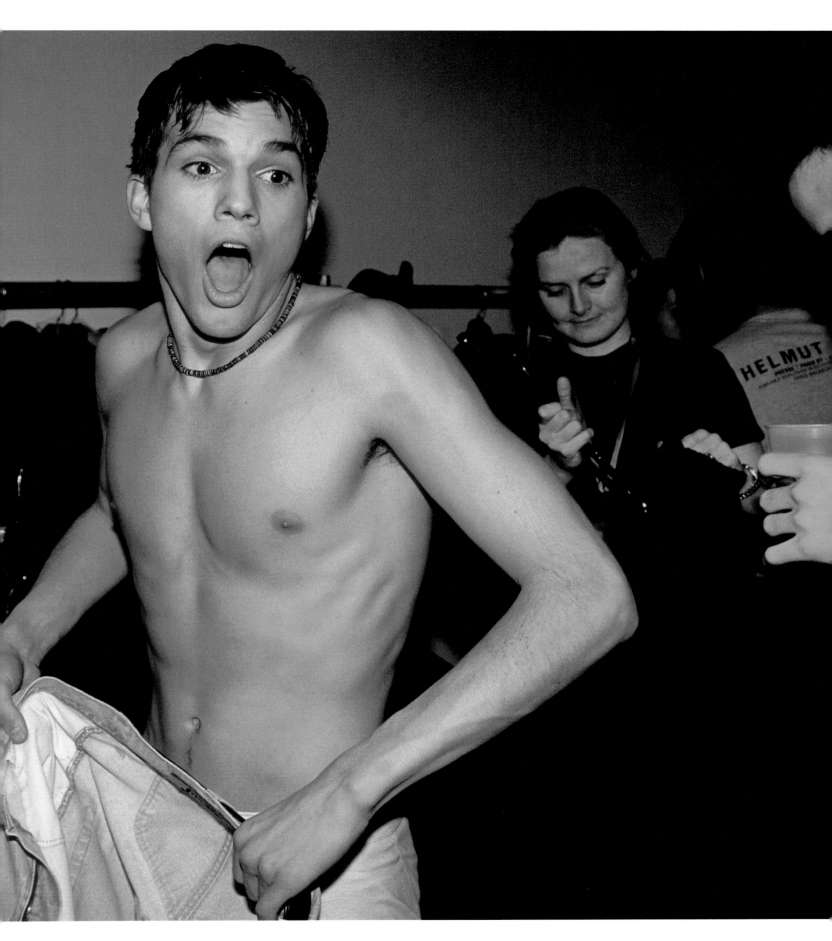

Ashton Kutcher at the Cynthia Rowley show, February 1998

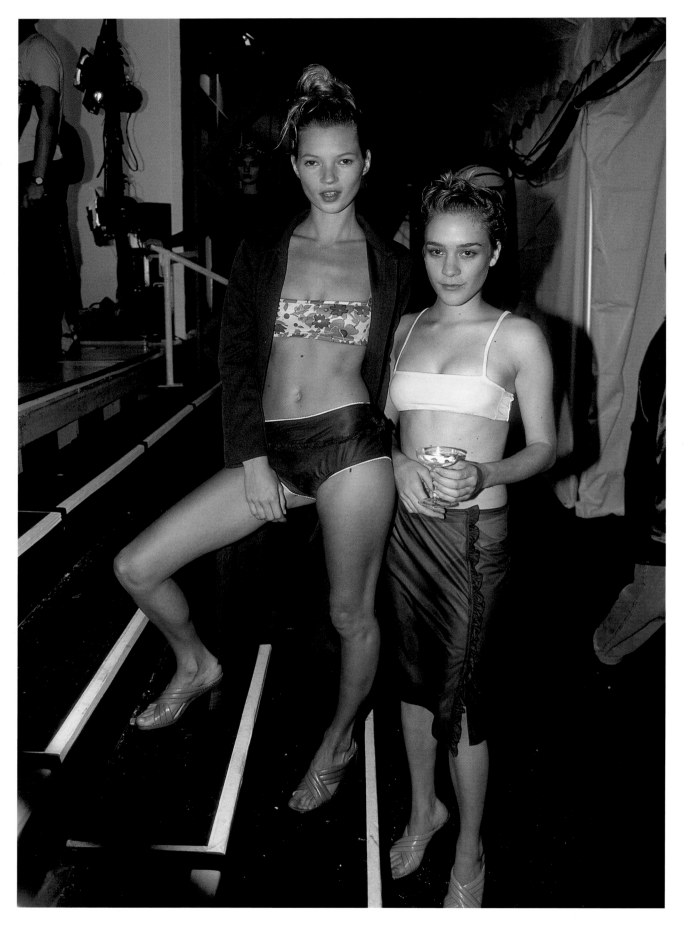

Kate Moss and Chloë Sevigny at the Miu Miu show, November 1995

THE TENTS BRING ALL THE PEOPLE IN THE "FASHION CIRCUS" TOGETHER. EVERY TIME, I ENJOY MEETING FRIENDS WHO I OTHERWISE WOULDN'T SEE, BECAUSE I WORK SO HARD DURING THE YEAR. I KNOW ONE DAY I'LL MISS THE TENTS.

ANOUCK LEPÈRE

Anouck Lepère, Liisa Winkler, Caroline Ribeiro, and Michelle Alves at the Tommy Hilfiger show, September 2002

Models lined up at the Bespoke Couture show, February 2001

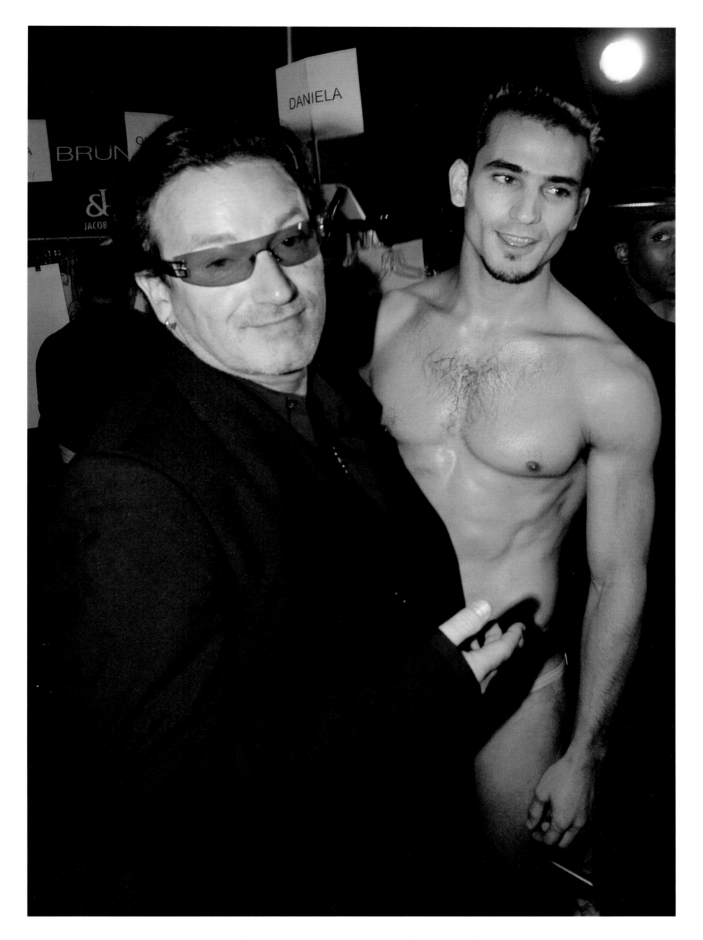

Bono and Enrique Palacios at the Rosa Cha by Amir Slama show, September 2002

Goofing around at the Diesel StyleLab show, September 2002
Jason and models lined up at the John Varvatos show, September 2002

I KNEW I NEEDED TO LEAVE THE FASHION BUSINESS WHEN A MAN BEFORE ONE SHOW SAID TO ME, "YOU KNOW, GLASSES ARE THIS YEAR'S SOCKS," AND I KNEW EXACTLY WHAT HE MEANT.

FRANK DECARO
WRITER/PERFORMER AND
FORMER FASHION EDITOR

Orlando Pîta, Tyson Ballou, and Dick Page at the Michael Kors show, September 2002

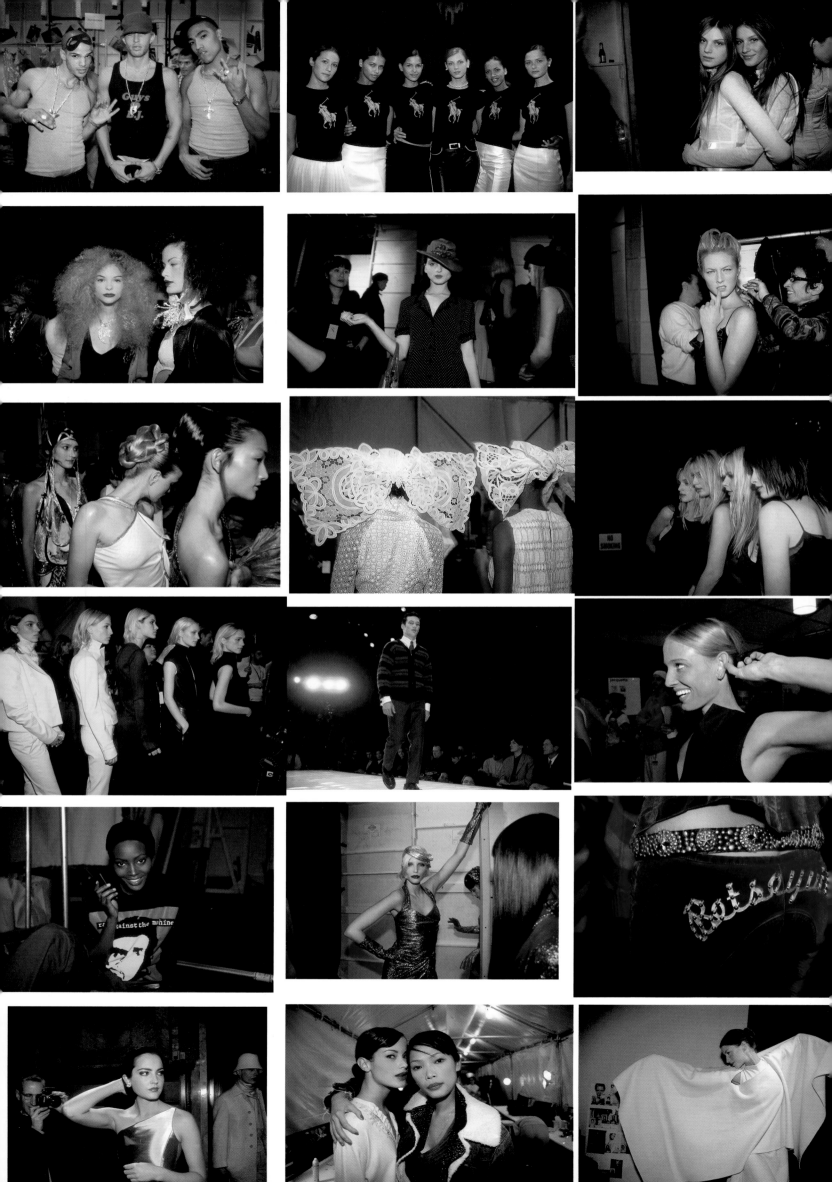

WHAT CAN I POSSIBLY SAY ABOUT THE FRENZY AND MADNESS THAT SURROUNDS THE FASHION WORLD DURING SHOW SEASON? MAYBE IT IS JUST THAT: ABSOLUTE INSANITY. BUT FOUND AT THE CORE OF THIS INSANITY AMONG THE DESIGNERS, STYLISTS, SHOW PRODUCERS AND MEDIA IS THE VERY ESSENCE OF CREATIVITY AND STYLE.

KATIE FORD

From top, left to right:
Betsey's guys at the Betsey Johnson show, September 2003
Polo Girls at the Ralph Lauren show, September 2000
Angela Lindvall and Gisele Bundchen at the Betsey Johnson show, February 1999
James King and Carolyn Murphy at the Ghost show, October 1994
Michelle Hicks at the Prada show, October 1994
Maggie Rizer at the Badgley Mischka show, February 2001
Models lined up at the AsFour show, September 2003
Models at the Alice Roi show, February 2002
Models at the Richard Tyler show, April 1997
Models lined up at the Hugo Boss show, February 2002
Runway at the Matthew Batanian show, February 1996
Natasha Vojnovic at the Narciso Rodriguez show, September 2003
Kiara at the Michael Kors show, February 1999
Nadja Auermann at the Anna Sui show, November 1994
"Betseyville" at the Betsey Johnson show, January 2003
Chandra North at the Tomasz Starzewski show, February 1999
Carolyn Murphy and Navia Nguyen at the Richard Tyler show, October 1994
Gisele Bundchen at the Donna Karan show, February 1999

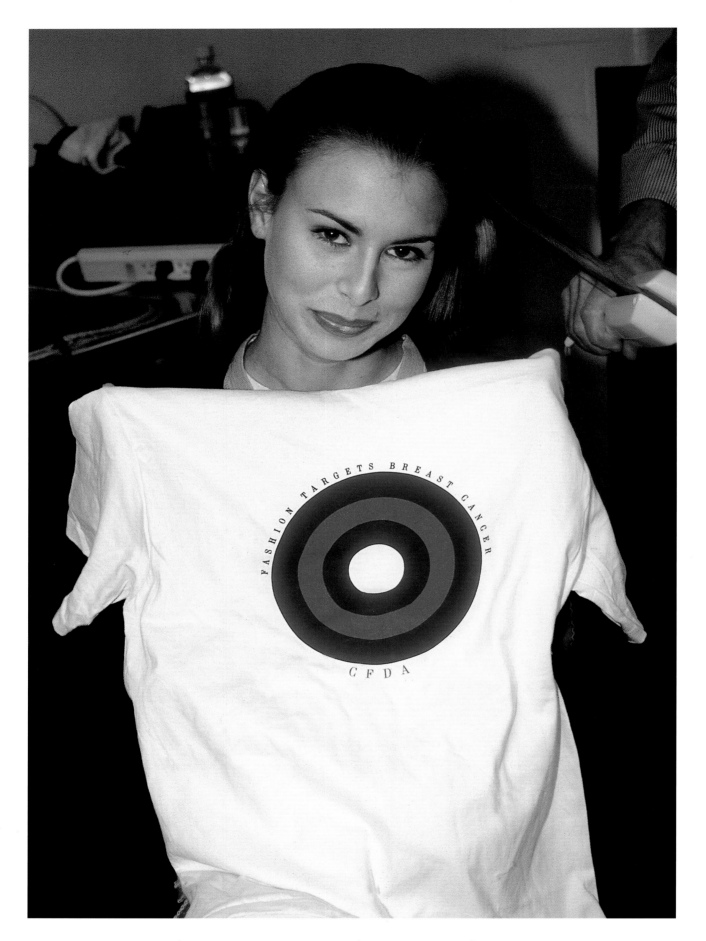

Nikki Taylor holding the CFDA's "Fashion Targets Breast Cancer" T-shirt, April 1994

Nadja Auermann at the Todd Oldham show, November 1994

Roller–skating models backstage at the Betsey Johnson show, April 1994

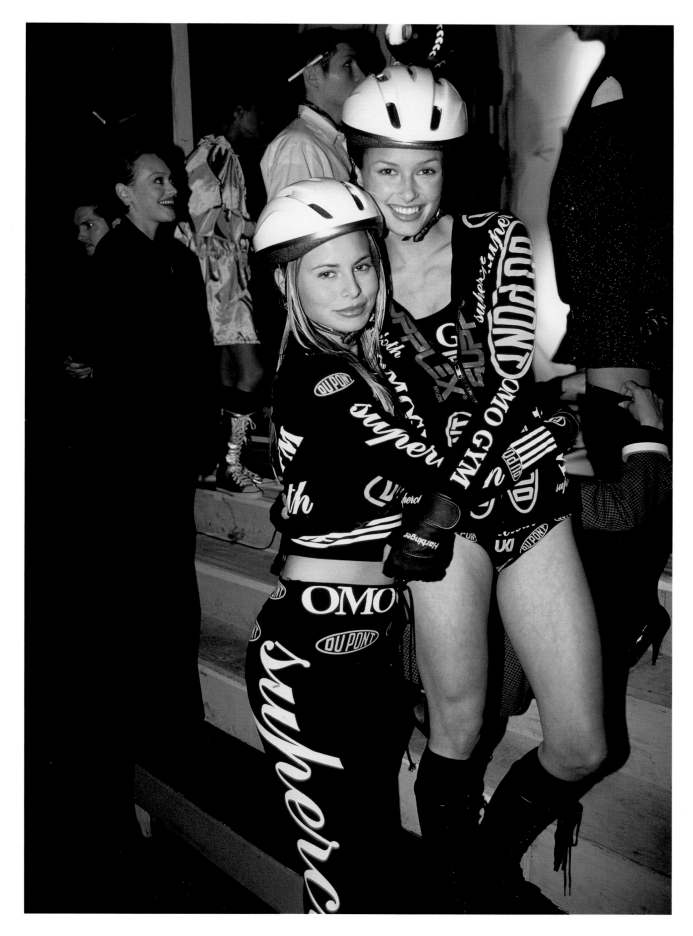

Nikki Taylor and Bridget Moynahan backstage at the Norma Kamali OMO show, April 1994

Frankie Rayder and Maggie Rizer at the Carolina Herrera show, September 2002

Model at the John Bartlett show, July 1998

THERE IS A LONG HISTORY OF EXCITEMENT REVOLVING AROUND TENTS — CIRCUSES, PAGEANTS, CEREMONIES — THEIR TEMPORARY NATURE SEEMS ENTIRELY APPROPRIATE FOR AN INDUSTRY THAT IS CONSTANTLY MOVING.

JOHN MATHER,
FASHION DIRECTOR OF BEST LIFE

Meghan Douglas at the Todd Oldham show, April 1995

Angie Schmidt at the Oscar de la Renta show, September 2003

Mariacarla Boscono and Liya Kebede at the Jeremy Scott show, February 2002

Oluchi Onweagba and Karolina Kurkova at the Jeremy Scott show, February 2002

THE CHAOS OF THE FASHION
SHOW IS THE ULTIMATE SET
FOR THE INTENSE CREATIVE
PROJECTION OF THE FUTURE.

DONNA KARAN
DESIGNER

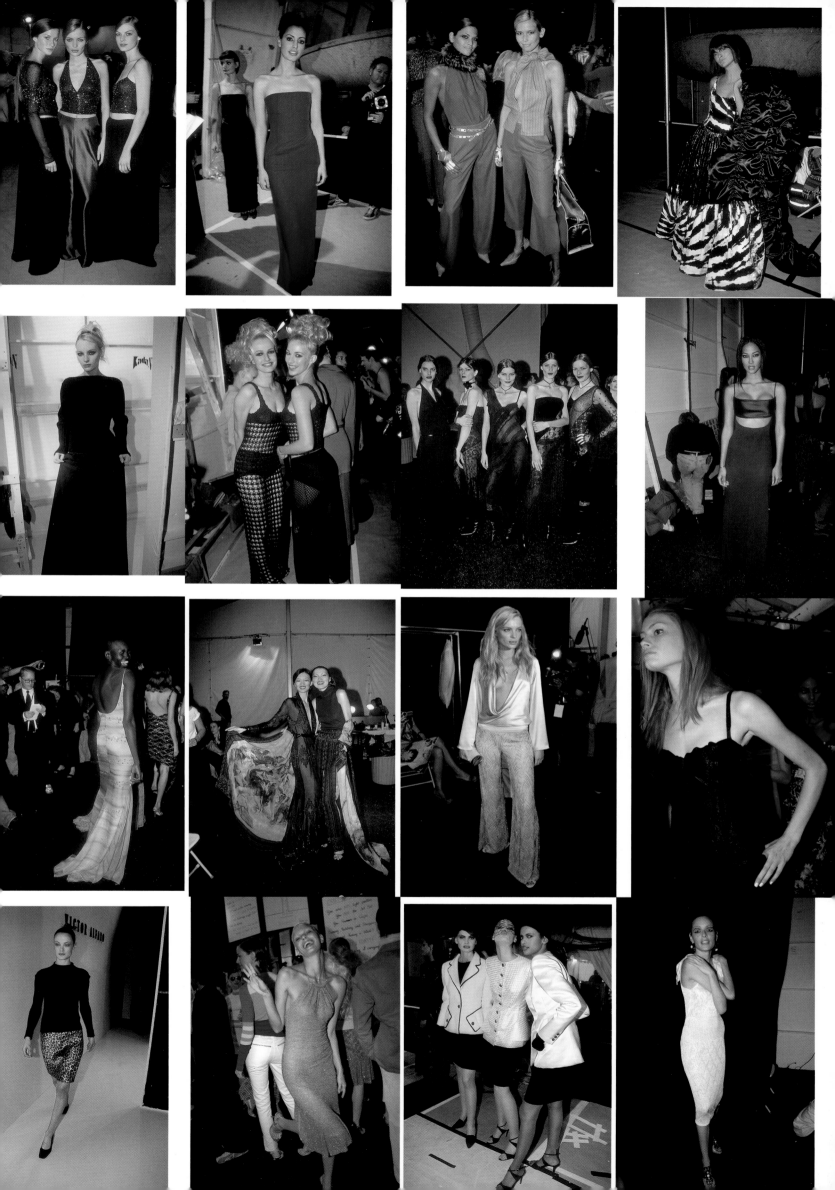

AFTER ONE OSCAR DE LA RENTA SHOW SEVERAL YEARS AGO, I SAW BROOKE ASTOR LEAP FROM HER SEAT ONTO THE RUNWAY TO GO BACKSTAGE AND CONGRATULATE HIM. SHE WAS 95 AT THE TIME, BUT SHE JUMPED UP ONTO THAT RUNWAY LIKE A TEENAGER. FASHION HAS THAT EFFECT ON PEOPLE. IT MAKES THEM YOUNG. IT ALSO MAKES THEM MEAN, BUT THAT'S ANOTHER STORY.

BOB MORRIS

Jewelry backstage at the Oscar de la Renta show, February 2003

Michelle Alves at the Tommy Hilfiger show, September 2002
Natalia Vodianova at the Narciso Rodriguez show, February 2003

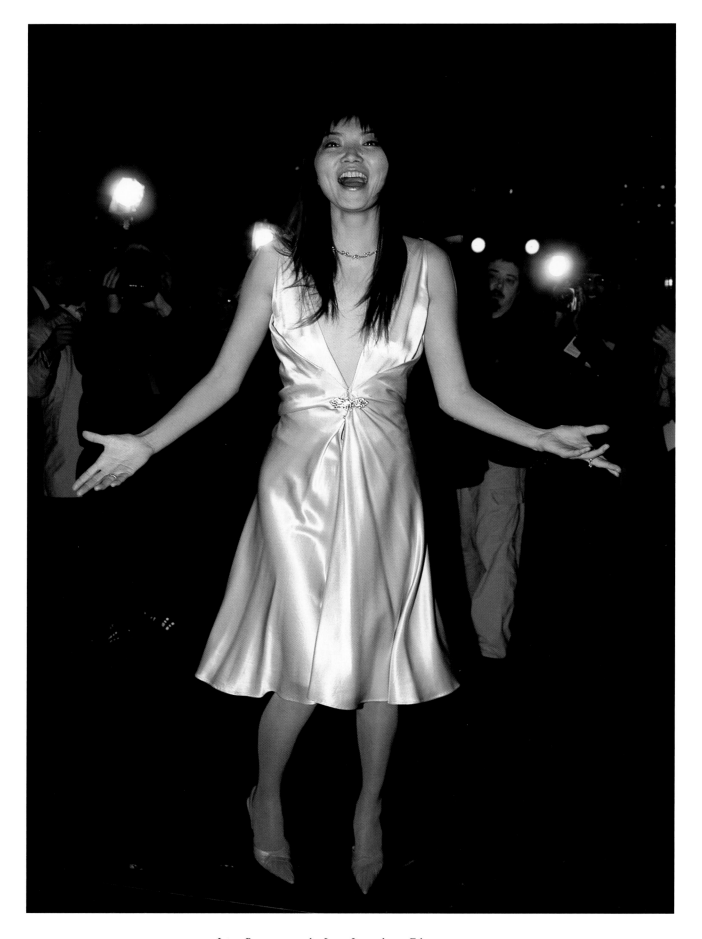

Irina Pantaeva at the Luca Luca show, February 2003

From top, left to right:
Angela Lindvall and Kiara at the Anna Sui show, November 1997
Carmen Kass, Karolina Kurkova, and Liya Kebede at the Michael Kors show, February 2003
Mariacarla Boscono at the Oscar de la Renta show, February 2003
Model at the Luca Luca show, February 2002

Dewi Driegen, Marcelle Bittar, and Ai Tominaga at the Luca Luca show, September 2003

Karolina Kurkova at the Oscar de la Renta show, September 2003
Dresses at the Victor Alfaro show, October 1995

Karen Mulder at the Isaac Mizrahi show, November 1995
Caroline Ribeiro and Karolina Kurkova at the Badgley Mischka show, February 2001

Yasmeen Ghauri at the Victor Alfaro show, October 1995

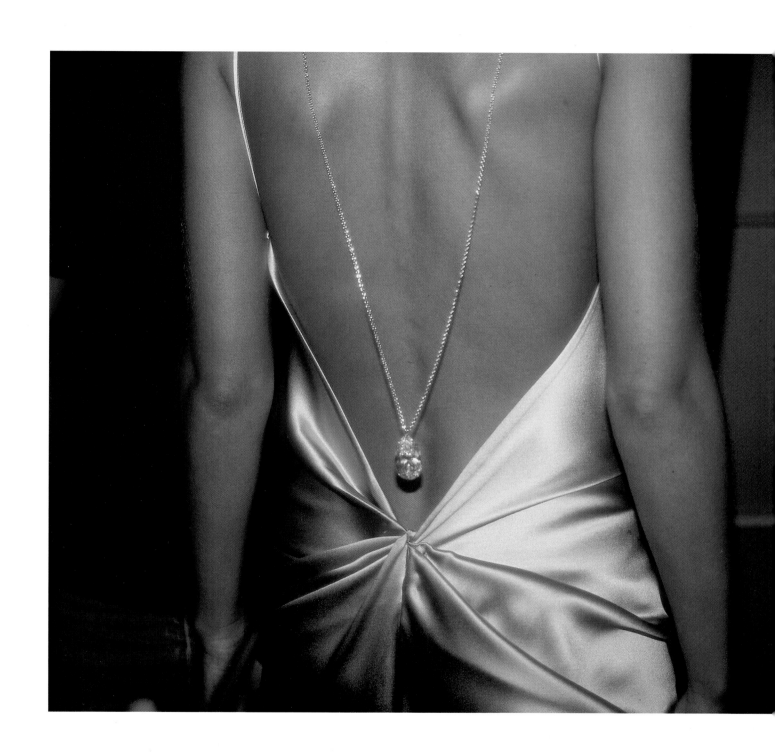

Jewelry at Pamela Dennis show, September 2000

Isaac Mizrahi mask, October 1996

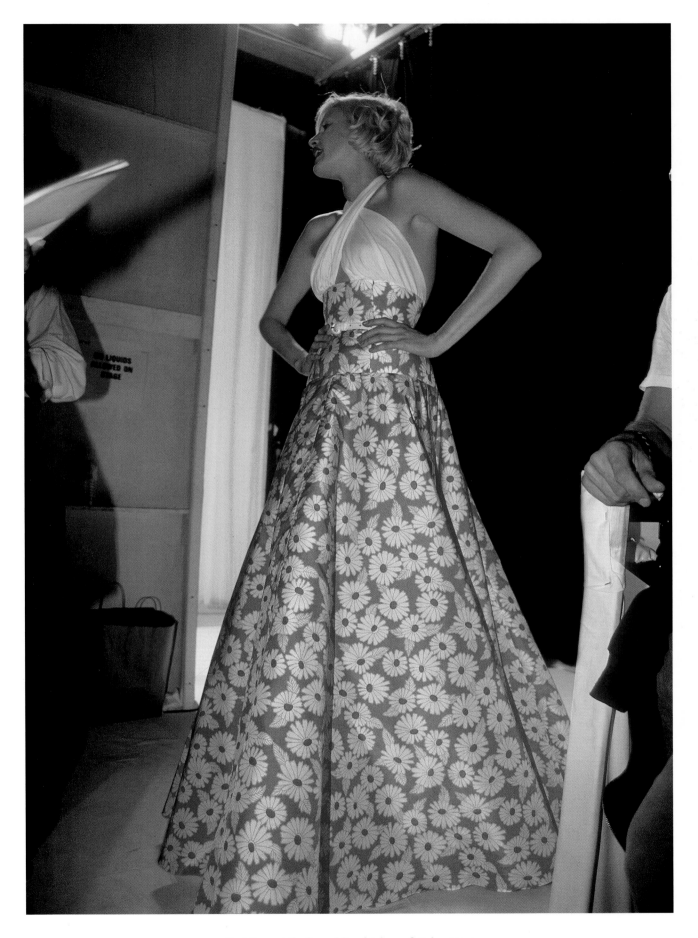

Backstage at the Isaac Mizrahi show, October 1994

Backstage at the Betsey Johnson show, November 1997

MY MOST UNFORGETTABLE
MOMENT IN THE TENTS HAPPENED
ON SEPTEMBER 11, 2001. I'D
HEARD THE FIRST REPORTS OF
THE TERRORIST ATTACKS ON
TELEVISION, BUT FELT SOMEHOW
DRAWN TO BRYANT PARK TO SEE
IF FASHION FRIENDS WERE SAFE.
WHILE WAITING IN LINE FOR THE
DOUGLAS HANNANT SHOW, THE
ANNOUNCEMENT CAME THAT
THE SHOW WOULD NOT GO ON
AND THE TENTS WERE BEING
EVACUATED. THE REAL WORLD
WAS SUDDENLY MORE SURREAL
THAN ANY FASHION SHOW.

MARYLOU LUTHER
INTERNATIONAL FASHION
SYNDICATE

Backstage at the Mark Eisen show, April 1997

Kate Moss at the Calvin Klein show, April 1995

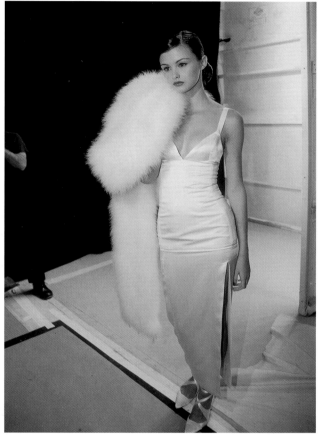

Nikki Taylor backstage, April 1995
Trish Goff at the Richard Tyler show, October 1994

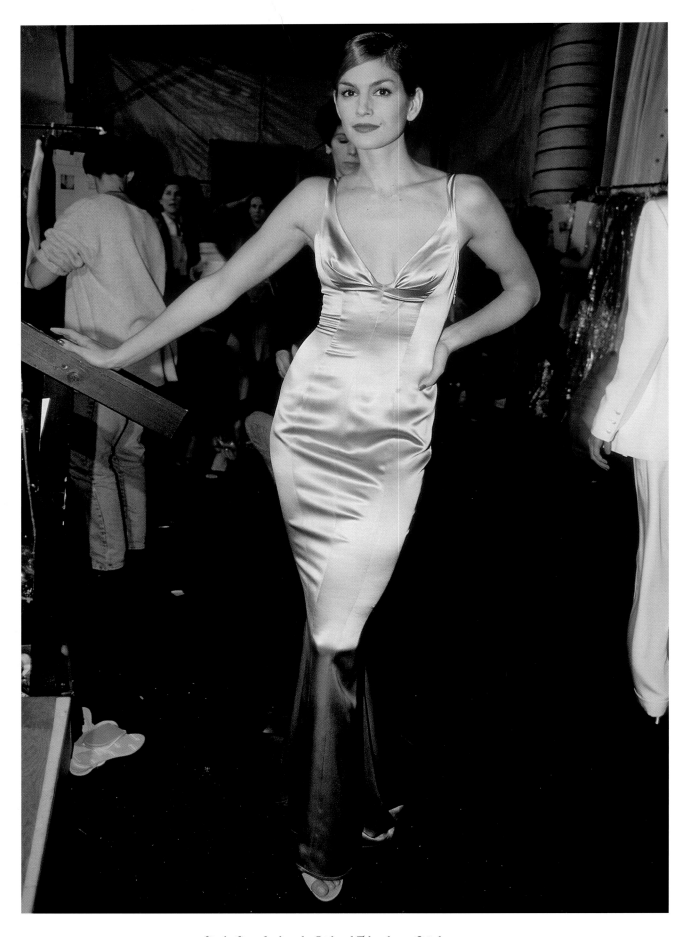

Cindy Crawford at the Richard Tyler show, October 1994

Karen Mulder at the Isaac Mizrahi show, April 1994

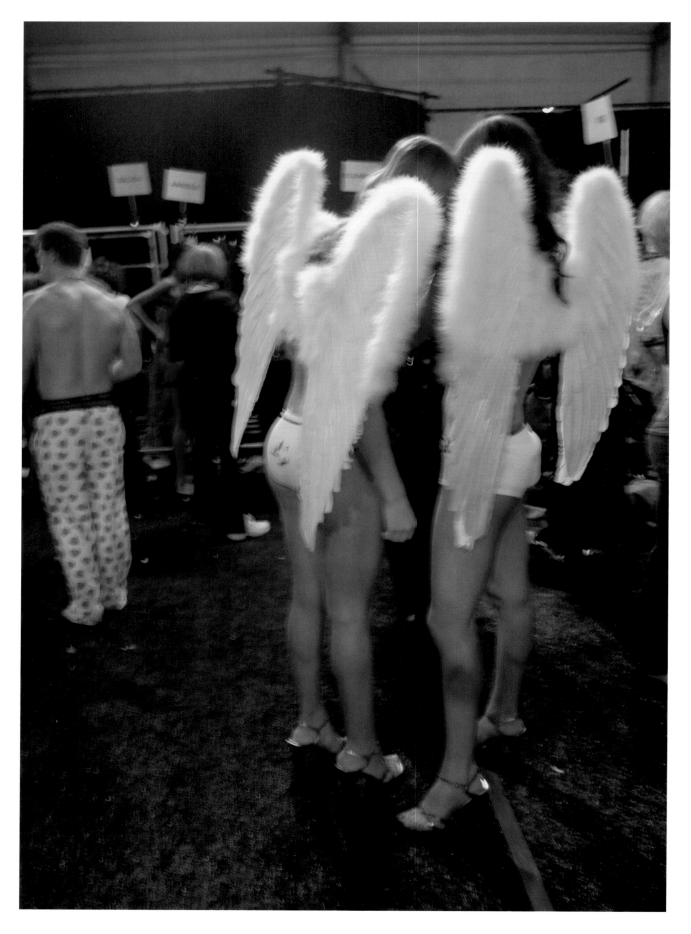

Angels at the Joe Boxer show, February 2003

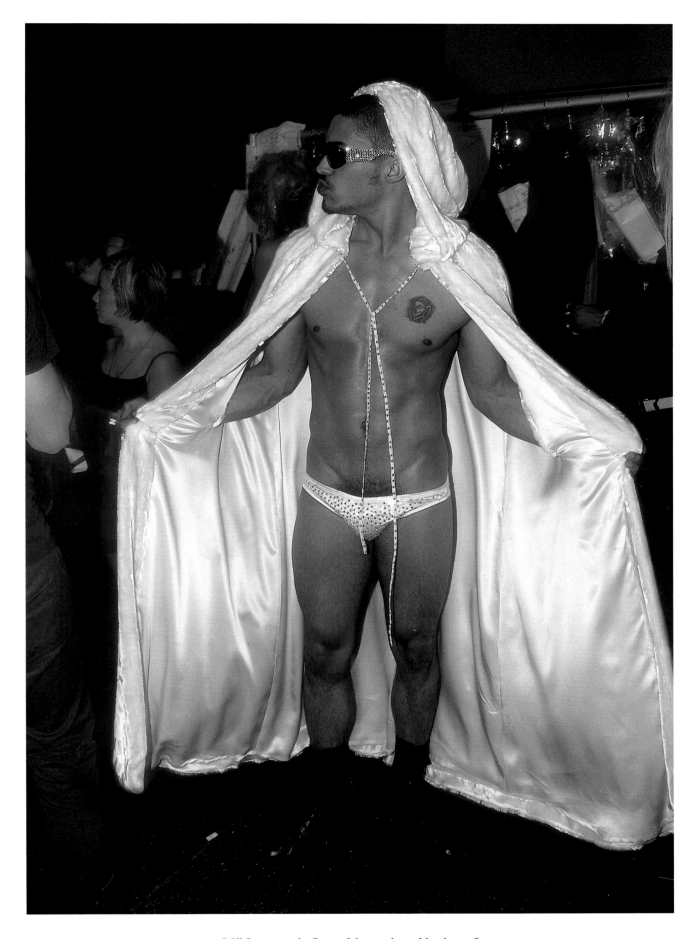

Will Lemay at the Betsey Johnson show, March 1998

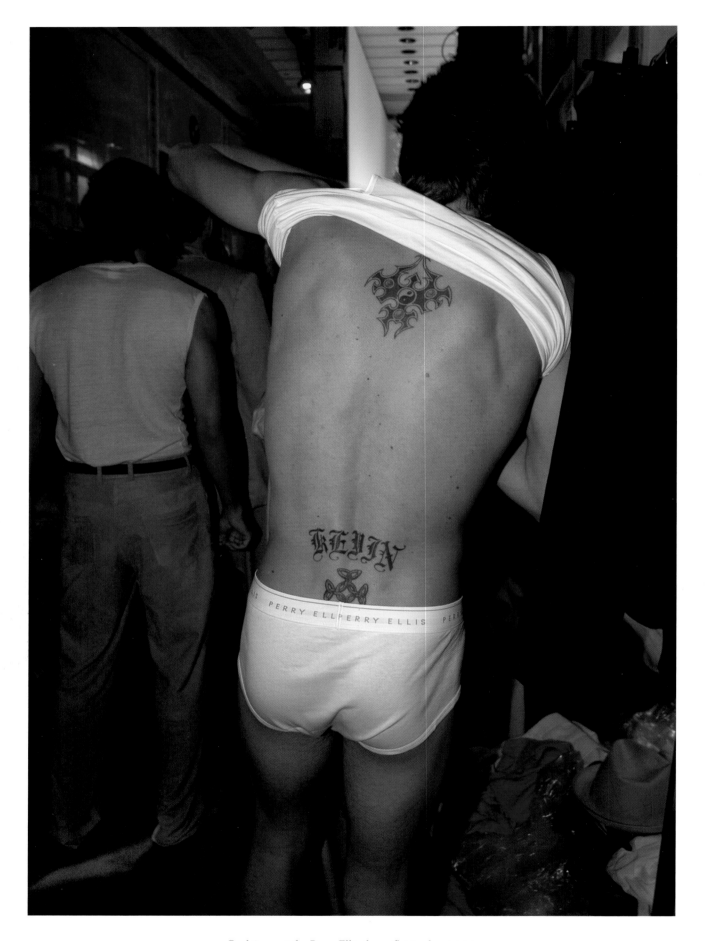

Backstage at the Perry Ellis show, September 2002

Backstage at the Perry Ellis show, September 2002

IN THE EARLY 90S, DURING ONE PARTICULARLY BUSY SEASON DURING THE PARIS PRET-A-PORTER, I LOOKED ACROSS THE RUNWAY AT THE CHANEL SHOW AND SPOTTED A FAMILIAR BUT OUT OF PLACE FACE, FERN MALLIS, THEN THE NEWLY SELECTED DIRECTOR OF THE COUNCIL OF FASHION DESIGNERS OF AMERICA. AFTER THE SHOW, I WENT OVER TO MALLIS, WHOM I HAD RECENTLY PROFILED IN THE *PHILADELPHIA INQUIRER*, TO INQUIRE AS TO WHY SHE WAS IN PARIS. AFTER MUCH HEMMING AND HAWING, SHE CONFIDED IN ME OFF THE RECORD THAT SHE WAS CHECKING THE ORGANIZED SHOWS TO SEE IF SHE COULD CENTRALIZE THE SCATTERED NEW YORK SHOWS. I SWORE I WOULDN'T REPEAT WHAT SHE TOLD ME, BUT AS SOON AS I COULD I WHISPERED HER INTENT TO A VETERAN FASHION JOURNALIST. "DO YOU THINK THEY CAN DO IT?" I ASKED NOTING THE FRACTIOUS NEW YORK FASHION CLAN.

"SHE HAS ABOUT AS MUCH CHANCE AS GETTING THOSE NEW YORK DESIGNERS TO WORK TOGETHER AS," THE JOURNALISTS STOPPED MID-SENTENCE AND POINTED TO THE GIANT TENT ERECTED IN THE COURTYARD OF THE LOUVRE MUSEUM JUST FOR THE FASHION SHOWS — "AS GETTING THE MAYOR OF NEW YORK TO LET HER PUT UP A GIANT TENT IN THE MIDDLE OF THE CITY."

ROY H. CAMPBELL
PRODUCER AND FORMER FASHION EDITOR OF THE *PHILADELPHIA INQUIRER*

HOW GREAT TO HAVE ALL OF AMERICAN FASHION PRESENTED UNDER ONE ROOF.... HOW GREAT TO SEE ALL THE LADIES WHO LUNCH AND THE LADIES WHO WORK AND THE MEN WHO GUIDE AND STYLE AND THE MEN AND THE WOMEN WHO LEAD....HOW GREAT TO SEE ALL THE CAMERAS AND THE ACTION....HOW GREAT TO SEE THE NEW FACES AND THE OLD FACES AND THE BEAUTIFUL FACES AND THE OLD CLOTHES AND THE NEW CLOTHES....HOW GREAT TO FEEL THE EXCITEMENT OF ANOTHER SEASON AND ANOTHER SHOW AND SHOW AND SHOW AND SHOW AND SHOW AND SHOW AND SHOW....IT IS WORK....IT IS EXCITING....IT IS STIMULATING.... AND IT CAN BE BEAUTIFUL!!!!!

ELLIN SALTZMAN

THE BRYANT PARK TENTS HAVE BEEN A TREMENDOUS FOCAL POINT FOR THE NEW YORK SHOWS. THEY TOOK OUR FASHION INDUSTRY TO LEVELS OF PROFESSIONALISM THAT EASILY SURPASS THAT OF MILAN AND PARIS. AND, ON A PERSONAL NOTE, IT PLEASES ME ENORMOUSLY THAT THE CITY'S YOUNG DESIGNERS HAVE REALLY STARTED TO UNDERSTAND THE BENEFITS OF SHOWING THERE.

ANNA WINTOUR

Gabriel Aubry at the Michael Kors show, September 2002

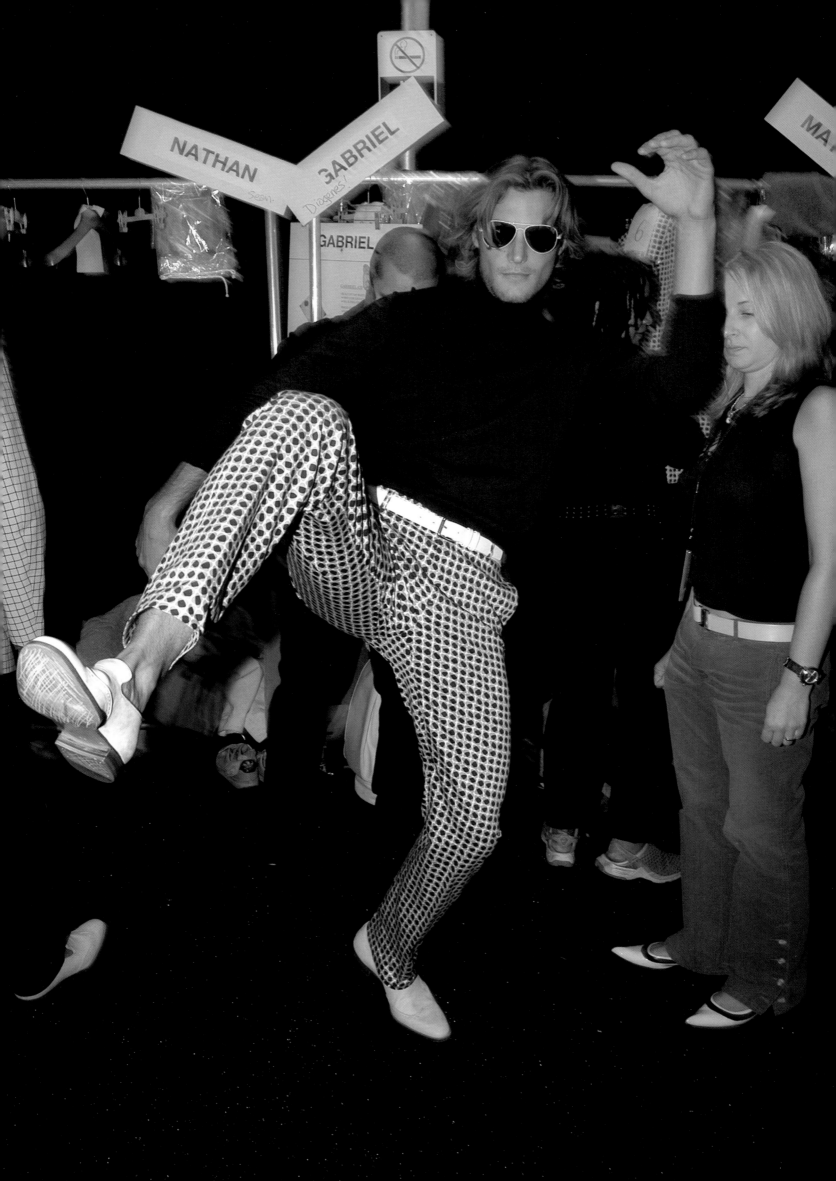

Tyson Ballou at the Michael Kors show, September 2003

THE FASHION SHOWS AT NEW YORK'S BRYANT PARK
HARNESS ALL THE GREAT ENERGY AND TALENT,
PLUS THE REMARKABLE MIX OF PEOPLE THAT MAKE
NEW YORK THE CAPITAL OF THE WORLD.

MICHAEL KORS

Nico Malleville and Carmen Kass at the Michael Kors show, September 2003
Lindsay Frimodt and Bekah Jenkins at the Baby Phat show, September 2002

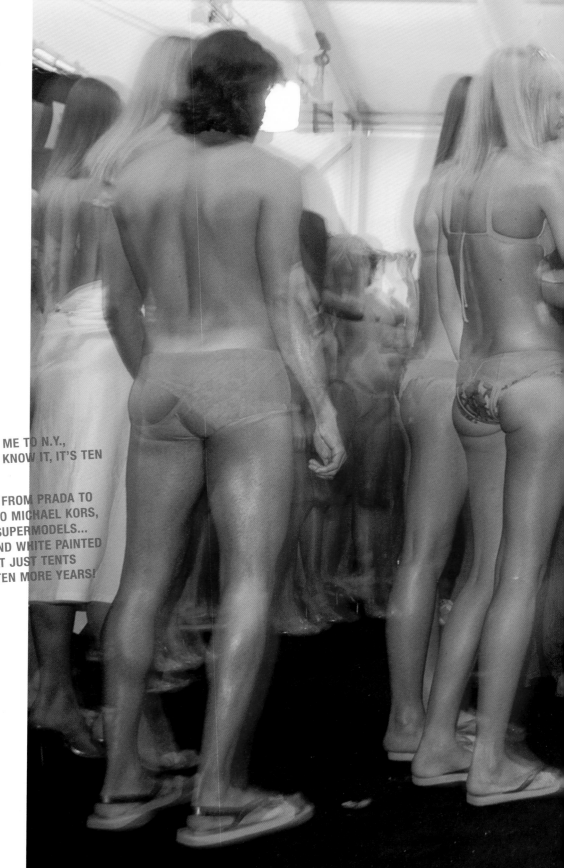

TEN YEARS OF THE TENTS?

TEN YEARS AGO, THEY ATTRACTED ME TO N.Y.,
TRAPPED ME IN, AND BEFORE YOU KNOW IT, IT'S TEN
YEARS LATER:

TWO KIDS, HUNDREDS OF SHOWS, FROM PRADA TO
DONNA KARAN, JOHN BARTLETT TO MICHAEL KORS,
COUNTLESS LOOKS, CUES, SETS, SUPERMODELS...
AND EVEN ROOSTERS, HORSES, AND WHITE PAINTED
MEN....WHO COULD IMAGINE WHAT JUST TENTS
COULD DO TO YOU....READY FOR TEN MORE YEARS!

ALEXANDRE DE BETAK

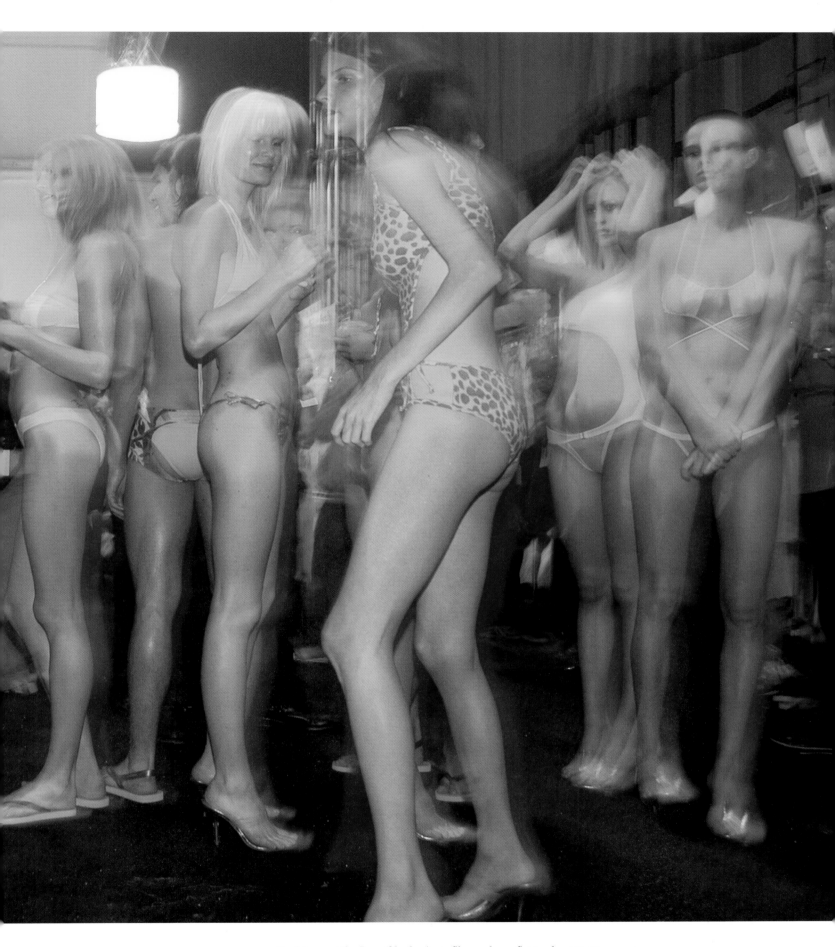

Backstage at the Rosa Cha by Amir Slama show, September 2003

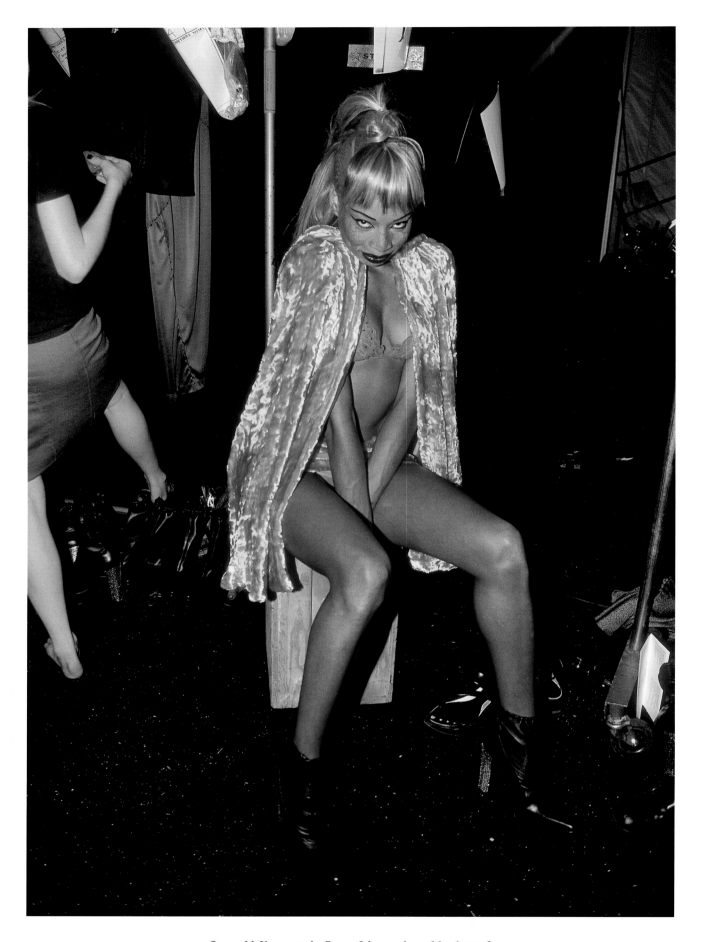

Stacey McKenzie at the Betsey Johnson show, March 1998

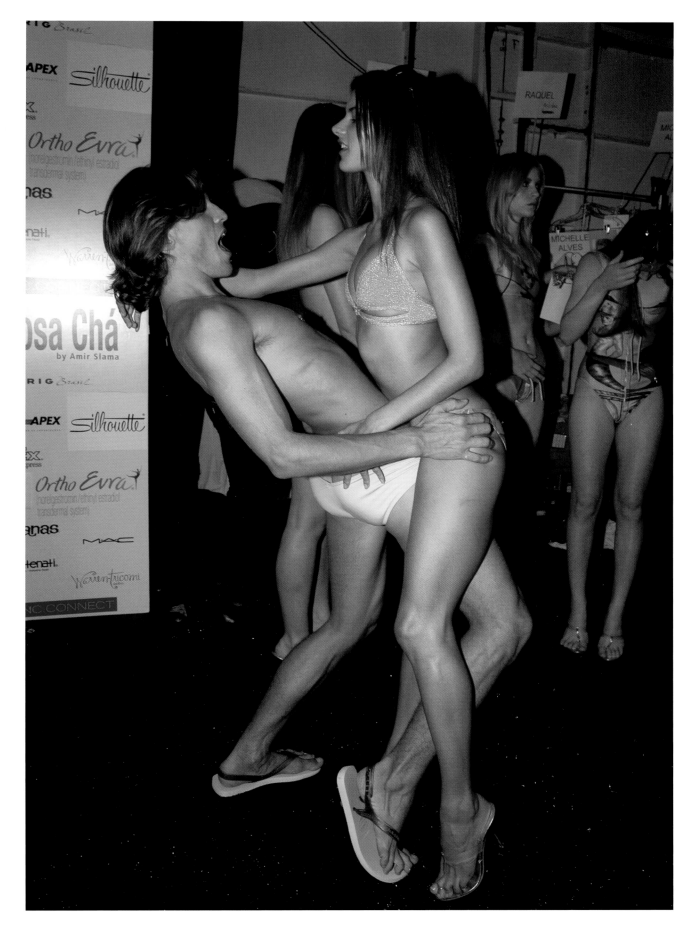

Marcelo Boldrini and Alessandro Ambrosio at the Rosa Cha by Amir Slama show, September 2003

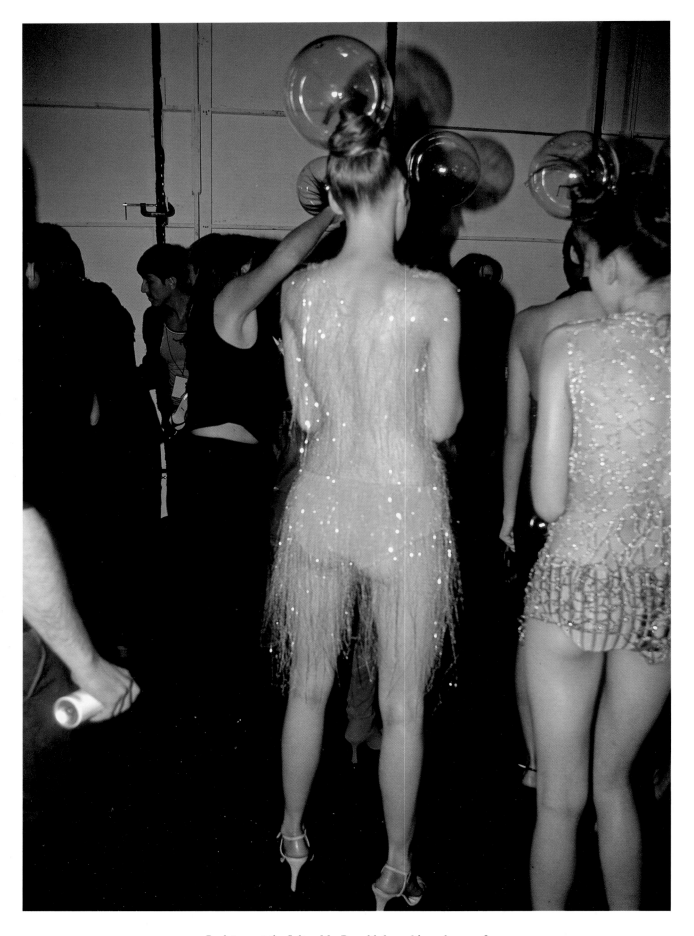

Backstage at the Julien MacDonald show, November 1998

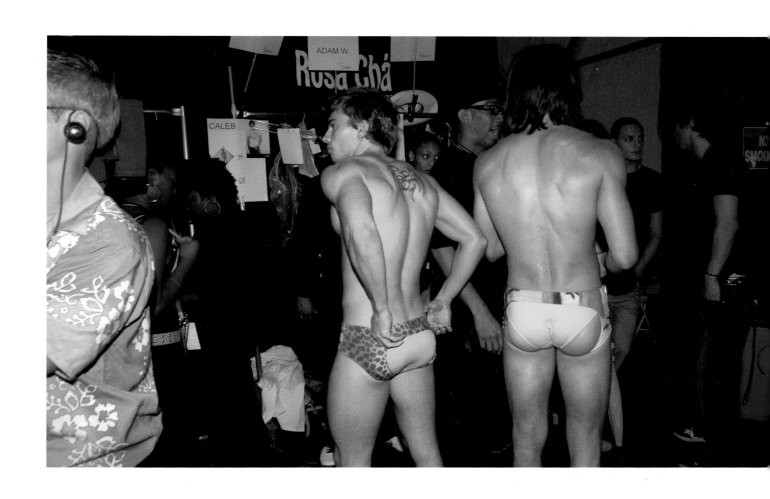

Backstage at the Rosa Cha by Amir Slama show, September 2003

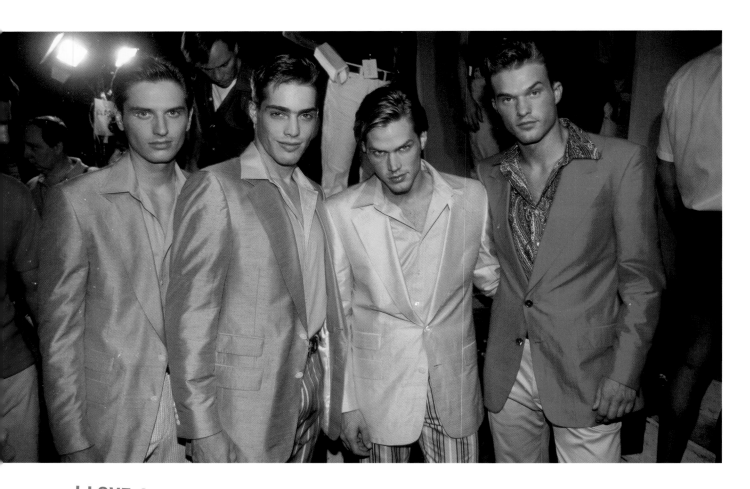

I LOVE GOING TO THE NEW YORK SHOWS BECAUSE THEY ARE ALWAYS FULL OF ENERGY AND STYLE, AND THEY ARE A GREAT SOURCE OF INSPIRATION FOR ME. BECAUSE THE SHOWS ARE SO CLOSE BY AND ORGANIZED, IT MAKES IT SO EASY TO GO AND SEE THE DESIGNERS WITH WHOM I HAVE CLOSE, PERSONAL RELATIONSHIPS, BUT I ALSO GET TO SEE YOUNGER DESIGNERS THAT I MIGHT NOT HAVE HAD THE CHANCE TO SEE OTHERWISE.

AERIN LAUDER

Sasha, Jason Fedele, Jason Lewis, and Gandalf at the Tommy Hilfiger show, July 1996

Alice Dodd at the Vivienne Tam show, October 1995
Model at the Luca Luca show, September 2000

Gisele Bundchen and model at the Miu Miu show, October 1996
Gisele Bundchen and Scott Barnhill at the Tommy Hilfiger show, September 1999

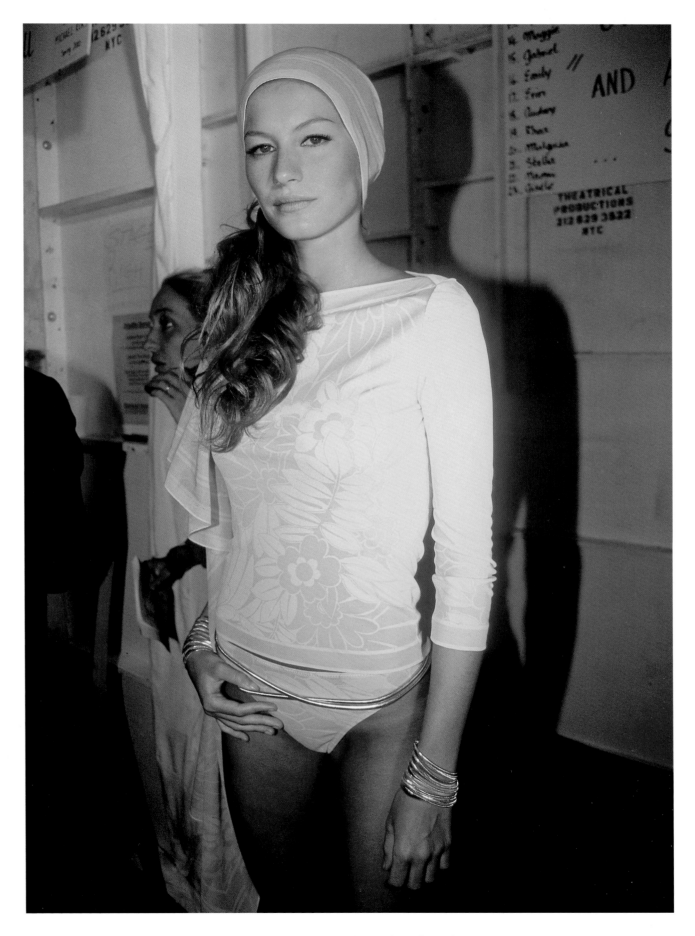

Gisele Bundchen at the Michael Kors show, September 1999

Backstage at the Gemma Khang show, October 1994

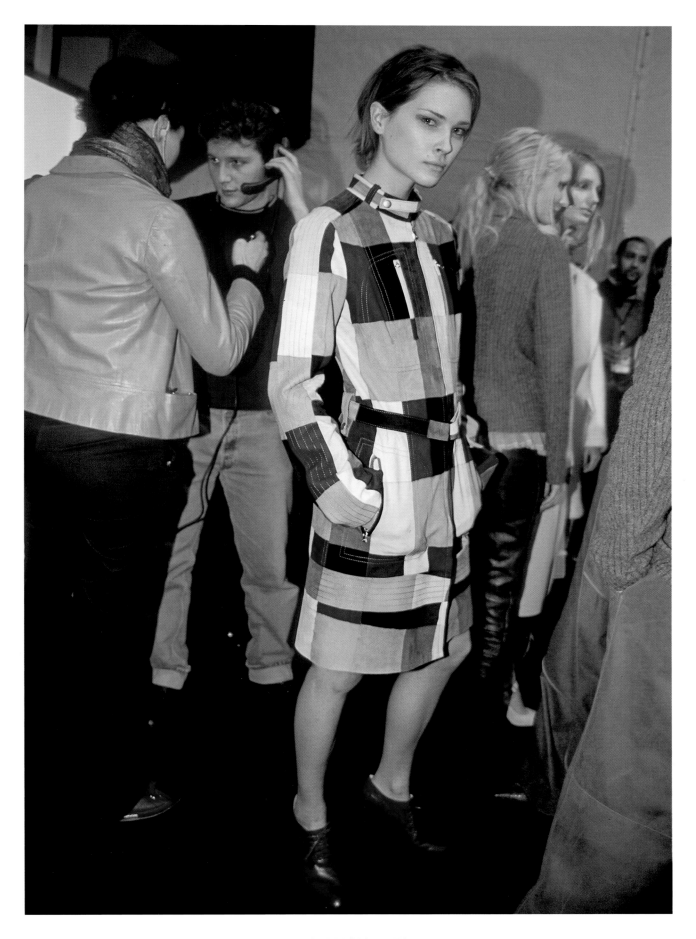

Erin Wasson at the DKNY show, February 2002

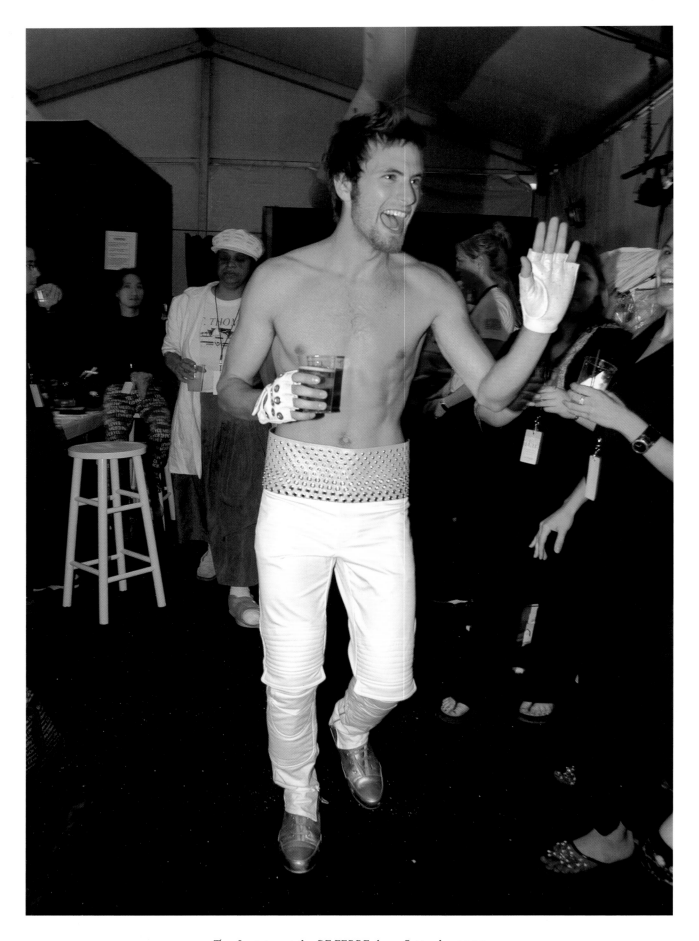

Tom Lariviere at the GF FERRE show, September 2003

Backstage at the Nautica show, July 1997

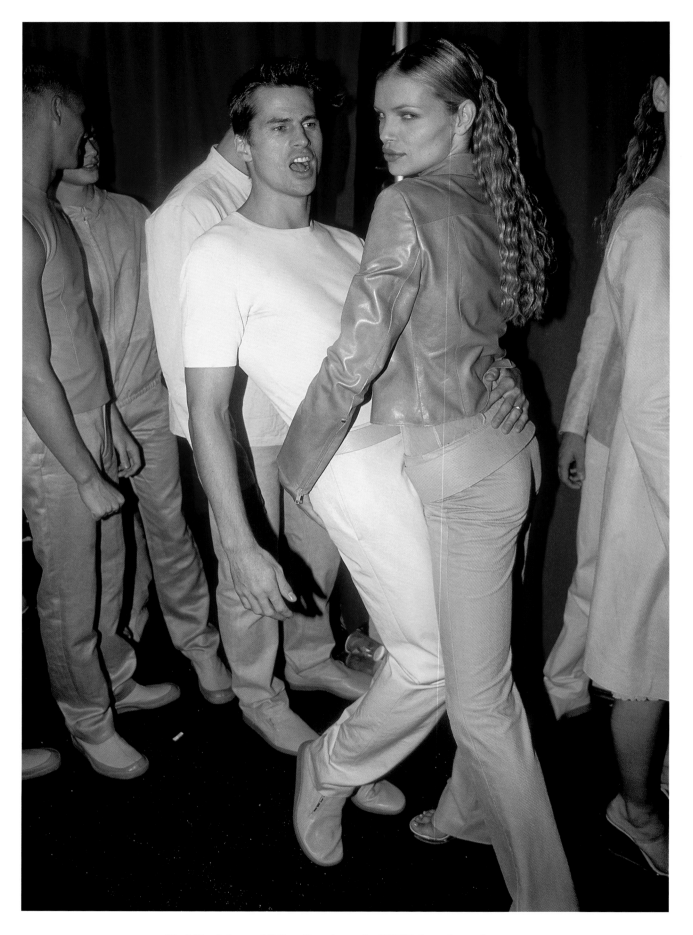

Mark Vanderloo and Esther Canadas at the DKNY show, September 1999

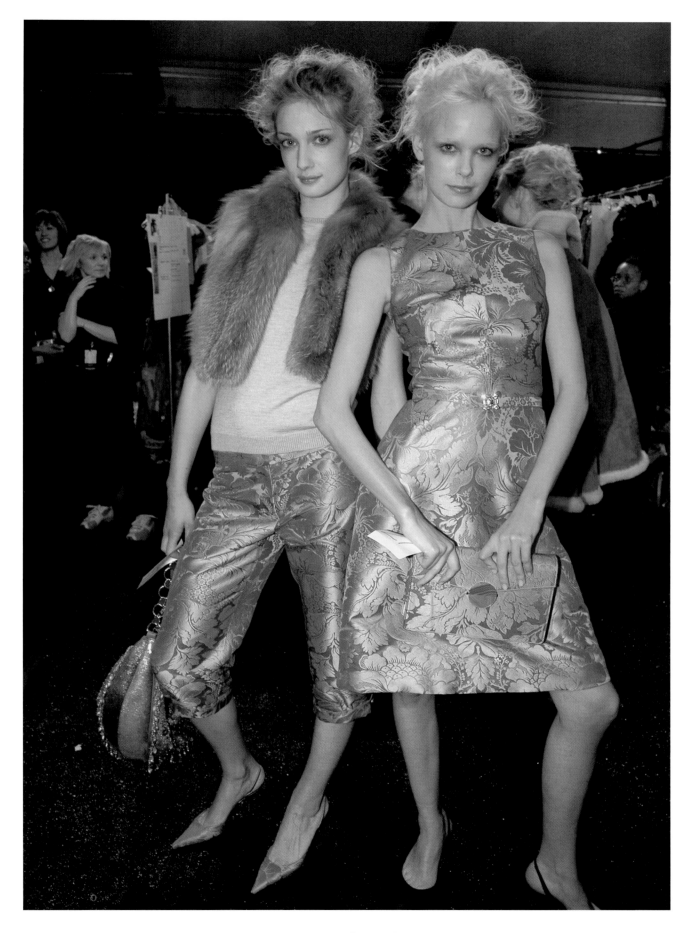

Eva Riccobono and Dewi Driegen at the Oscar de la Renta show, February 2003

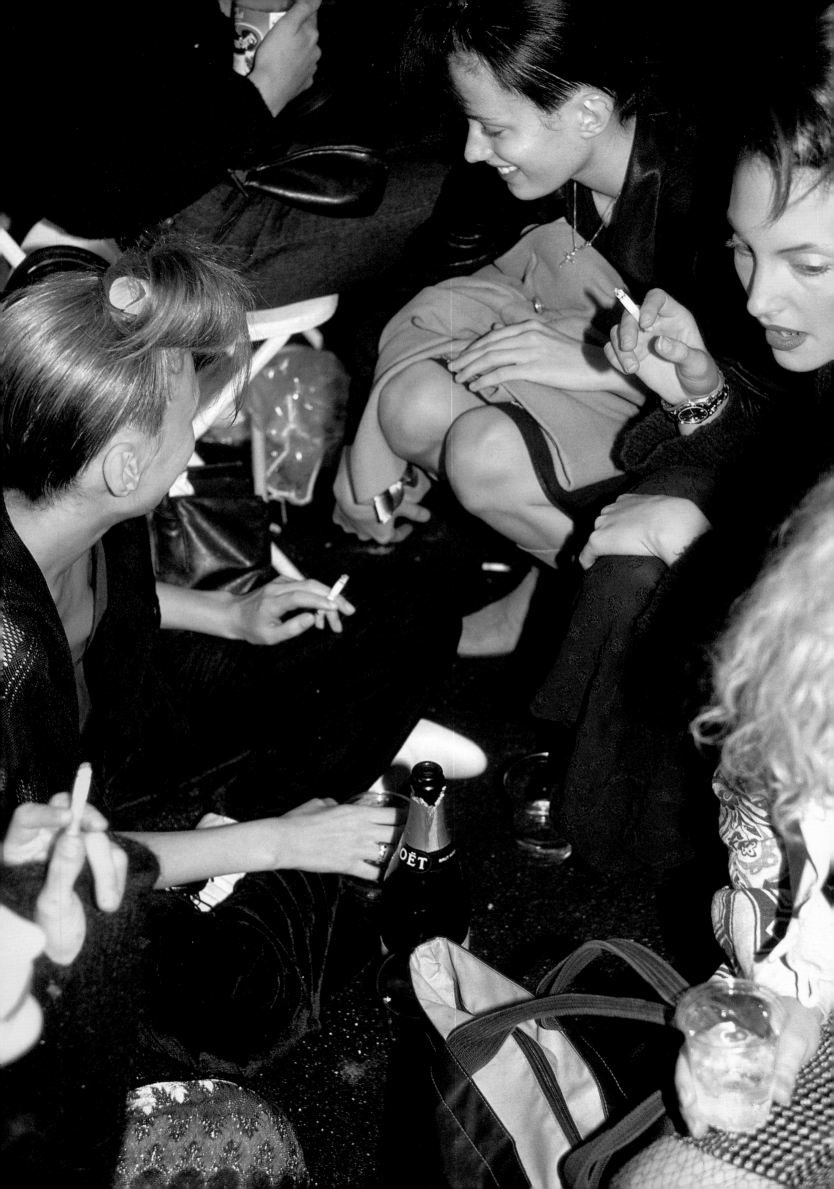

THE FASHION SHOW, WITH ALL ITS RIGOROUS PERFECTION, IS IMPOSSIBLY GLAMOROUS, OF COURSE. BUT THE REAL ACTION IS BACKSTAGE. BEFORE THE SHOW, THE MUSIC IS BLARING. THE MODELS HAVE A CELL PHONE PLANTED TO ONE EAR AND SIP CHAMPAGNE THROUGH A STRAW SO AS NOT TO MUSS THEIR LIPSTICK. SOMEONE SHOUTS FOR EVERYONE TO CLEAR OUT, TEN MINUTES TO SHOWTIME. TO SEE THE MODELS EMERGE FROM THAT CHAOS AND TENSION, LOOKING LIKE THEY JUST STEPPED OUT OF A BILLBOARD, IS TO WITNESS MAGIC. AFTER THE SHOW, BACKSTAGE BECOMES A PARTY. THE GIRLS ARE UNDRESSING, BUT NO ONE SEEMS TO NOTICE. PATRICK MCMULLAN PLAYS THE HOST, SHOOTING PICTURES AND INTRODUCING EVERYONE: "WYCLEF, DO YOU KNOW SARAH JESSICA?" "P. DIDDY, YOU SHOULD MEET IVANA." "PARIS, SAY HELLO TO MR. TRUMP."

LINDA WELLS
EDITOR IN CHIEF
ALLURE

Backstage at the Ghost show, November 1996

AFTER THEY SEE THEIR FIRST RUNWAY SHOW, PEOPLE OUTSIDE OF
THE FASHION BUSINESS OFTEN REMARK THAT THE OUTFITS WERE TOO
OVER-THE-TOP, WHEN IN FACT THE CLOTHES ARE USUALLY THE LEAST
INTERESTING THING ON DISPLAY DURING FASHION WEEK.

CLOTHES BRING US TO NEW YORK FASHION WEEK;
THE PEOPLE KEEP US COMING BACK.

LIBBY CALLAWAY
FASHION EDITOR

Lining up at the Betsey Johnson show, October 1994

The "Grunge" look at the Marîthé+François Girbaud show, April 1995

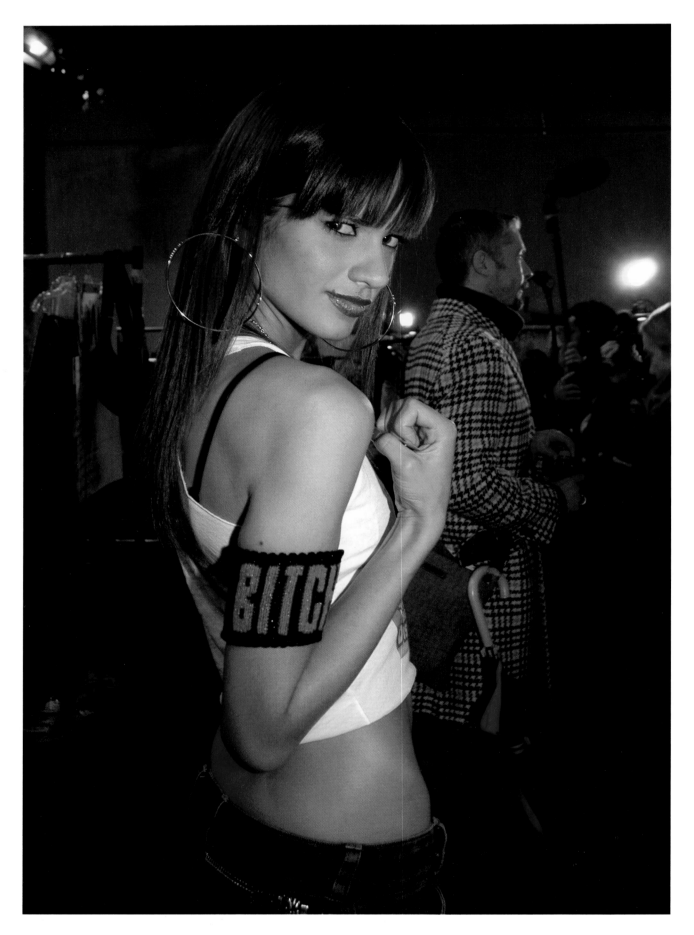

Lindsay Frimodt at the Betsey Johnson show, February 2003

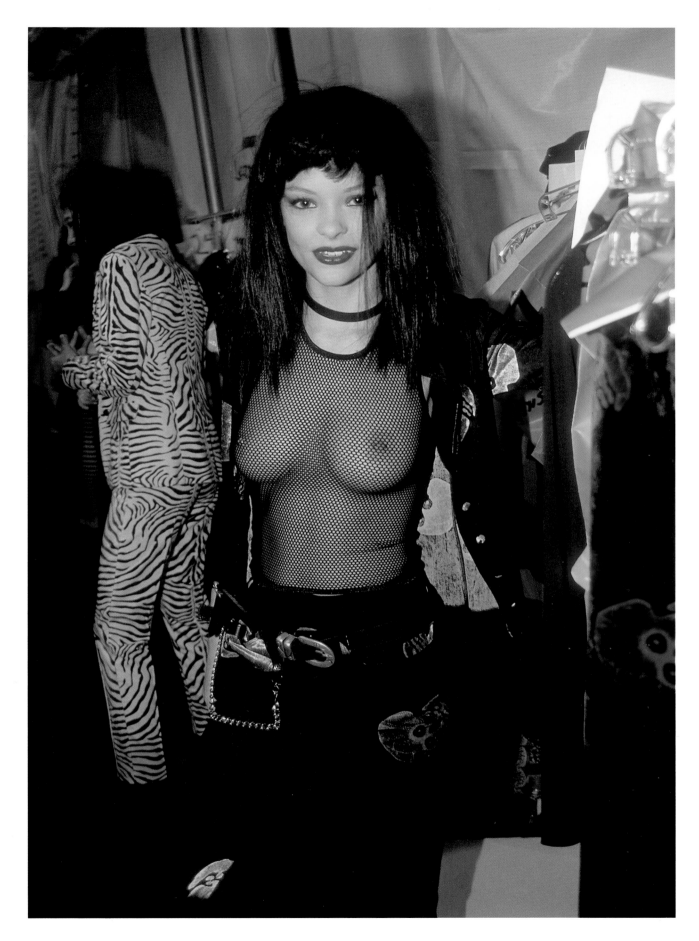

James King at the Betsey Johnson show, March 1996

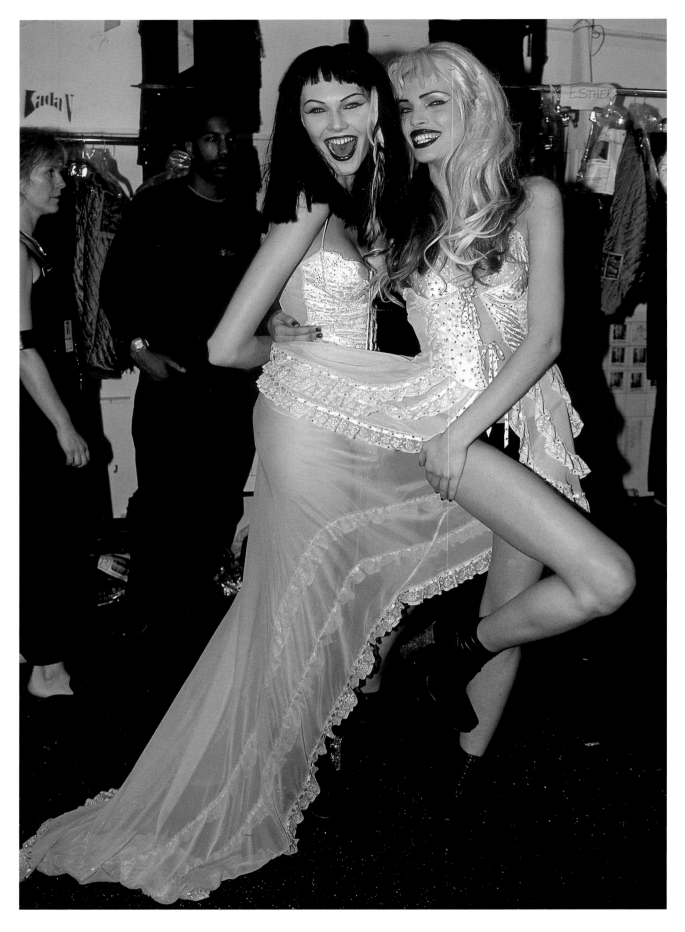

Shirley Mallman and Esther Canadas at the Betsey Johnson show, March 1998

EVEN THROUGH THE FRENZY OF
FASHION WEEK, WE STILL HAVE TIME
TO GIVE A LOOK TO THE LENS

KYLIE BAX

Backstage at the Betsey Johnson show, March 1996

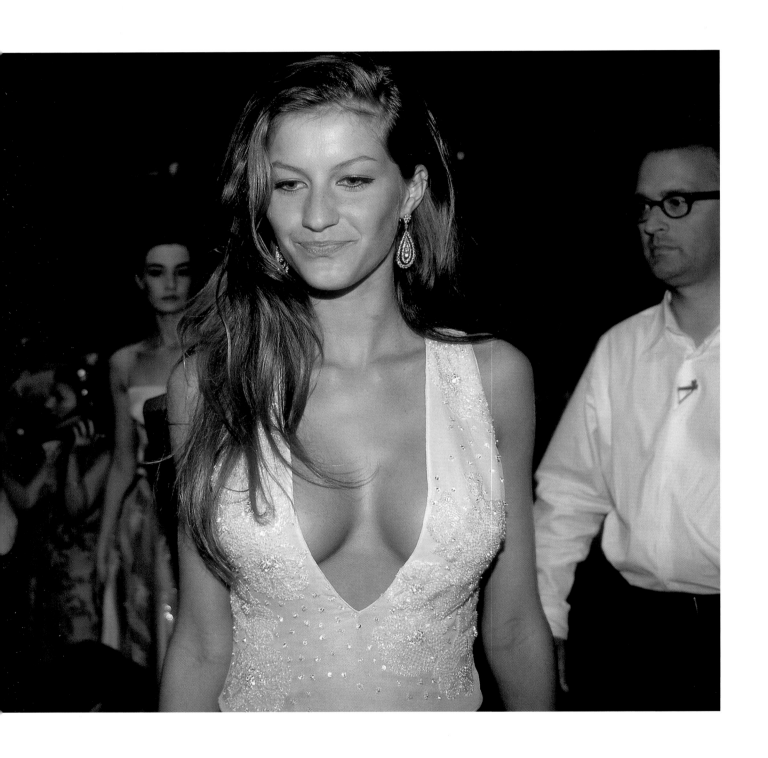

Gisele Bundchen at the Badgley Mischka show, September 1999

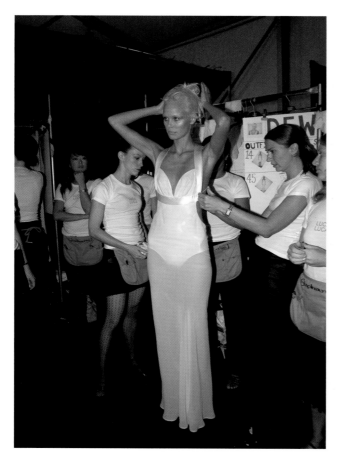

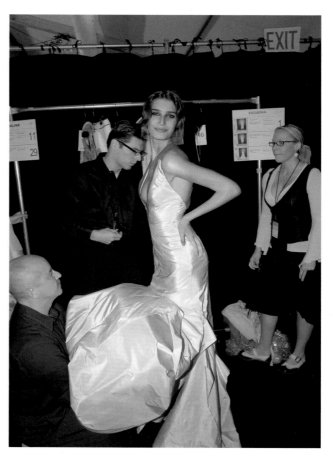

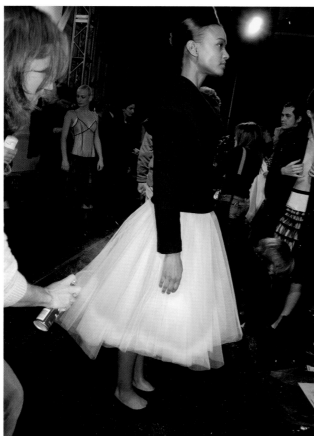

From top, left to right:
Dewi Driegen at the Luca Luca show, September 2003
Eugenia Volodina at the Carolina Herrera show, September 2003
Designer Behnaz Sarafpour and Liya Kebede at the Behnaz Sarafpour show, February 2003
Veronica Webb at the Isaac Mizrahi show, November 1995

Backstage at the Carolina Herrera show, October 1995

THE TENTS ARE INTENSE AND POWERFUL WITH ENERGY AND HYSTERIA.

NAOMI CAMPBELL

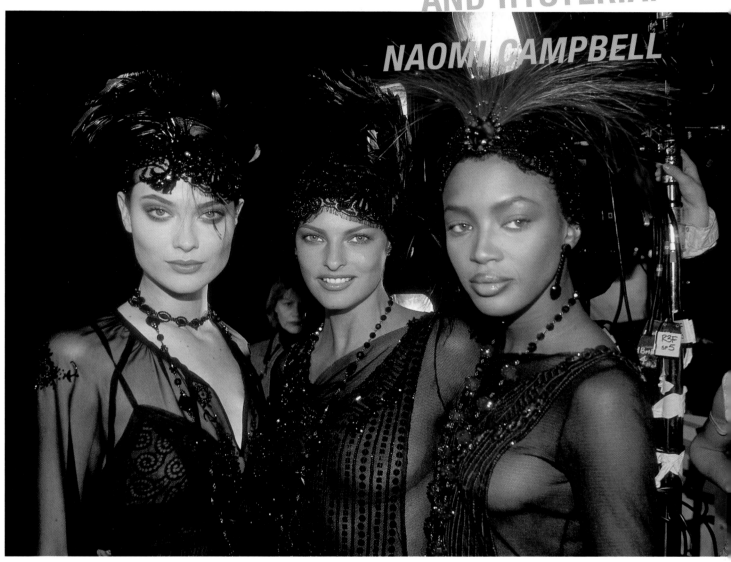

Shalom Harlow, Linda Evangelista, and Naomi Campbell at the Anna Sui show, March 1996

Backstage at the Oscar de la Renta show, September 2002

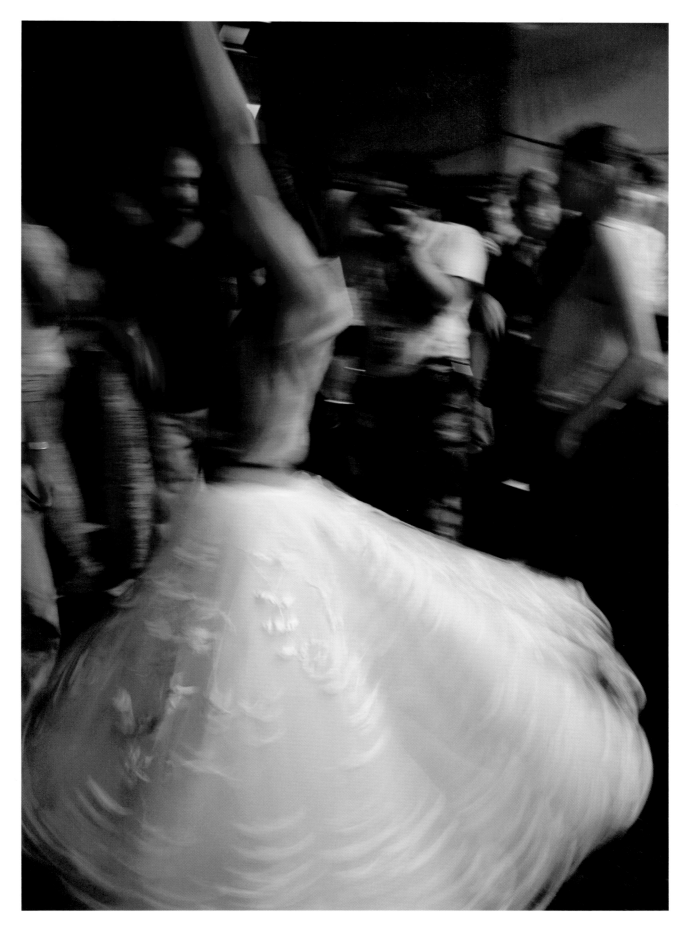

Backstage at the Oscar de la Renta show, September 2002

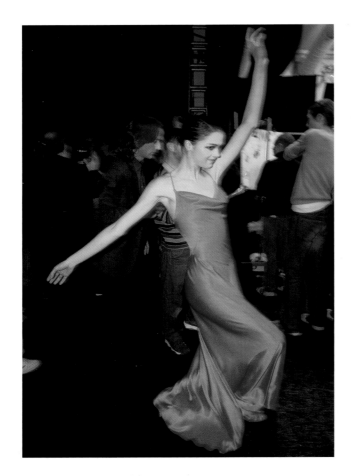

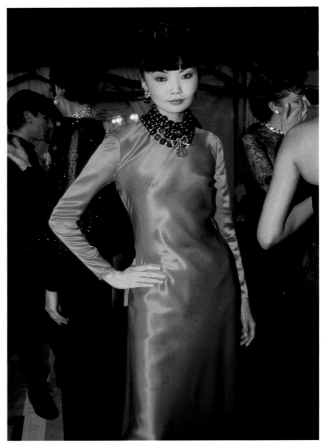

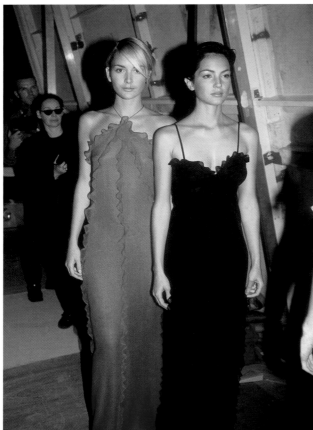

From top, left to right:
Mariacarla Boscono at the Luca Luca show, February 2003
Irina Pantaeva at the Oscar de la Renta show, April 1995
Georgina Grenville and Chandra North at the Bill Blass show, October 1996
Backstage at the Gen Art show, September 2001

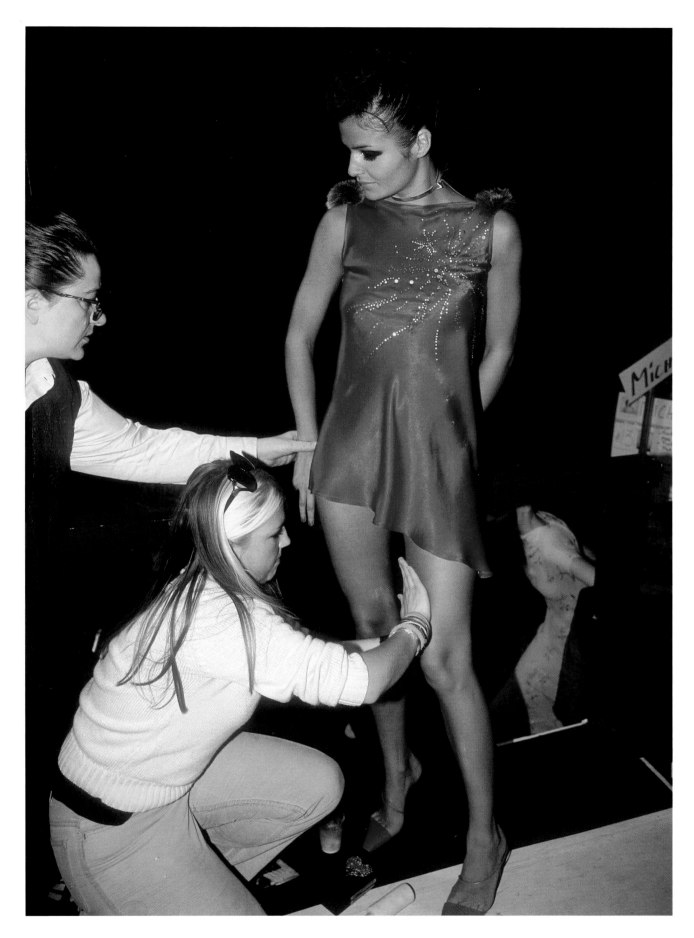

Helena Christensen at the Ghost show, April 1997

NEW YORK AND PARIS ARE THE FASHION CAPITALS OF THE WORLD.
IF YOU ARE INTERESTED IN FASHION, YOU HAD BETTER BE THERE.
IT'S A GREAT OPPORTUNITY TO SEE THE BEST THEATER IN TOWN.

BLAINE TRUMP

Kirsty Hume at the Isaac Mizrahi show, April 1994

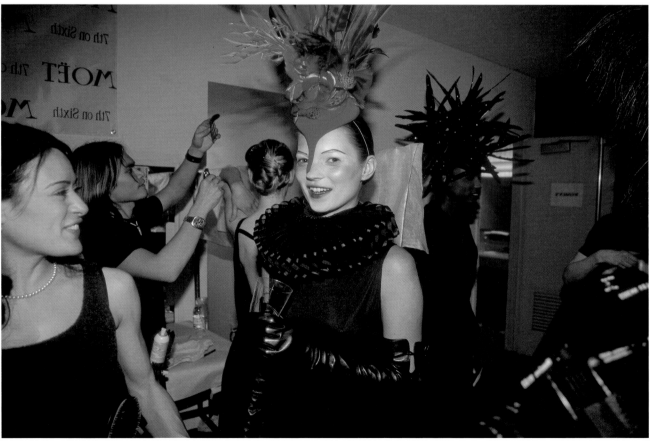

Chrystele and Shalom Harlow at the Philip Treacy show, April 1997
Kate Moss at the Philip Treacy show, April 1997

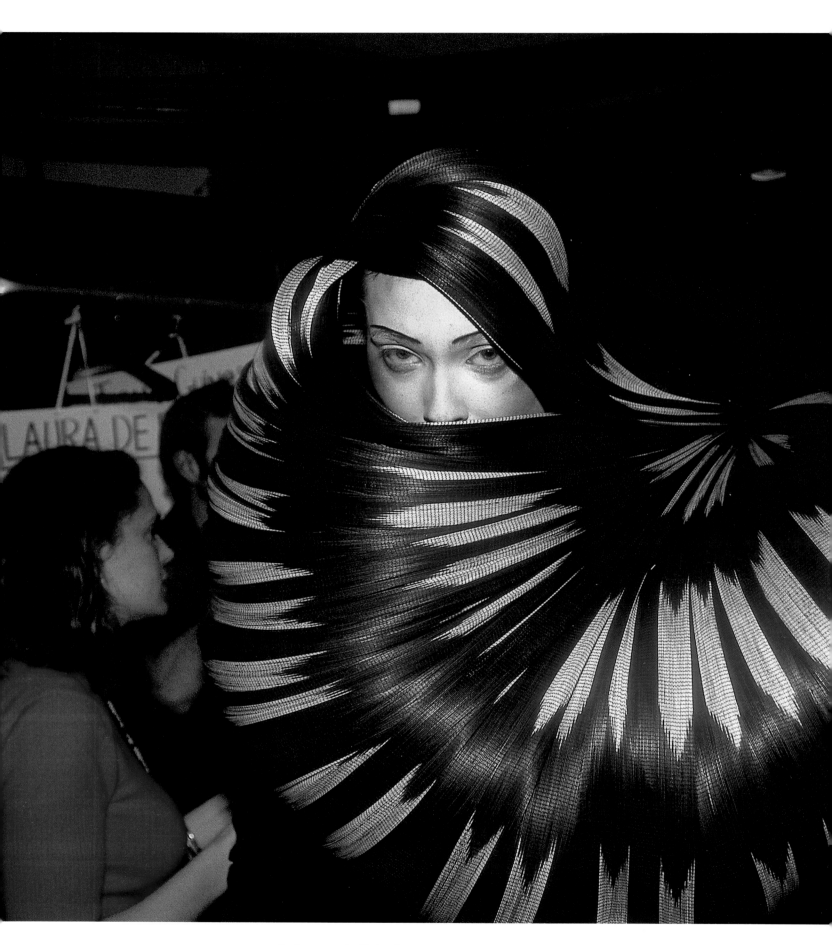

Backstage at the Philip Treacy show, April 1997

AFTER NEARLY TWENTY YEARS COVERING THE
SHOWS THE EXCITEMENT IS STILL THRILLING.
NEVER KNOWING WHAT IS GOING TO HAPPEN IT
IS LIKE WAITING FOR THE CURTAIN TO GO UP
AT THE OPERA OR BALLET. I LOVE IT.

HILARY ALEXANDER

Gisele Bundchen at the Michael Kors show, September 2002

Backstage at the Tommy Hilfiger show, September 2002

Shirley Mallman and Jonathan Chick stealing a kiss at the Cynthia Rowley show, February 1998

Men/women backstage at the Kenneth Cole show, February 2003

I'VE BEEN ATTENDING THE NEW YORK COLLECTIONS FOR MANY YEARS, BUT DURING MY FIRST SEASON AS EDITOR-IN-CHIEF OF AMERICAN *MARIE CLAIRE*, I WAS SEATED NEXT TO MIKE TYSON. THE NEXT MORNING, A PICTURE OF MIKE AND ME APPEARED ON THE COVER OF SEVERAL NEWSPAPERS. I'VE ALWAYS THOUGHT THE CAPTION SHOULD HAVE READ: "HEARST HIRES NEW BODYGUARD FOR BAILEY."

GLENDA BAILEY

From top, left to right:
Tim Burton and Lisa Marie at the Prada show, April 1994
Dave Navarro backstage at the Anna Sui show, October 1996
Milla Jovovich and pal sipping champagne backstage at the Miu Miu show, November 1995
Mischa Barton at the Tommy Hilfiger show, September 2003
Liza Minnelli and Donna Karan at the DKNY show, October 1995
Pat Field, Robert Verdi, Sonia Braga, and Janice Dickinson at the Carlos Miele show, September 2002
Debbie Harry at the Versus show, March 1996
Stephen Dorff and Guy O'Seary at the Versus show, March 1996
Angie Harmon at the Michael Kors show, September 2003
Elizabeth Hurley and Sheryl Crow at the Versus show, March 1998
James Iha backstage at the Anna Sui show, November 1995
Marcus Schenkenberg at the Sean John show, February 2001
Chili, Catie Cole, and Maxwell at the Kenneth Cole show, September 2003
Chuck Zito and Joan Jett kissing at the Cynthia Steffe show, February 2002
Tim Roth, Drew Barrymore, and Milla Jovovich at the Miu Miu show, November 1995
Pharrell Williams at the Rosa Cha by Amir Slama show, September 2003

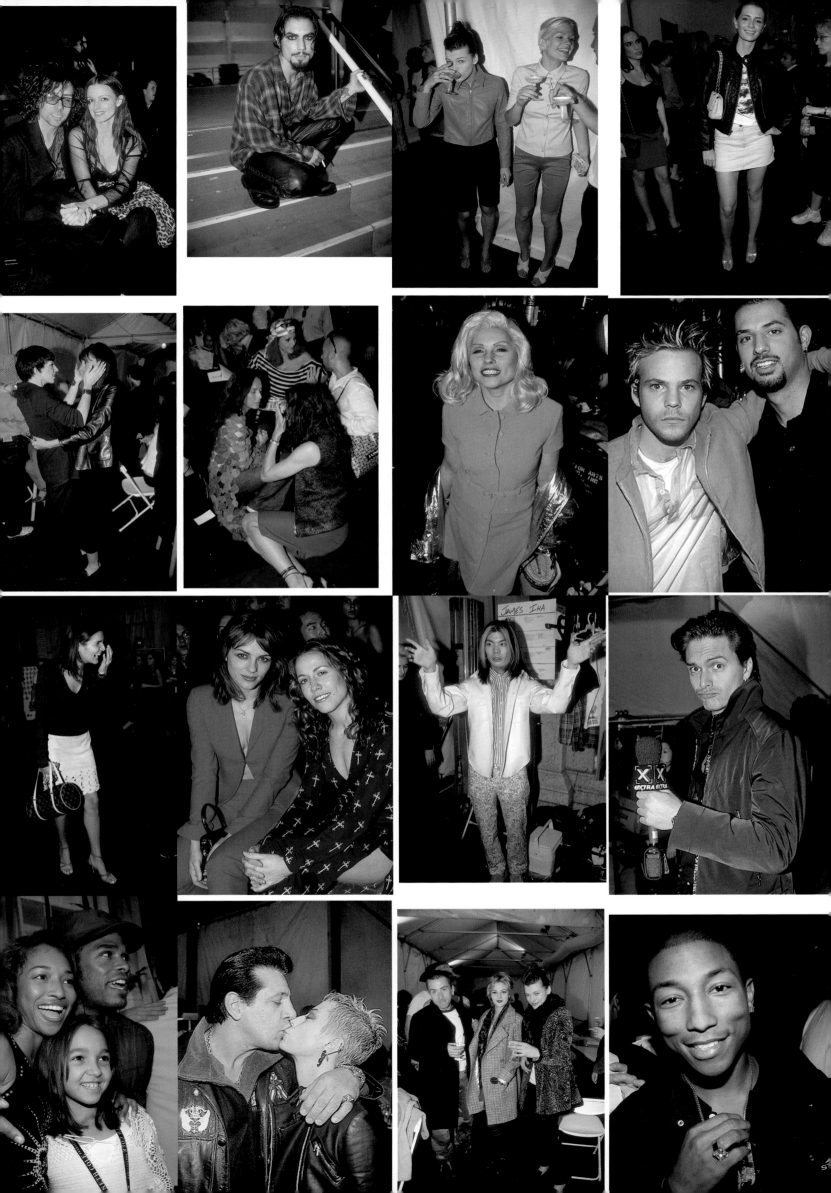

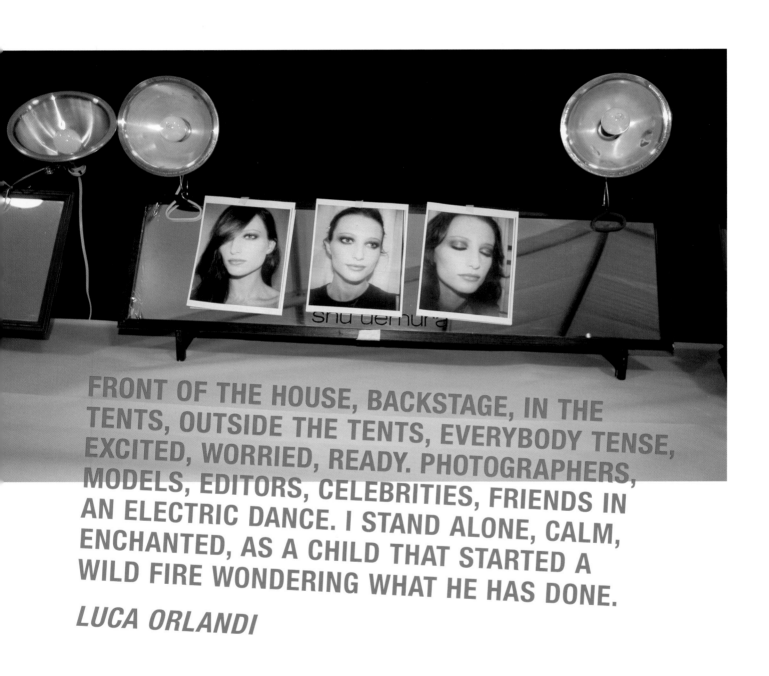

FRONT OF THE HOUSE, BACKSTAGE, IN THE TENTS, OUTSIDE THE TENTS, EVERYBODY TENSE, EXCITED, WORRIED, READY. PHOTOGRAPHERS, MODELS, EDITORS, CELEBRITIES, FRIENDS IN AN ELECTRIC DANCE. I STAND ALONE, CALM, ENCHANTED, AS A CHILD THAT STARTED A WILD FIRE WONDERING WHAT HE HAS DONE.

LUCA ORLANDI

Beauty polaroids at the Luca Luca show, September 2002

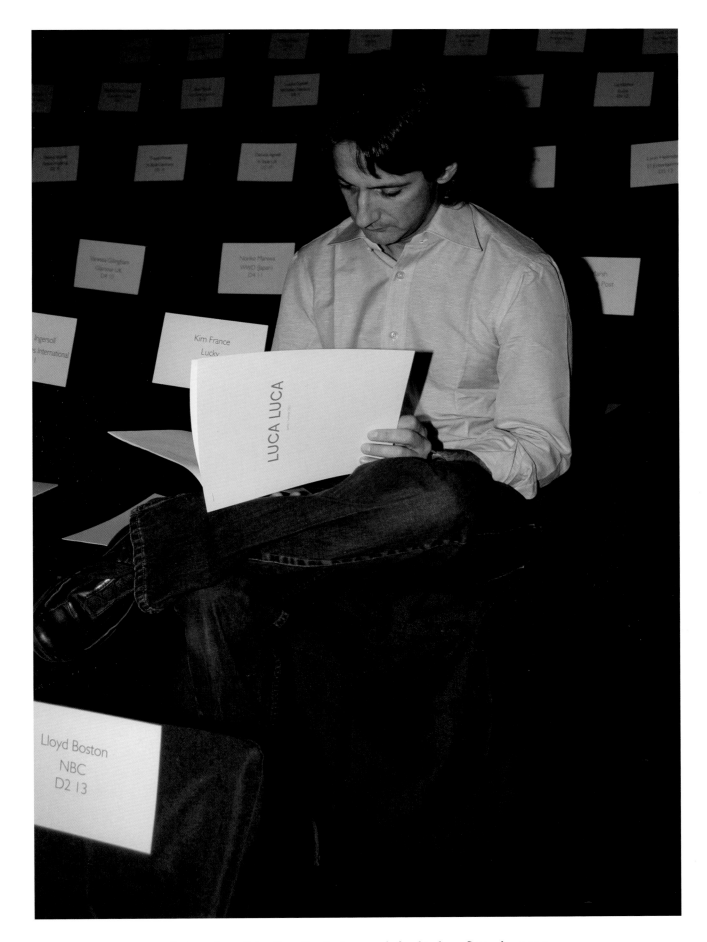

Designer Luca Orlandi reading the program before his show, September 2002

THE TENTS ARE LIKE A LIVE-ACTION PRESENTATION OF DYNASTY
THE T.V. SHOW. TOTALLY DOLLED-UP GLAMOUR PUSSES CROWD THE
FRONT ROWS. CELEBRITIES MAKE CAMEOS AND FASHION BESSIES
DISSECT THEIR LOOKS. CAREERS ARE MADE AND DESTROYED BY
THE ROW OF YOUR SEAT. REPUTATIONS ARE MADE AND DESTROYED
BY THE QUALITY OF A DESIGNER'S GIFT BAG. IT'S MADNESS.
OH, AND THEY HAVE LOTS OF GREAT FASHION SHOWS TOO.

MICKEY BOARDMAN

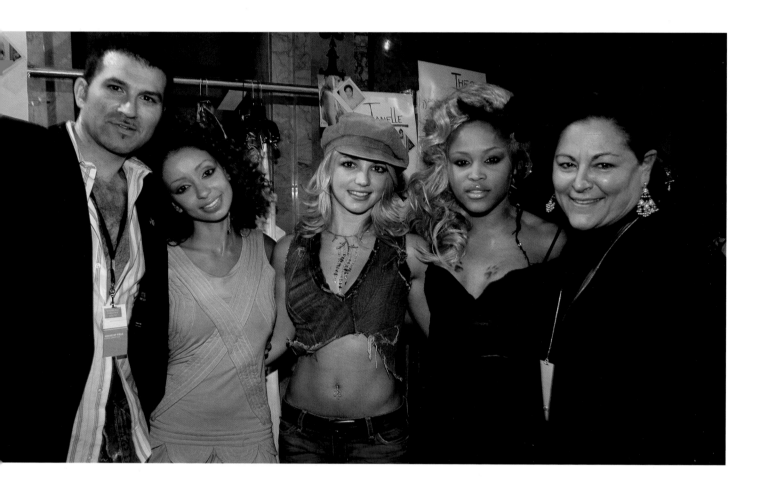

Designer David Dalrymple, Mya, Britney Spears, Eve, and Fern Mallis at the House of Field show, September 2002

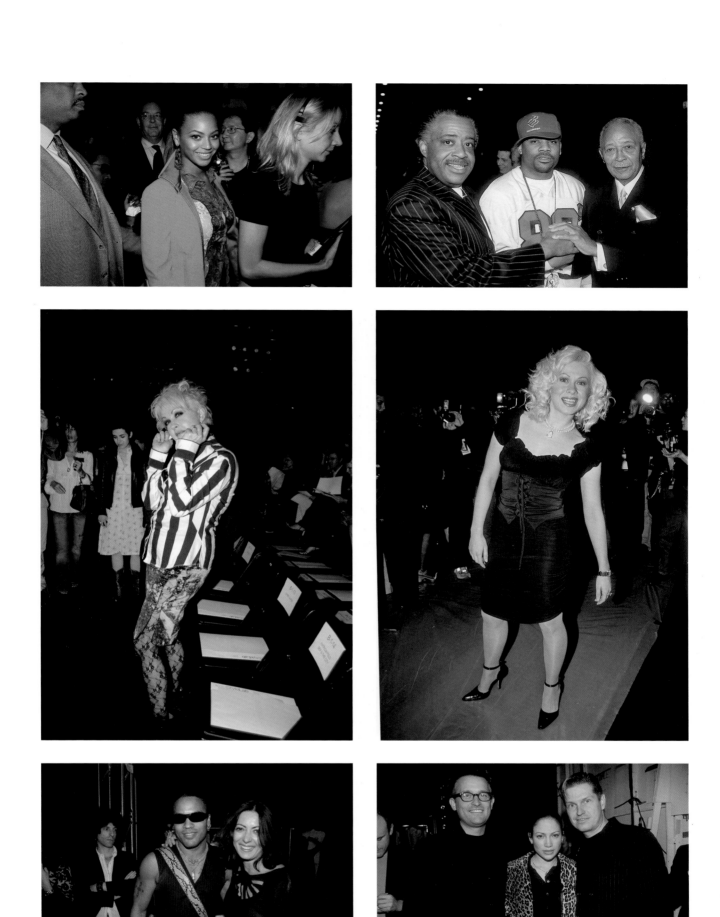

From top, left to right:
Beyoncé Knowles at the GF FERRE show, September 2003
Al Sharpton, Damon Dash, and former NYC mayor, David Dinkins, at the Baby Phat show, February 2002
Cyndi Lauper at the Diesel StyleLab show, September 2002
Oksana Baiul at the Luca Luca show, February 2002
Lenny Kravitz and Catherine Malandrino at the Catherine Malandrino show, September 2003
Mark Badgley, Jennifer Lopez, and James Mischka at the Badgley Mischka show, April 1998

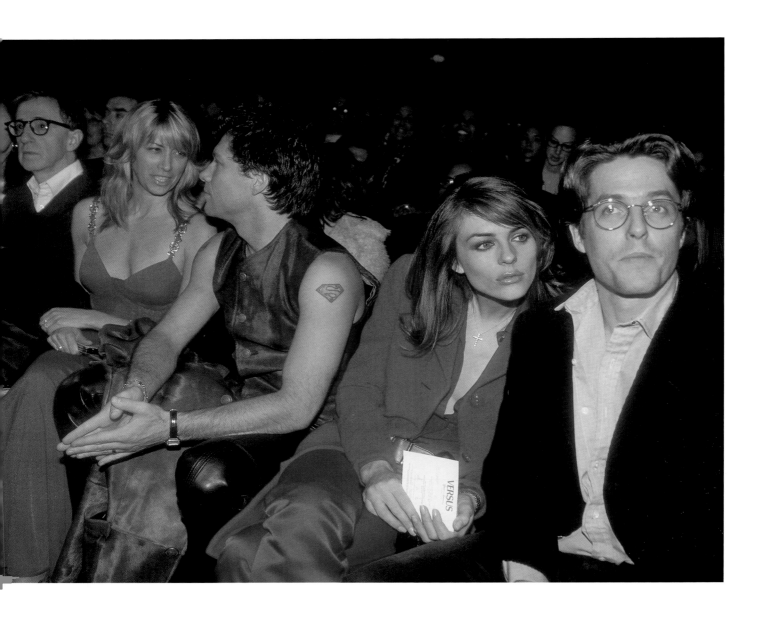

Woody Allen, Dorothea Bon Jovi, Jon Bon Jovi, Elizabeth Hurley, and Hugh Grant at the Versus show, October 1996

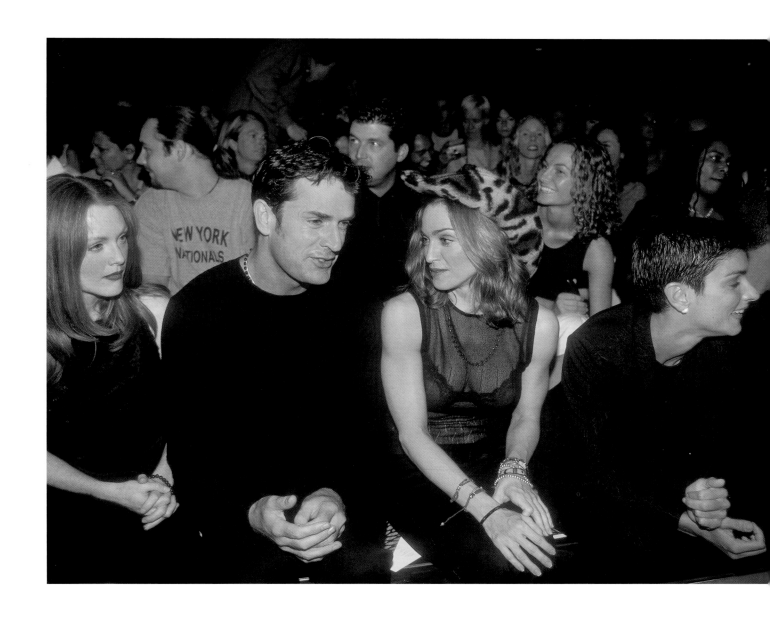

Julianne Moore, Rupert Everett, Madonna, and Ingrid Casares at the Versus show, September 1999

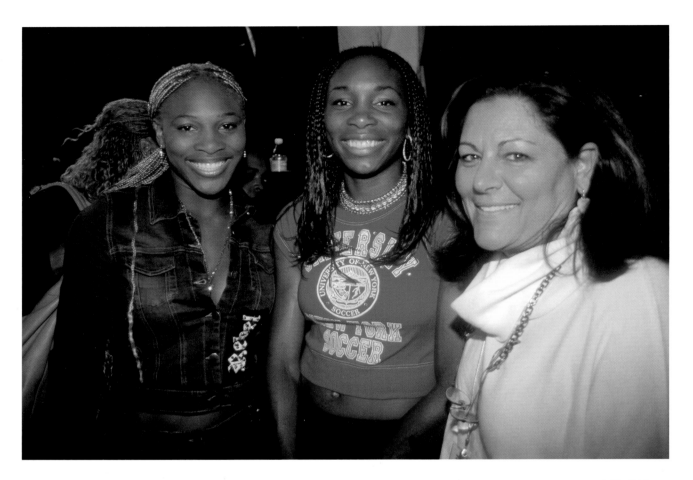

Venus Williams, Serena Williams, and Fern Mallis at the Luella Bartley show, September 2001
Domenico Dolce, Demi Moore, and Stefano Gabbana at the D&G show, October 1996

BACKSTAGE AFTER A SHOW IS LIKE THE BEST FIFTEEN MINUTE
COCKTAIL PARTY — TAKE PICTURES, HANG OUT, EXCHANGE IDEAS,
SEE CELEBS YOU DON'T ALWAYS SEE — LIKE DEMI OR LIZA.
JUST BE FABULOUS AND ALL THE REALITIES OF LIFE DISAPPEAR
FOR A FEW MOMENTS....

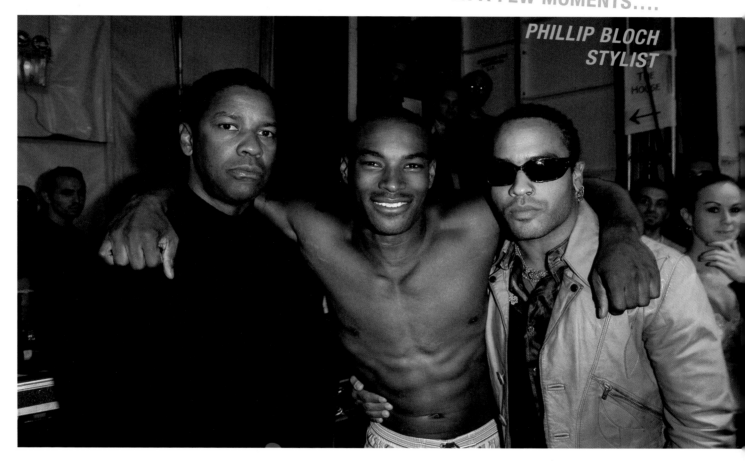

Denzel Washington, Tyson Beckford, and Lenny Kravitz at the Tommy Hilfiger show, September 2003

IT'S APPROPRIATE THAT THE SHOWS ARE HELD IN THE "TENTS" BECAUSE FROM THE FIRST MOMENT YOU GO UP THE FIRST STEP YOU GET THAT FRENZIED FEELING THAT YOU'RE ENTERING A CIRCUS. THE DESIGNERS ARE THE RINGMASTERS WHILE THE SUPERMODELS ON THE CATWALK ARE THE RARE ANIMALS. IT'S FUN TO WATCH THE PHOTOGRAPHERS JOCKEY FOR THE BEXT POSITION RIGHT AT THE VERY END...IT'S A BALANCING ACT ONE ON TOP OF THE OTHER. ONE OF THE FUNNIEST SPECTACLES IS WATCHING THE MOVIE STAR CELEBRITY ARRIVE LATE, WITH HOARDS OF PHOTOGRAPHERS SHOUTING HER NAME, LIKE BEES SWARMING AROUND THE QUEEN BEE! ONLY TO FIND THAT HER FRONT ROW SEAT WAS...STOLEN! THE PRODUCERS RUSH IN TO SEE WHO THE IMPOSTER IS IN THE FRONT ROW AND WHO THEY CAN SAFELY SHOO AWAY.... IT'S QUITE ENTERTAINING!

DAYSSI OLARTE DE KANOVAS

Joanna Lumley and Jennifer Saunders of "AbFab" and Josh Hamilton at the Jared Gold show, September 2002

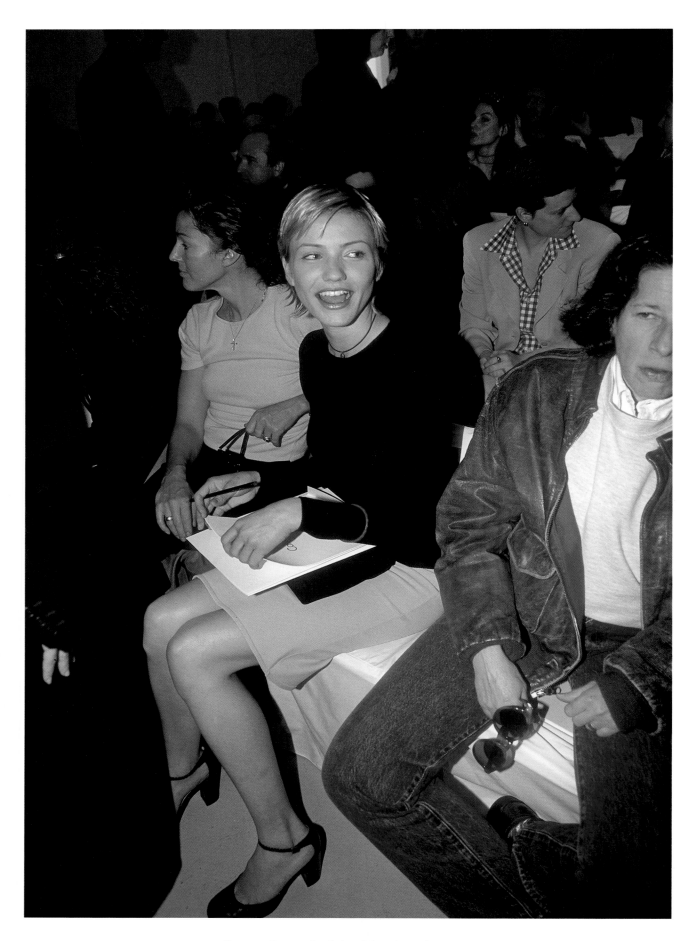

Cameron Diaz at the Calvin Klein show, April 1997

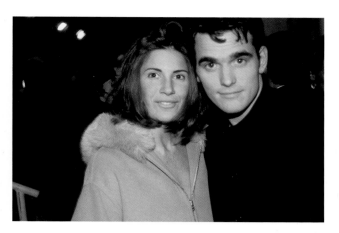

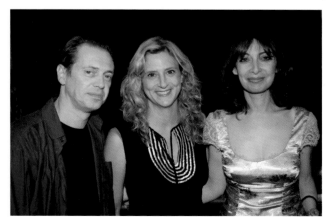

From top, left to right:
Hilary Swank at the Narciso Rodriguez show, February 2003
Elizabeth Saltzman and Matt Dillon at the Todd Oldham show, October 1995
Moby backstage at the Jill Stuart show, April 1998
Marisa Tomei at the DKNY show, April 1995
Molly Ringwald and Elsa Klensch at the Tommy Hilfiger show, September 2002
Steve Buscemi, Nanette Lepore, and Ileana Douglas at the Nanette Lepore show, September 2003

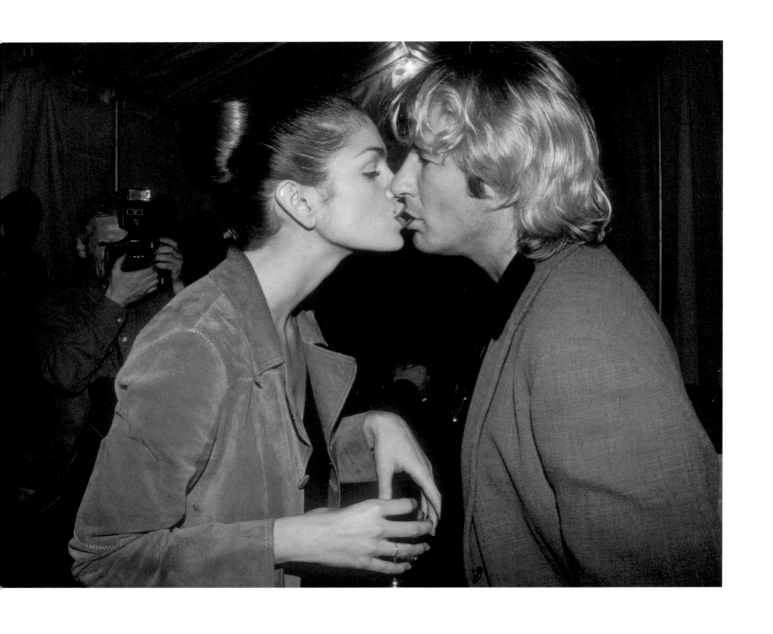

Cindy Crawford and Richard Gere at the Isaac Mizrahi show, April 1994

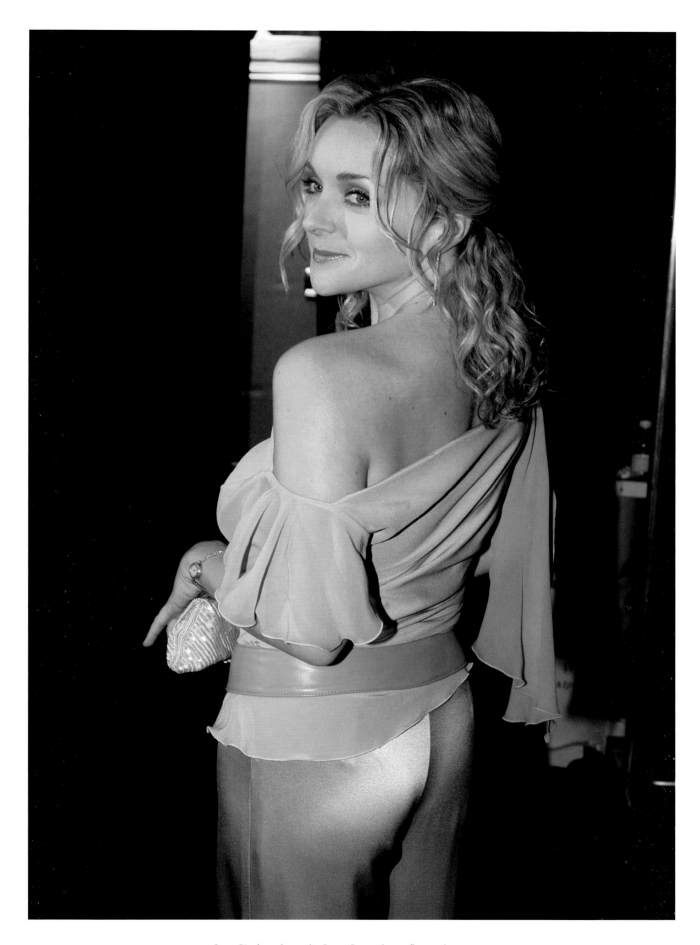

Jane Krakowski at the Luca Luca show, September 2002

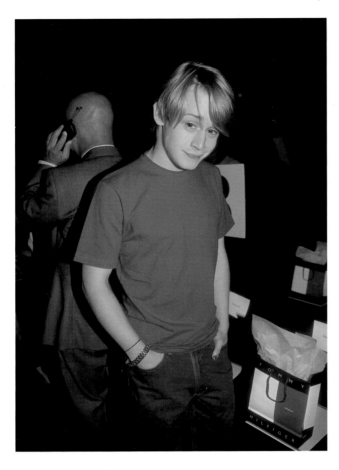
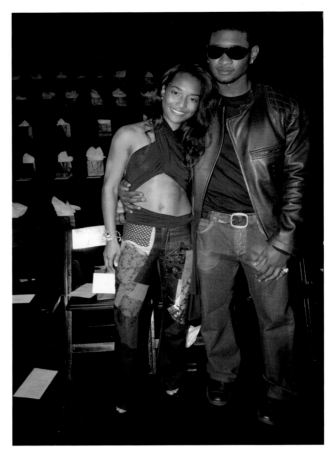
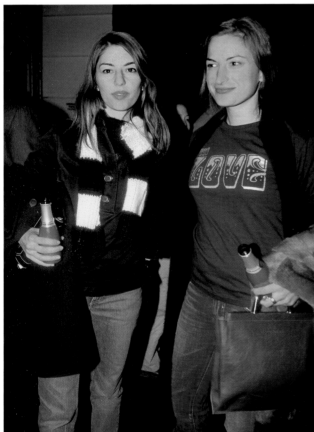

From top, left to right:
Macaulay Culkin at the Tommy Hilfiger show, September 2001
Chili and Usher at the Kenneth Cole show, September 2002
Sofia Coppola and Zoe Cassavetes at the Anna Sui show, February 2002
Leonardo DiCaprio at the Maria Snyder show, April 1994

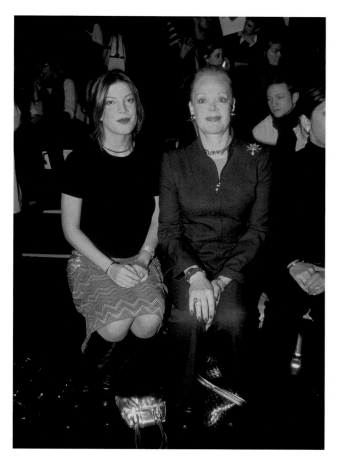

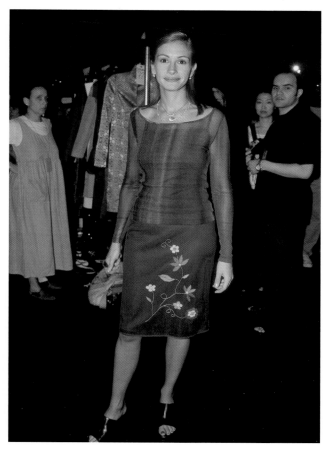

From top, left to right:
Tori and Candy Spelling at the Badgley Mischka show, February 2001
Julia Roberts at the Vivienne Tam show, March 1998
Rikki Lake and Rob Sussman at the Todd Oldham show, October 1994
Max Azria and Sarah Michelle Gellar at the BCBG Max Azria show, September 2003

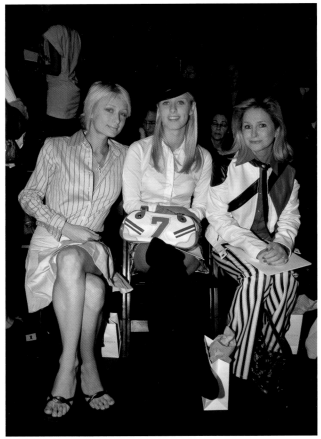

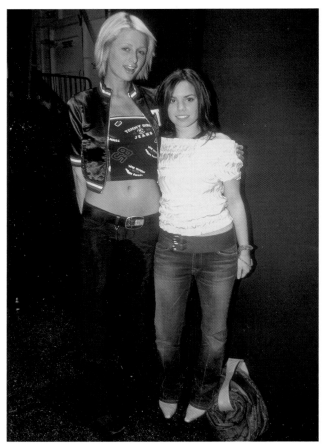

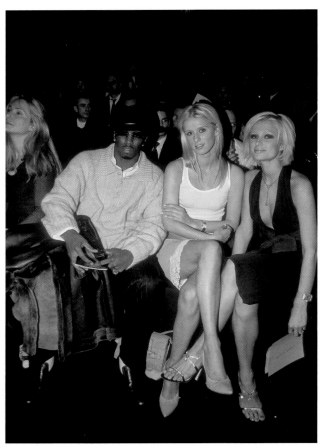

From top, left to right:
Nicky and Paris Hilton with Candace Bushnell at the Luca Luca show, September 2002
Paris, Nicky, and Kathy Hilton at the Tommy Hilfiger show, September 2002
Paris Hilton and Ally Hilfiger at the Tommy Hilfiger show, February 2002
Sean Combs with Nicky and Paris Hilton at the Luca Luca show, February 2002

From top, left to right:
Sarah Jessica Parker and Kristen Davis at the Oscar de la Renta show, February 2000
Cynthia Nixon and Bebe Neuwirth at the Badgley Mischka show, September 2003
Kim Cattrall and Darren Star at the House of Field show, September 2001
Pat Field and Rebecca Weinberg at the JOOP! show, February 2001

I'VE FORMED LASTING FRIENDSHIPS WHILE WAITING FOR CAROLINA HERRERA'S SHOWS TO START. SHE SEATS HER AUDIENCES AS IF THEY WERE AT A DINNER PARTY — MIXING AND BLENDING WITH THE SKILL OF A GREAT HOSTESS. AND CAROLINA'S THE ONLY ONE WHO PLACES SOCIAL STARS IN THE THIRD AND FOURTH ROWS.

AMY FINE COLLINS

DEAR PATRICK — HE GREETS YOU WITH THAT WONDERFUL "BEST PARTY IN TOWN" SMILE AND MAKES EVERYONE FEEL SO ENTHUSIASTIC AND HAPPY TO BE AT THE TENTS.

ANNE K. SLATER

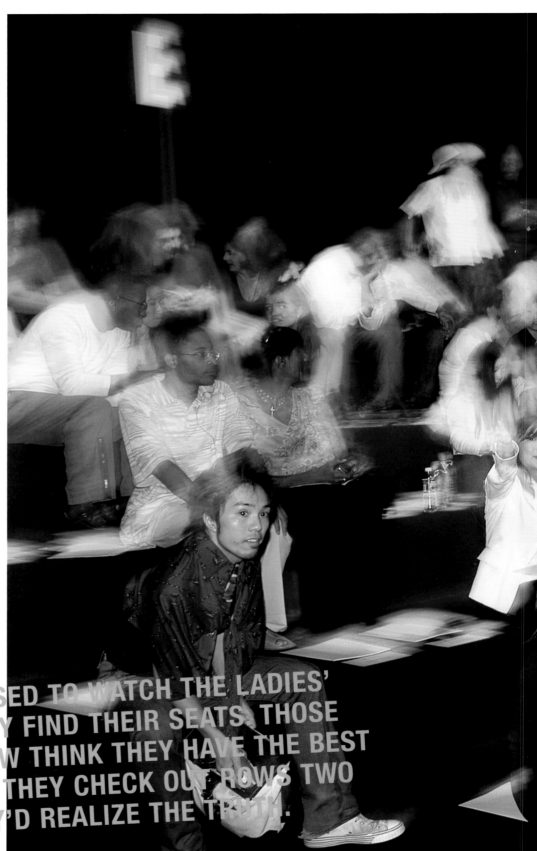

I'M ALWAYS AMUSED TO WATCH THE LADIES'
FACES WHEN THEY FIND THEIR SEATS. THOSE
IN THE FRONT ROW THINK THEY HAVE THE BEST
SEATS — BUT, IF THEY CHECK OUT ROWS TWO
AND THREE, THEY'D REALIZE THE TRUTH.

KENNETH JAY LANE

The crowd at the Diesel StyleLab show, September 2002

THE SHOWS ARE A FEEDING FRENZY....
WHO SAID THE CASTE SYSTEM WAS DEAD?
SAMANTHA BOARDMAN

The crowd at the Diesel StyleLab show, September 2002

Bill Cunningham at the Liza Bruce show, April 1994

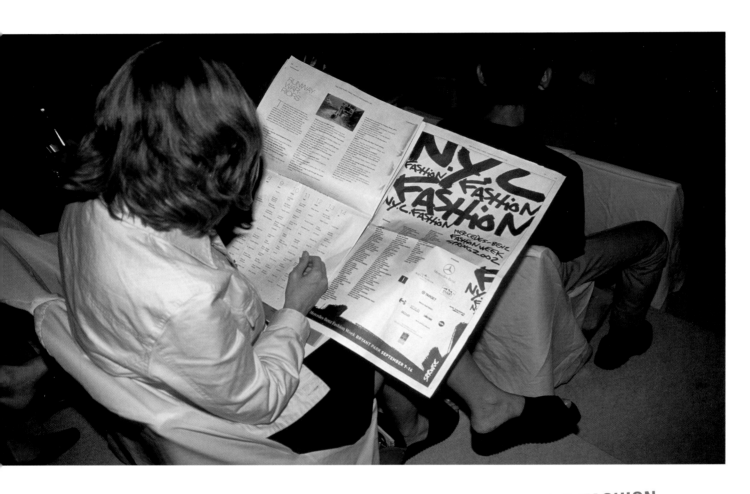

THE TENTS CREATED A FASHION SCENE IN NEW YORK. A FASHION, CELEBRITY, ANIMATED MINUTE THAT SWEEPS THROUGH NEW YORK CITY TWO TIMES A YEAR. IT'S ANOTHER FANTASTIC INGREDIENT IN THE RECIPE OF THE GREATEST CITY IN THE UNIVERSE.

PATRICIA FIELD

Reading The New York Times before the Gene Meyer show, September 2001

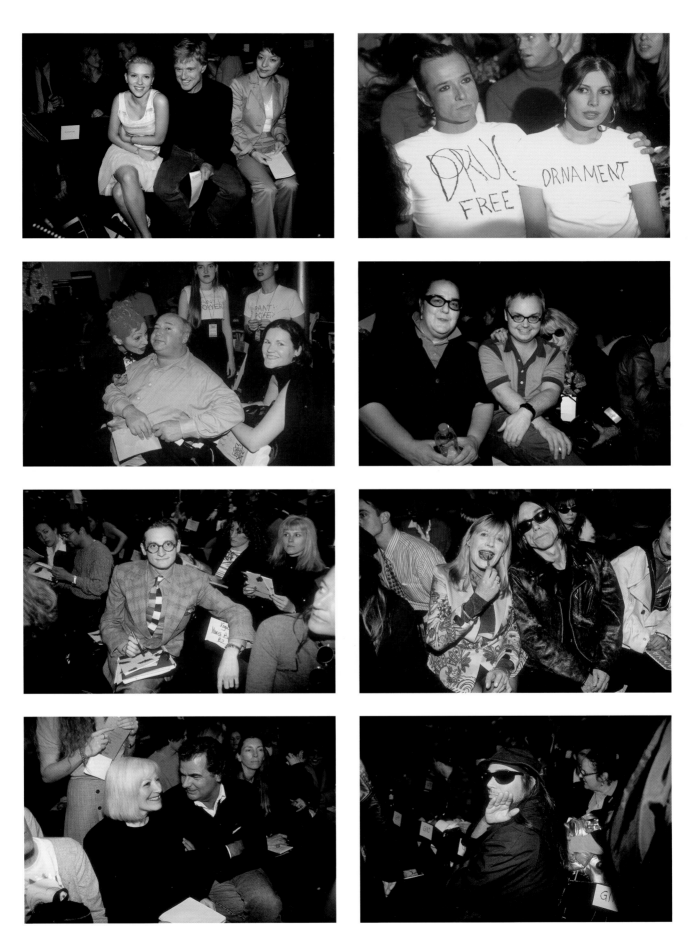

From top, left to right: Scarlett Johansson, Robert Redford, and Lily Scaggars at the Kenneth Cole show, September 2003
Scott Weiland and Mary Forsberg at the Anna Sui show, February 2000
Pat Field, Kal Ruttenstein, and Kim Koshol at the Betsey Johnson show, October 1994
Kim Hastreiter, Mickey Boardman, and Caroline Torem Craig at the Diesel StyleLab show, September 2003
Hamish Bowles at the Ghost show, April 1994
Marianne Faithfull and Iggy Pop at the Anna Sui show, April 1995
Liz Tilberis and Patrick Demarchlier at the Anna Sui show, April 1994
Steven Meisel at the Anna Sui show, November 1994

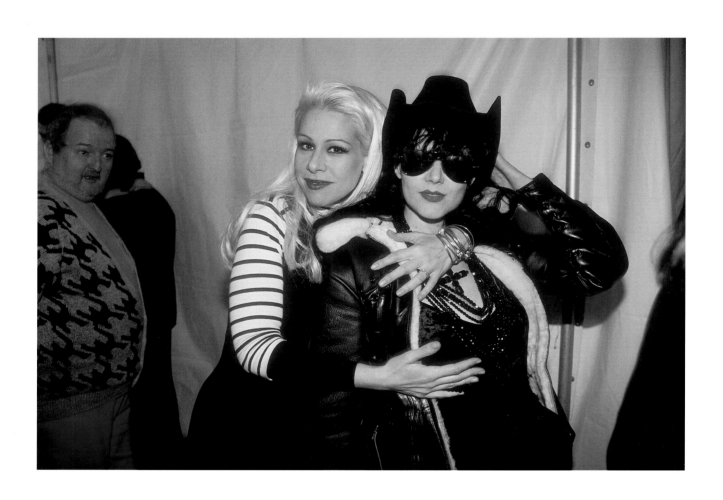

Dianne Brill and Suzanne Bartsch at the Todd Oldham show, April 1994

I LOOK FORWARD TO WHEN THE FASHION CIRCUS COMES TO TOWN — 7TH ON SIXTH IS THE BEGINNING OF THE HALF-YEAR FASHION CYCLE AROUND THE WORLD — AND PATRICK IS ALWAYS THERE BEHIND THE SCENES AS MASTER OF CEREMONIES.

JOHN DEMSEY

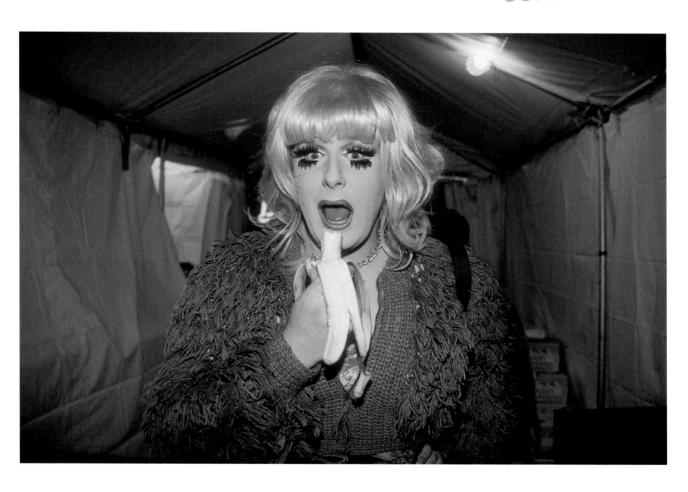

Lady Bunny at the Todd Oldham show, October 1994

From top, left to right:
Tyson Beckford and Robin Givhan at the Diesel StyleLab show, September 2002
Carolina Herrera, Jr. and Salma Hayek at the Carolina Herrera show, September 2003
Nas and Kelis at the Baby Phat show, September 2003
Damon Dash and Lizzie Grubman at the Alice Roi show, February 2003

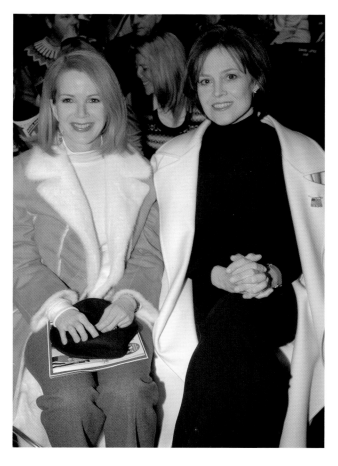
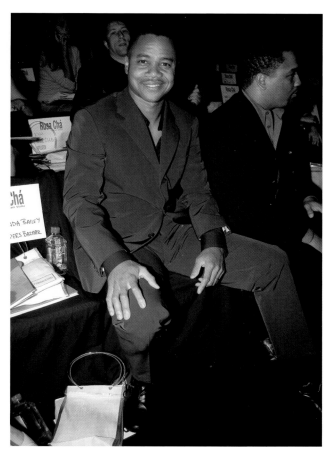

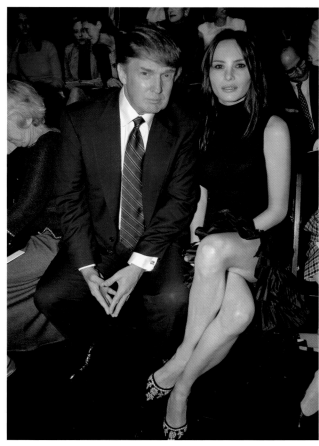

From top, left to right:
Blaine Trump and Sigourney Weaver at the Michael Kors show, February 2003
Cuba Gooding, Jr. at the Rosa Cha by Amir Slama show, September 2003
Mario Cantone at the Diesel StyleLab show, September 2003
Donald Trump and Melania Knauss at the Oscar de la Renta show, September 2002

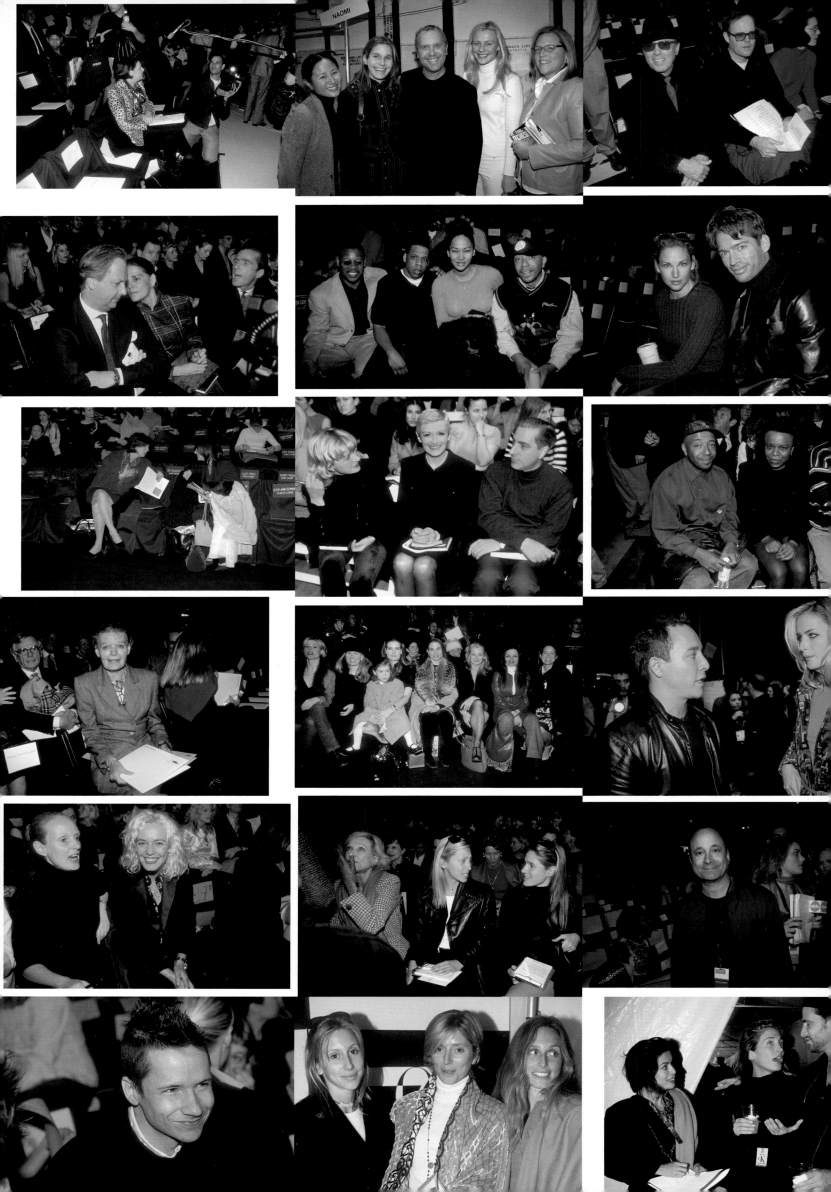

THE TENTS ARE AN EXCELLENT MIX OF A SOCIETY BLACK TIE PARTY AND THE OSCARS.

MARJORIE GUBELMANN RAEIN

From top, left to right:
Suzy Menkes at the Oscar de la Renta show, April 1998
Lillian von Stauffenberg, Aerin Lauder, Michael Kors, Renee Rockefeller, and Marjorie Gubelman Raein at
the Michael Kors show, February 2003
Francesco Scavullo and Sean Byrnes at the Tommy Hilfiger show, February 1996
Graydon Carter and Ali McGraw at the Ralph Lauren show, November 1995
Andre Harrell, Jay-Z, Kimora Lee Simmons, and Russell Simmons at the Sean John show, February 2000
Jill Goodacre and Harry Connick, Jr. at the Tommy Hilfiger show, February 2000
Pamela Fiori and Bonnie Fuller at the Michael Kors show, February 2003
Sarajane Hoare, Liz Tilberis, and Paul Cavaco at the Todd Oldham show, March 1996
Russell Simmons and Teri Agins at the Victor Alfaro show, April 1995
Chessy Rayner at the Carolina Herrera show, November 1997
Julie Bowen, Julie Frist, and Jennifer Creel and her daughter with Whitney Fairchild, Debbie Bancroft, Rena Sindi, and
Helen Lee Schifter at the Badgley Mischka show, February 2001
Victor Alfaro and Georgina Grenville at the Victor Alfaro show, February 2000
Grace Coddington and Ellen von Unwerth at the Anna Sui show, November 1995
Alexandra von Furstenberg and Aerin Lauder at the Donna Karan show, April 1997
Ross Bleckner at the Carolina Herrera show, September 2002
John Cameron Mitchell at the Gen Art show, February 2002
Alexandra von Furstenberg, Princess Marie Chantal of Greece, and Pia Getty at the Anna Sui show, April 1994
Bianca Jagger, Carolyn Bessette, and John Enos at the Calvin Klein show, April 1994

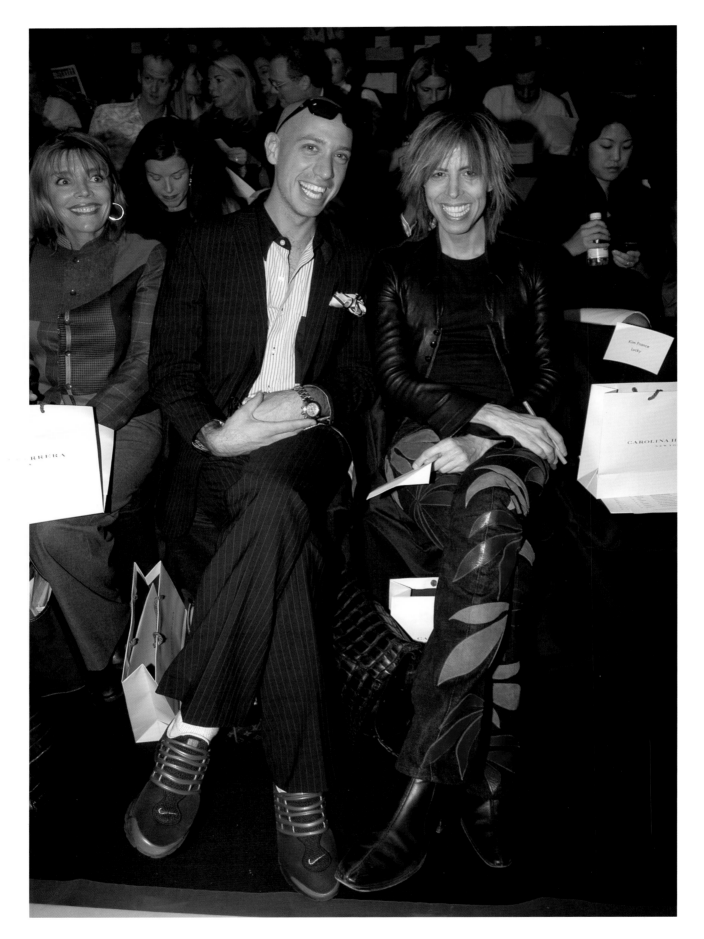

Judy Licht, Robert Verdi and Steven Cojocaru at the Carolina Herrera show, September 2002

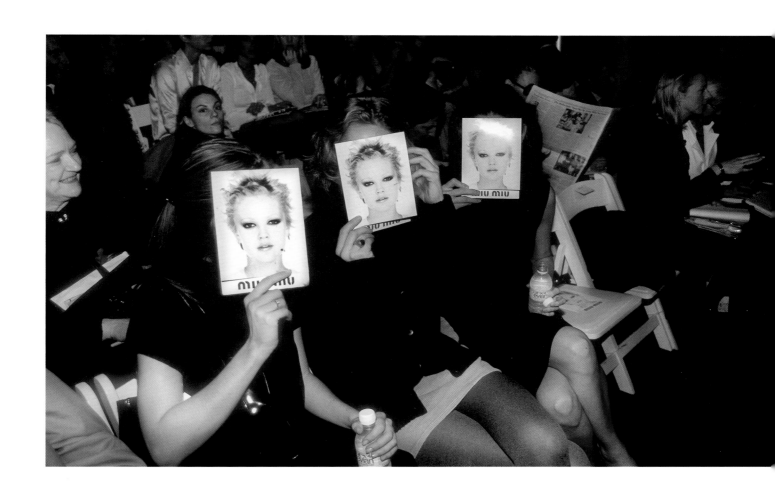

Drew Barrymore masks at the Miu Miu show, November 1995

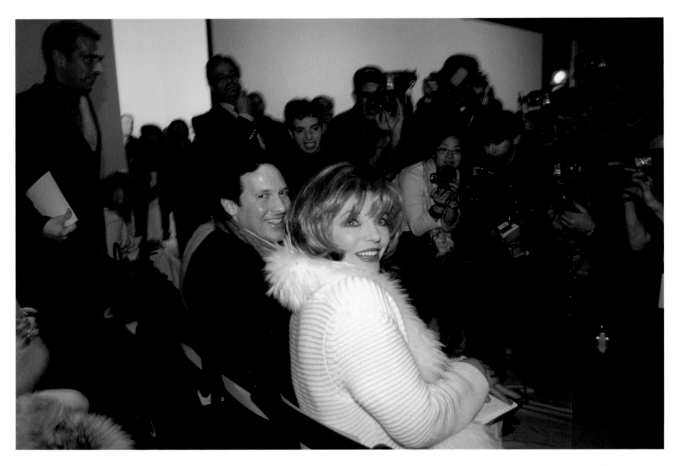

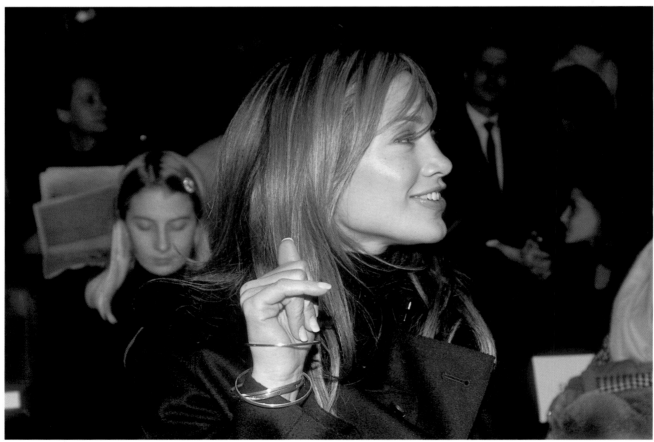

Percy Gibson and Joan Collins at the Oscar de la Renta show, February 2003
Jennifer Lopez at the Randolph Duke show, February 1999

From top, left to right: Charlie Rose and Amanda Burden at the Ralph Lauren show, April 1994

Pat Buckley, Nan Kempner, and Casey Ribicoff at the Bill Blass show, October 1996

Mia, Steven, and Chelsea Tyler at the Betsey Johnson show, November 1994

Kal Ruttenstein and Michael Gould at the Ralph Lauren show, April 1994

Tom Florio and Ron Galotti at the BCBG Max Azria show, July 1999

Eleanor Lambert at the Carolina Herrera show, September 1999

Judy Licht at the Carolina Herrera show, February 2000

Chris Cuomo, Kenneth Cole, and John F. Kennedy, Jr. at the Kenneth Cole show, February 1998

I ENJOY THE COLLECTIONS HERE IN NEW YORK UNDER THE TENTS MORE THAN I ENJOY THE COLLECTIONS IN PARIS. IT'S SOMETHING I ALWAYS LOOK FORWARD TO, AND I'M NEVER DISAPPOINTED.

DONALD J. TRUMP

From top, left to right:
Guy O'Seary and Anthony Kiedis at the Marc Jacobs show, February 2002
Kate Betts at the Kenneth Cole show, September 2003
John Demsey at the Tuleh show, September 2003
Stan Herman and Peter Arnold at Luca Luca, February 2003
Jaqui Lividini at the Peter Som show, September 2003
Grace Coddington, Tonne Goodman, and Sally Singer at the Michael Kors show, September 2003
Jane and Aerin Lauder with Mario Testino at the Michael Kors show, September 2003
Gigi Mortimer and Jennifer Creel at the Carolina Herrera show, February 2003
Jeff Slonim outside the Tents before the Luca Luca show, September 2002
Kelly Klein at the Jill Stuart show, September 2000
Richard Buckley and Carine Roitfeld at Michael Kors show, February 2002
Jennifer Lopez at the Badgley Mischka show, April 1998
Hamish Bowles and Suzy Menkes at the Lacoste show, September 2003
Dawn Mello at the Tuleh show, September 2003
Cindy Weber Cleary and Charla Lawhon at the Kenneth Cole show, September 2003
Elsa Klensch at the Ralph Lauren show, February 2001

From top, left to right: Aerin Lauder, Jane Lauder, Rena Sindi, Serena Boardman, Helen Lee Schifter, and
Lisa Airan at the Oscar de la Renta show, September 2002
Cece Cord, Debbie Bancroft, Samantha Gregory, and Jamee Gregory at the Badgley Mischka show, September 2003
Anna Wintour, Anne McNally, and Elizabeth Saltzman at the Anne Klein show, February 2003
Jennifer Creel, Fernanda Niven, Julie Frist, Emila Fanjul Pfeifler, Helen Lawson, Jane Lauder, and
Serena Boardman at the Oscar de la Renta show, February 2003
Samantha and Serena Boardman, Cece Cord, Brook de Ocampo, Nina Griscom, and Jamee Gregory at the
Michael Kors show, September 2000

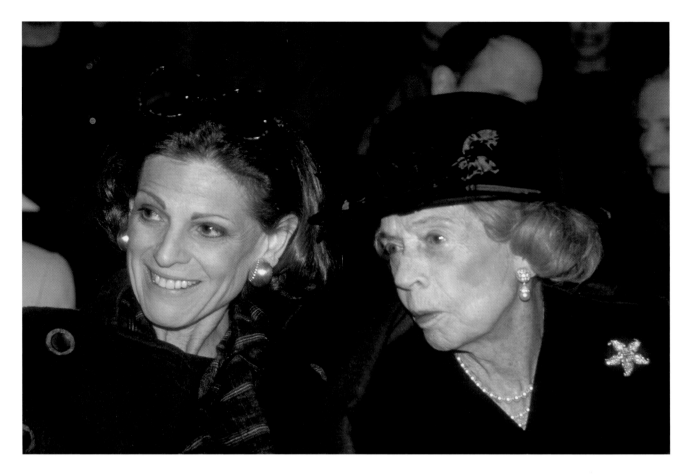

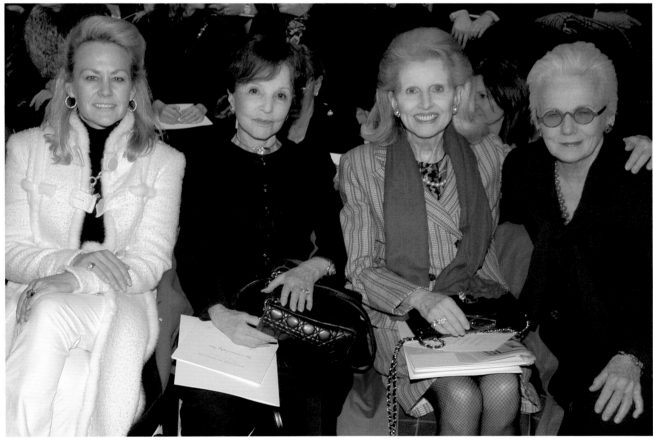

Page 246 continued: Patrick Demarchelier, Glenda Bailey, Kerry Diamond, Mary Alice Stephenson, and Brana Wolf at the Anna Sui show, September 2002
Phillip Bloch, Jane Krakowski, Deborah Gibson, and Esther Canadas at the Luca Luca show, February 2003
Melania Knauss, Shoshana Gruss, Cornelia Guest, Kelly Klein, and Blaine Trump at the Badgley Mischka show, September 2003

This page:
Annette de la Renta and Brooke Astor at the Oscar de la Renta show, April 1997
Muffie Potter Aston, Lee Thaw, Judy Peabody, and Helen O'Hagan at the Oscar de la Renta show, February 2003

The Strokes' Julian Casablancas and Albert Hammond, Jr. at the Anna Sui show, February 2003

AT THE TENTS THE PULSE OF FASHION IS AT FEVER TEMPERATURE! EDITORS WAIT, CAMERAS GEAR-UP, MODELS GET ONE LAST GLOSS AND PRESTO — A NEW LOOK WALKS!

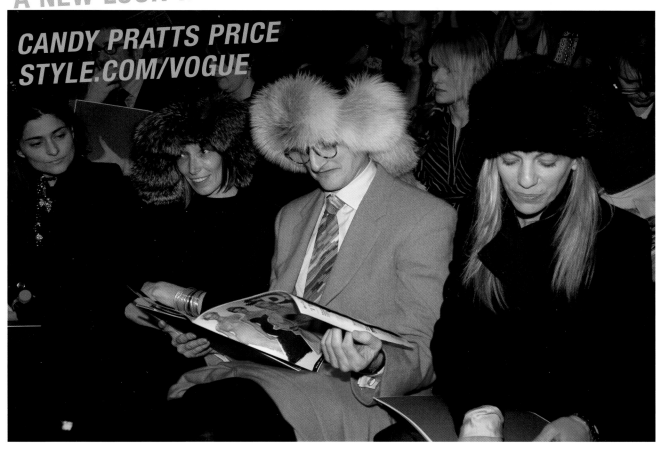

CANDY PRATTS PRICE
STYLE.COM/VOGUE

Michelle Sanders, Camilla Nickerson, Hamish Bowles, and Virginia Smith at the Michael Kors show, February 2003

From top, left to right:
Cornelia Guest and Kelly Klein at the Badgley Mischka show, September 2000
Atoosa Rubenstein at the Chaiken show, February 2003
Linda Wells at the Michael Kors show, September 2002
Ivana Trump and Rossano Rubicondi at the Oscar de la Renta show, September 2002

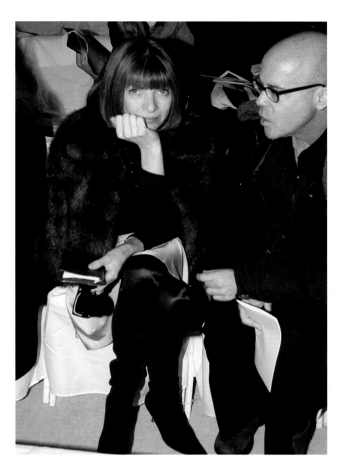
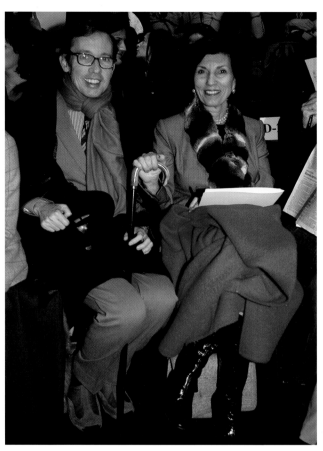
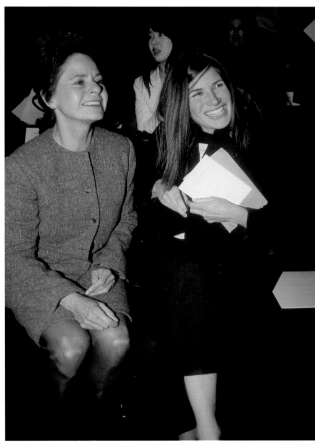
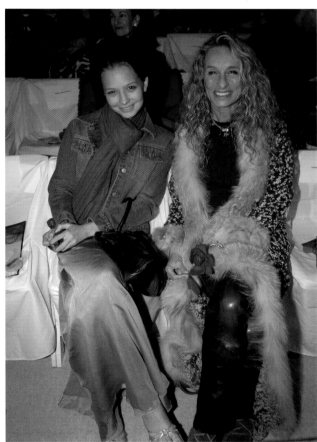

From top, left to right:
Anna Wintour and Billy Norwich at the Behnaz Sarafpour show, February 2003
Michael Cannon and Pamela Fiori at the Bill Blass show, February 2003
Ellin and Elizabeth Saltzman at the Carolina Herrera show, February 2001
Annabelle and Ann Dexter Jones at the Anand Jon show, February 2003

IT FEELS LIKE A LIFETIME AGO THAT PATRICK MCMULLAN FIRST INVITED ME WITH HIM BACKSTAGE AT THE TENTS IN BRYANT PARK. OVER A DECADE, THE CURVY 1980S SUPERMODELS WERE QUICKLY REPLACED BY THE WAIF/GRUNGE GENERATION, WHO WERE LATER JOINED BY GISELE BUNDCHEN AND THE VOLUPTUOUS BRAZILIANS. THE BELGIANS WERE FOLLOWED BY THE EASTERN EUROPEANS — CAGEY, LITHE CARMEN KASS, WHO HAS A KILLER HIPS-OUT WALK, AND MORE RECENTLY, EUGENIA AND THE HAUGHTY, PALE RUSSIANS.

EVERY SEASON, FOURTEEN HOURS A DAY, GLASS-FRONTED FRIDGES WERE STOCKED WITH FLAT WATER IN PLASTIC BOTTLES AND FOLDING TABLES WERE STACKED WITH KRISPY KREME DONUTS OR CIPRIANI BELLINI AND BISCOTTI. AND THE MODELS CHAIN-SMOKED TO STAY THIN.

BEFORE A MARC JACOBS SHOW, I ONCE ACCIDENTALLY STOOD NEXT TO KATE MOSS WHEN SHE WHIPPED A SLIP DRESS OVER HER HEAD. SHE STOOD AS CLOSE AS IF WE WERE IN LINE FOR THE SAME PHONE BOOTH, EXCEPT THAT THE WAIF WAS BUCK-NAKED. THERE WAS NO ESCAPING HER FIERY PERFECTION. MID-INTERVIEW WITH GISELLE, GOD BLESS HER, THE SUPERMODEL WHO WAS THEN DATING LEONARDO DICAPRIO, DRAGGED ME WITH HER DOWN A CANVAS PASSAGE AND ASKED ME TO WAIT FOR HER AS SHE ENTERED A PORTO-SAN.

AT EACH SHOW, ABOUT TEN MINUTES BEFORE THE SECURITY GUARDS PULL THE CLEAR PLASTIC SHEATH OVER THE RUNWAY (WHICH KEEPS IT SPOTLESS), PATRICK AND I STEP OUT FROM THE BACK OF THE HOUSE TO CHAT WITH BORED CELEBS. WE'VE ENCOUNTERED REDFORD, DE NIRO, SOPHIA LOREN, JULIA ROBERTS, WYNONA RYDER, ED BURNS WHEN HE WAS STILL SINGLE ENOUGH TO HIT ON THE MODELS. LAST SEASON, BEYONCÉ'S DOUBLE-WIDE BODYGUARD HAD HANDS THE SIZE OF CANNED HAMS.

THE STYLE PARADE APPEARS EFFORTLESS ON TV, BUT OUR EXHAUSTION ACCUMULATES. OUR FEET ACHE WHEN DAY FOUR BEGINS AT 8:00 A.M., MELTS INTO 4:00 A.M., AND THE YOUNG GENERATION OF MODELS ARE SWINGING FROM POTTED PALM TREES AT BUNGALOW 8.

BUT IT WAS THE WEEK OF 9/11/2001 THAT WILL ALWAYS HAUNT FASHIONISTAS.

FOR THE LAST SHOW ON 9/10, MARC JACOBS HAD BUILT A PLASTIC TENT WITH VIEWS OF THE TWIN TOWERS. TRUCKS CARRYING THE CLOTHES ARRIVED OVER AN HOUR LATE. UNDER THE CLOSE TENT, CHEEK TO CHEEK ON THE RISERS, THE FASHION WORLD SWELTERED AND WAITED FOR THE SHOW.

THE NEXT MORNING WE WOKE TO NEWS OF THE TRADE CENTER ATTACKS. REPLACING THE BLUR OF EPHEMERAL BEAUTY THAT IS FASHION WEEK, THE SMUG SELF-IMPORTANCE, THE RACING, THE RUSHING, AND FASHION DRAMA (A PAIR OF ESSENTIAL STILETTO HEELS GO MISSING), A GUT-WRENCHING QUIET ENSUED.

UNUSED, THE TENTS IN BRYANT PARK WERE EVENTUALLY DISMANTLED.

JEFFREY SLONIM

Carrie Donovan at the Versace show, October 1995

André Leon Talley at the Bill Blass show, February 2002

From top, left to right:
Bethann Hardison and Fern Mallis at the Ralph Lauren show, April 1994
James LaForce and Cathy Horyn at the Perry Ellis show, September 2003
Kal Ruttenstein at the Calvin Klein show, April 1994
Lynn Yaeger at the Betsey Johnson show, September 2003
Polly Mellen at the Douglas Hannant show, September 2002
Liz Rohaytan and Bill Blass at the Bill Blass show, April 1997

From top, left to right:
Sandy Brant and Ingrid Sischy at the Michael Kors show, February 2003
Madeline Weeks and Jim Moore of GQ at the Lacoste show, September 2003
George Wayne and Liya Kebede at the Baby Phat show, September 2003
Joan Kaner at the Carolina Herrera show, February 2003

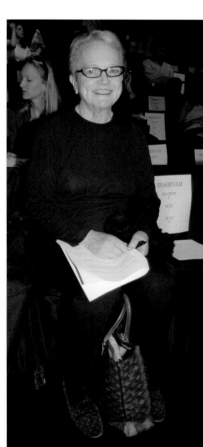

From top, left to right:
Ruth Finley and Bernadine Morris at the Tents, September 2001
Mary Alice Stephenson at the Baby Phat show, September 2003
Fran Lebowitz outside of the Calvin Klein show, April 1995
Pat Buckley and Kenneth Jay Lane at the Tents, April 1998
Marylou Luther at the Carmen Marc Valvo show, September 2002
Stefano Tonchi and Amy Spindler at the Ralph Lauren show, November 1998

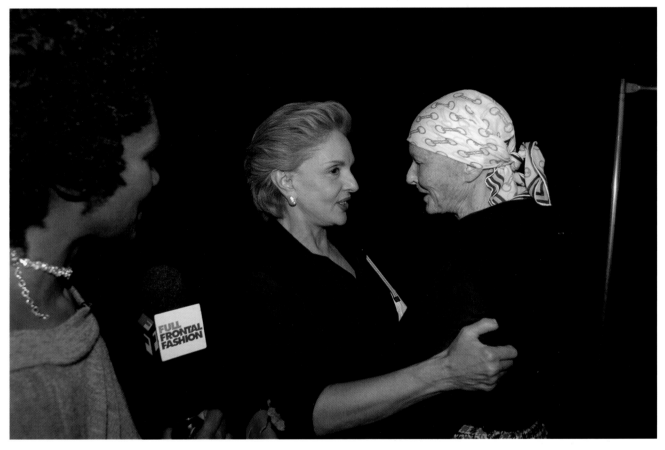

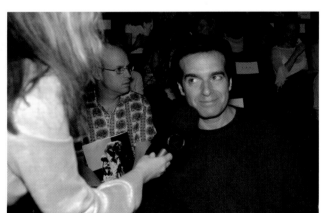

From top, left to right:
Matthew Williamson being interviewed at the Matthew Williamson show, September 2002
Naomi Campbell being interviewed by Nicky Hilton at the Luca Luca show, February 2003
Constance White, Carolina Herrera, and C.Z. Guest at the Carolina Herrera show, September 2002
Jeanne Beker interviewing Ralph Lauren at his show, April 1994
David Copperfield being interviewed at the Carlos Miele show, September 2002

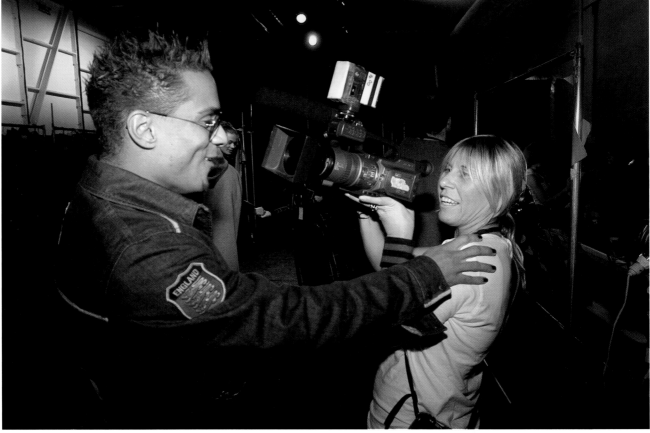

Lloyd Klein and Lauren Ezersky at the W Hotel's Green Room inside of the Bryant Park Tents, September 2003
Jive Jones and Mills at the Anand Jon show, February 2003

BILL BLASS' SPRING 2000 SHOW WAS A SPECTACULAR SWAN SONG. IT WAS SOMEWHAT POIGNANT THAT THE RAIN POURED DOWN OUTSIDE THE BRYANT PARK TENT WHERE HE PRESENTED HIS FINAL COLLECTION. INSIDE, WE WERE ALL COZY AND ENCHANTED BY THE RAZZMATAZZ HE GAVE US: HOT, DAZZLING, PRETTY CLOTHES THAT MADE US REALIZE HOW MUCH HE WAS GOING TO BE MISSED.

BACKSTAGE, BLASS FINALLY ADMITTED TO ME THAT HE'D DECIDED "NOT TO HANG IN ANYMORE." HE WANTED TO SPEND MORE TIME IN THE COUNTRY. "AND WHAT HAS A LIFE IN FASHION GIVEN YOU, IN THE END?" I ASKED. "A GREAT DEAL OF SATISFACTION," HE ANSWERED.

"WHAT DID HE TELL YOU?" BLASS' LOVELY ASSISTANT, YVONNE, ASKED WHEN SHE SAW ME WRAP MY INTERVIEW.

"HE SAID THIS WOULD BE HIS FINAL COLLECTION," I TOLD HER.

"REALLY? YOU MEAN HE ACTUALLY SAID THAT, ON THE RECORD? YOU KNOW, HE HASN'T REALLY ANNOUNCED ANYTHING OFFICIAL JUST YET. YOU'RE THE FIRST ONE HE'S TOLD."

"YEAH, WELL, I'M FLATTERED I'D BE THE ONE HE'D TELL FIRST," I TOLD HER.

"GOD — HE'LL BE MISSED SO MUCH."

TEARS WELLED UP IN YVONNE'S EYES. SHE TOOK OFF TO A CORNER AND WEPT, SAD, AS WE ALL WERE, THAT BILL BLASS HAD DECIDED TO BOW OUT BEFORE THE NEW MILLENNIUM GOT UNDERWAY.

JEANNE BEKER

Bill Blass, Karen Elson, and Kylie Bax at his show, April 1998

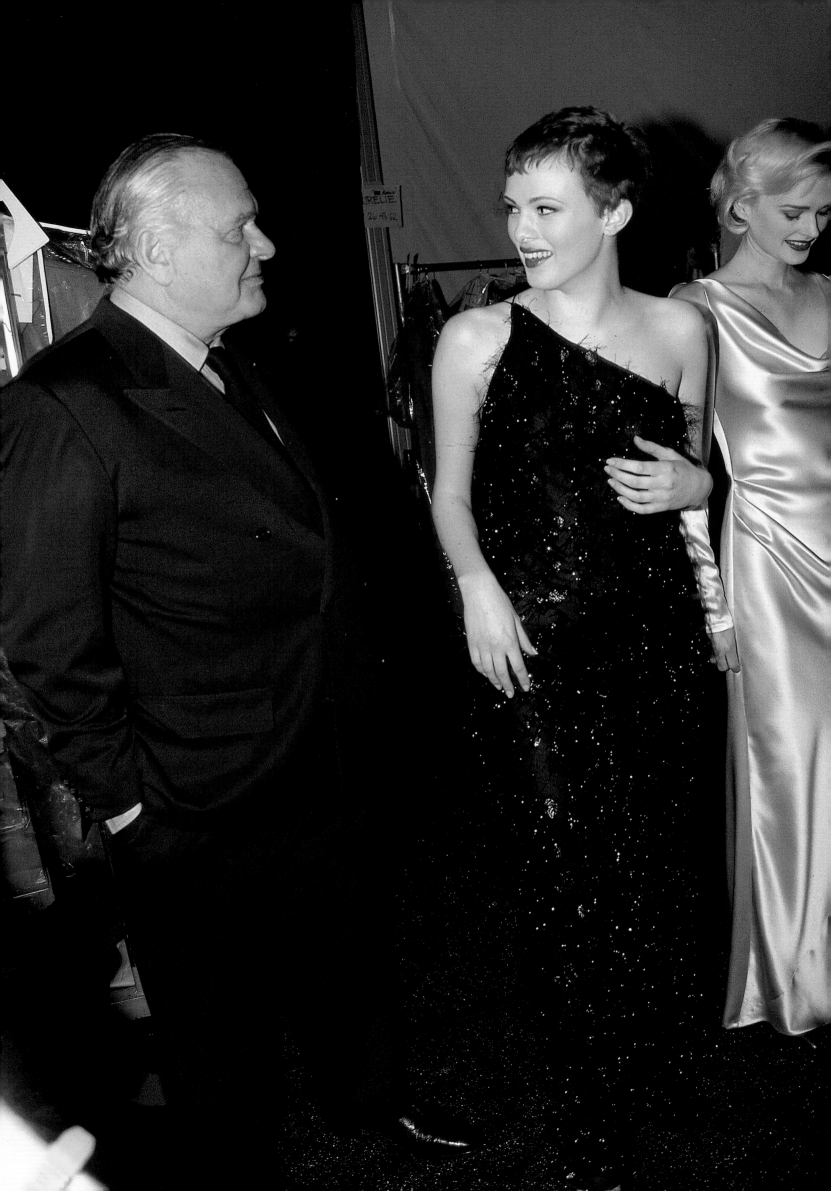

AT THE TAIL END OF THE SUPERMODEL ERA, I CHOSE TO USE UP-AND-COMING YOUNG ACTRESSES ON THE RUNWAY. WE MUST HAVE MET THIRTY OR MORE GIRLS WITH PROMISING CAREERS — SOME LOOKED LIKE MODELS AND THE OTHERS HOPEFULLY HAD INCREDIBLE TALENT!! I NEVER WOULD HAVE IMAGINED THE SUCCESS OF THE ACTRESSES I FINALLY CHOSE; EACH ONE OF THEM ACHIEVED SOME KIND OF FAME IN THEIR OWN RIGHT. THE LIST INCLUDED JILL HENNESSY, MINNIE DRIVER, REBECCA GAYHEART, GINA GERSHON, GRETCHEN MOL, KATIE HEIGL, RACHEL YORK, AND MAXINE BAHNS.

NICOLE MILLER

Last minute checking at the Nicole Miller show, March 1998

Carmen Marc Valvo at the Carmen Marc Valvo show, September 2002

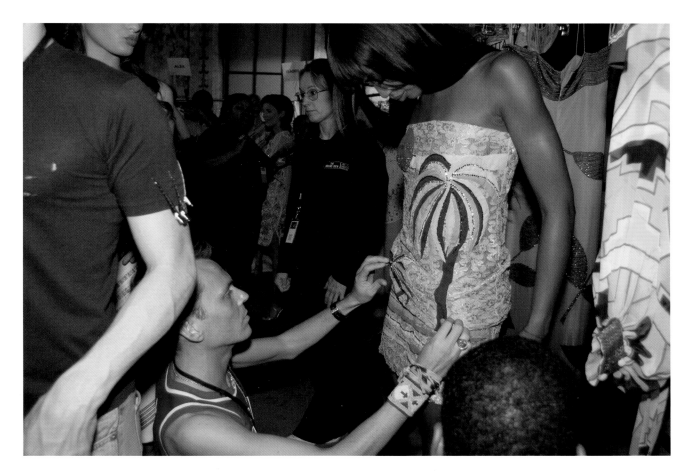

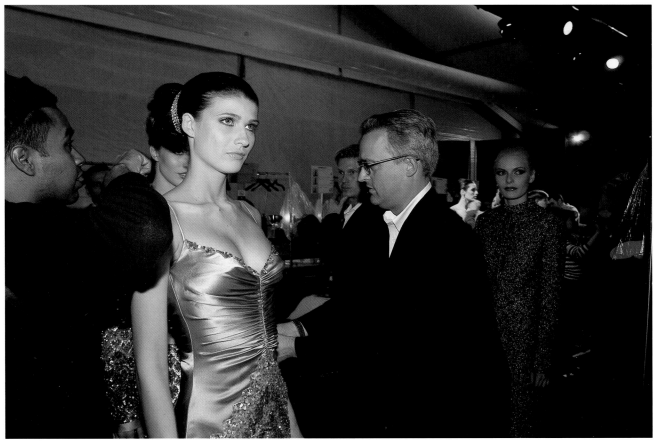

Matthew Williamson making last minute changes to Naomi Campbell's look before his show, September 2002
Mark Badgley adjusting a look at the Badgley Mischka show, February 2003

Todd Oldham making final changes to models' looks at his show, October 1995

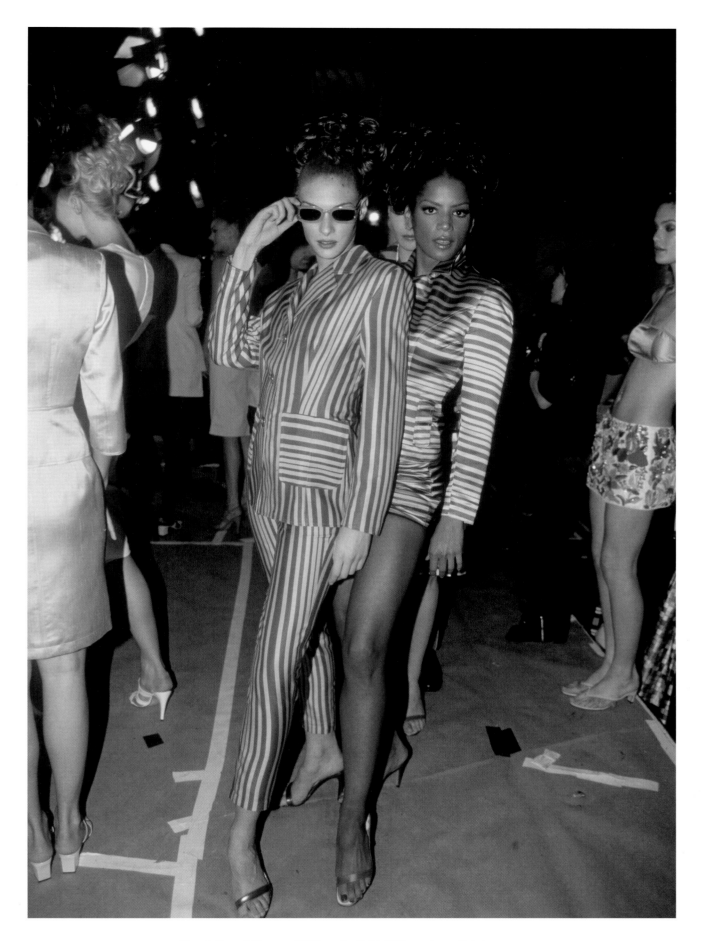

Chrystelle and Veronica Webb at the Todd Oldham show, October 1995

Backstage at the Anand Jon show, September 2000

AFTER 39 YEARS OF DESIGNING
COLLECTIONS I STILL GET NERVOUS
RIGHT BEFORE A SHOW. THE ELECTRICITY
AND EXCITEMENT IN THE TENTS IS
ABSOLUTELY AMAZING.

OSCAR DE LA RENTA

From top, left to right:
Naomi Campbell and Todd Oldham at his show, April 1994
Mark Badgley and James Mischka at the Badgley Mischka show, April 1995
Joseph Abboud at his show, July 1995
Douglas Hannant and Marylou Luther at the Douglas Hannant show, September 2002
John Bartlett and models at his show, September 2000
Johan Lindeberg at the J. Lindeberg show, February 2002
Georgina Grenville, Bill Blass, and Chandra North at the Bill Blass show, April 1997
Isaac Mizrahi and models with his mask on at the Isaac Mizrahi show, October 1996
Yeohlee with models at her show, October 1995
Betsey Bloomingdale and Oscar de la Renta at his show, April 1994
B. Michael with models at the B. Michael show, February 2002
Rose Marie Bravo and Randolph Duke at the Halston by Randolph Duke show, April 1997
Matthew Williamson at his show, February 2002
Kate Moss and designer Nicole Miller at her show, October 1994
John Varvatos at his show, September 2000
Joan Vass at her show, April 1998
Zang Toi, Geisha model, and Lora Samoza at the Zang Toi show, February 2003
Calvin Klein at his show, April 1995

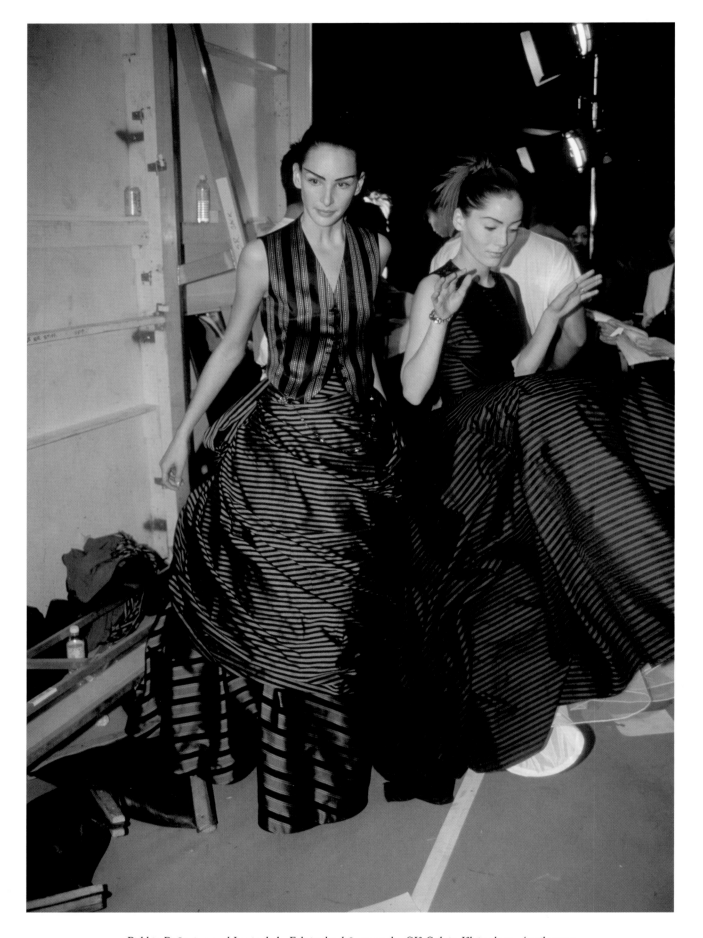

Debbie Deitering and Lucie de la Falaise backstage at the CK Calvin Klein show, April 1995

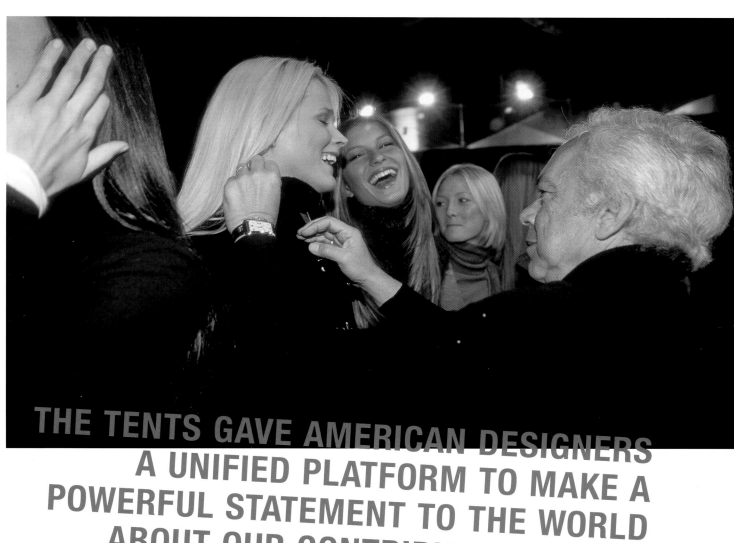

THE TENTS GAVE AMERICAN DESIGNERS A UNIFIED PLATFORM TO MAKE A POWERFUL STATEMENT TO THE WORLD ABOUT OUR CONTRIBUTION TO THE WORLD OF FASHION.

RALPH LAUREN

Carmen Kass, Gisele Bundchen, and Maggie Rizer getting fixed up by Ralph Lauren at his show, February 2000

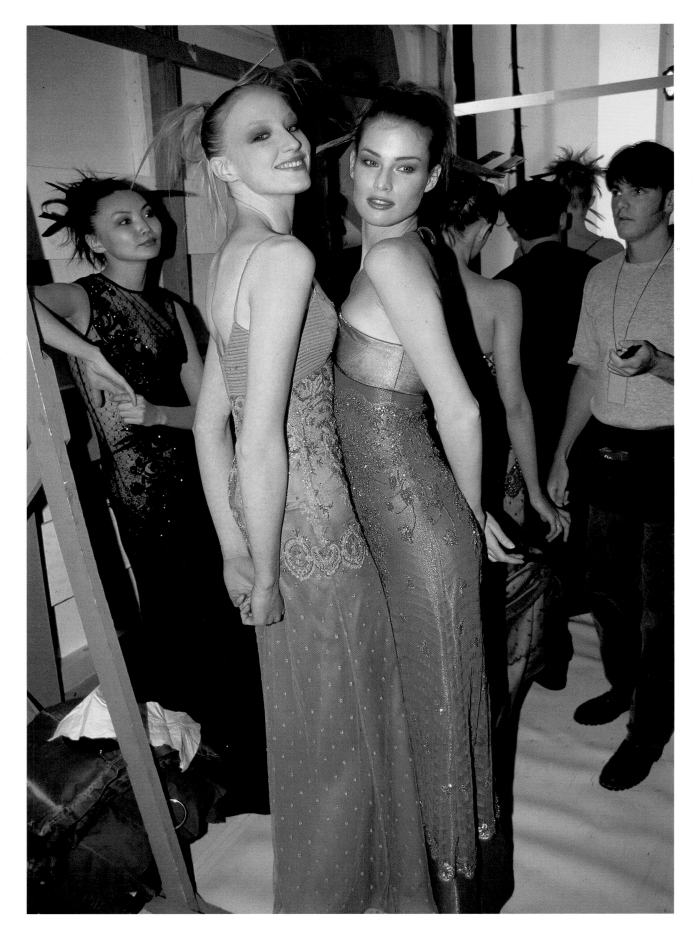

Jade Parfitt and Meghan Douglas at the Badgley Mischka show, April 1995

Tyra Banks and Patricia Velasquez at the Nicole Miller show, April 1995

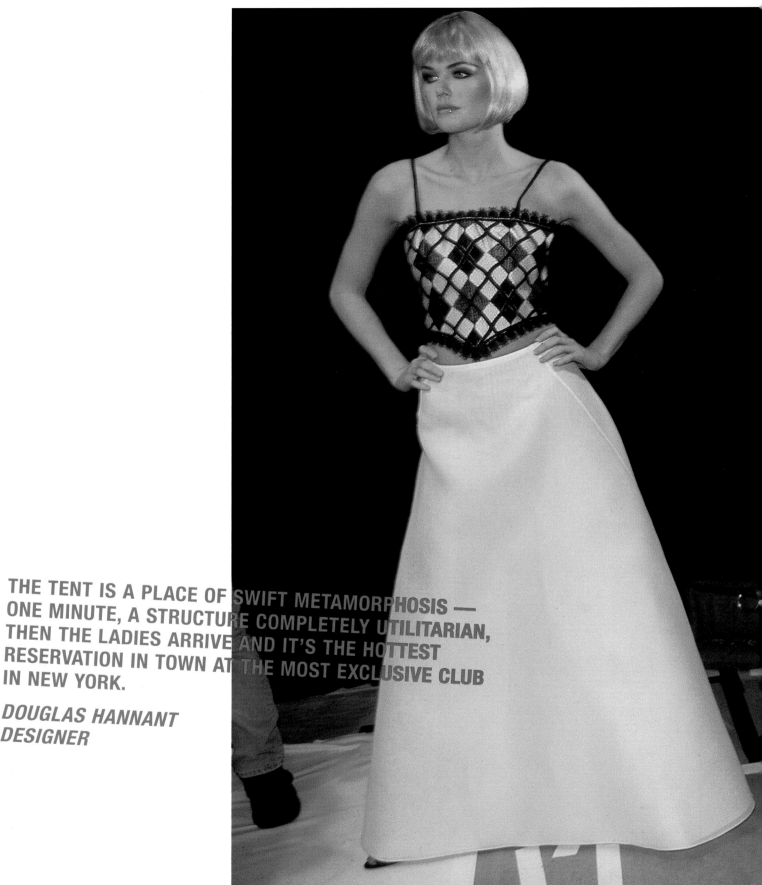

THE TENT IS A PLACE OF SWIFT METAMORPHOSIS —
ONE MINUTE, A STRUCTURE COMPLETELY UTILITARIAN,
THEN THE LADIES ARRIVE AND IT'S THE HOTTEST
RESERVATION IN TOWN AT THE MOST EXCLUSIVE CLUB
IN NEW YORK.

DOUGLAS HANNANT
DESIGNER

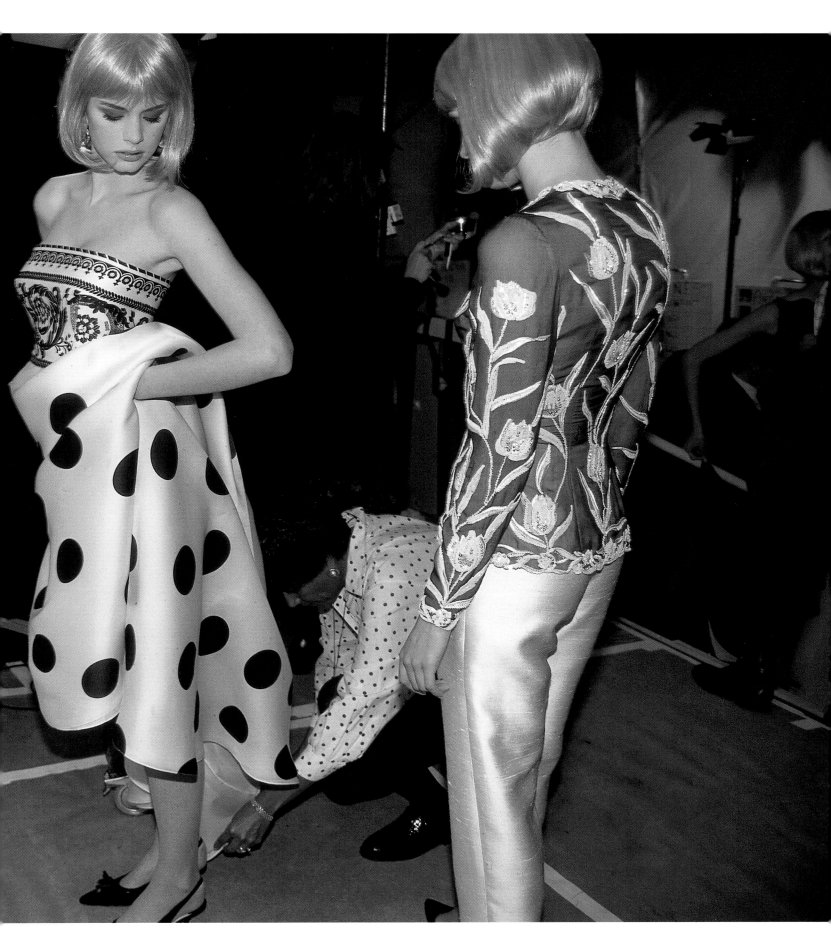

Models backstage at the Carolina Herrera show, October 1995

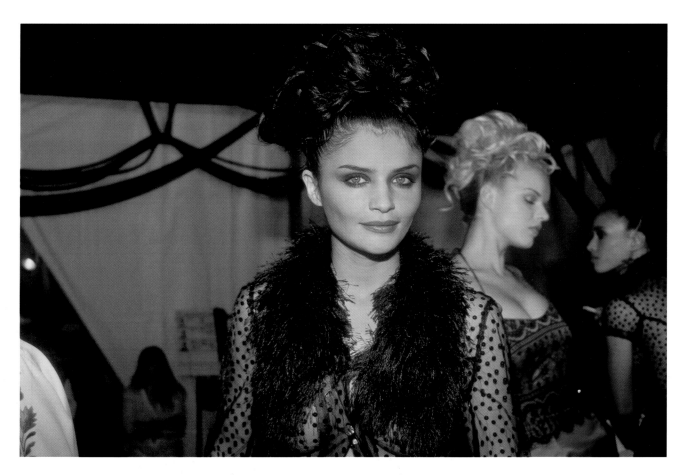

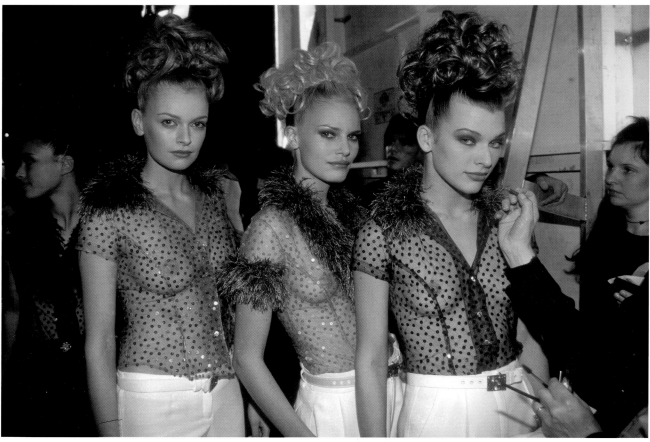

Helena Christensen at the Todd Oldham show, October 1995
Sarah O'Hare, Anna Klevhag, and Milla Jovovich at the Todd Oldham show, October 1995

Backstage at the Todd Oldham show, October 1995

WHEN I THINK OF BACKSTAGE OR BEHIND THE SCENES IN NEW YORK, PATRICK IS RIGHT UP FRONT. QUICK WITH A SMILE AND HIS CAMERA; HE ALMOST EFFORTLESSLY MIXES HIS WORK IN WITH THE AMBIANCE. THERE ARE VERY FEW PHOTOGRAPHERS WHO CAN CAPTURE THE MOMENT WITHOUT DISTURBING IT. PATRICK BLENDS IN AND BECOMES PART OF THE MOMENT. HIS MAGNETIC PRESENCE CAN DRAW THE TALENT TO HIM, WHICH IS A RARE GIFT IN THE FIELD. HE CAN SHOOT FROM THE HIP, WITHOUT MOVING HIS LIPS. AND WHEN DIRECTION BECOMES A NECESSITY, HE CAN TAKE CONTROL LIKE THE CONDUCTOR FOR A SYMPHONY, BOTH POISED AND WELL REHEARSED.

RANDY BROOKE

From top, left to right:
Yasmeen Ghauri, Shalom Harlow, Victor Alfaro, and Amber Valletta at the Victor Alfaro show, October 1995
Eliza Reed Bolen and Oscar de la Renta at the Oscar de la Renta show, February 2003
Catherine Malandrino at her show, September 2003
Mark Montano at his show, September 2001
Mark Badgley dressing a model at the Badgley Mischka show, September 2003
Ling and Vivienne Tam at her show, September 1999
Kenneth Cole and his daughter Catie Cole at the Kenneth Cole show, February 2003
Carolina Herrera at her show, March 1996
Nanette Lepore and her daughter at the Nanette Lepore show, September 2003
Olivia Chantecaille and Lars Nilsson at the Bill Blass show, September 2002
Rebecca Taylor at her show, February 2000
Nicole Farhi at her show, February 2000
Ron Chereskin at his show, September 2000
Wolfgang Joop at the JOOP! show, July 1996
Kimora Lee Simmons at her Baby Phat show, February 2003
Jill Stuart and her daughter at the Jill Stuart show, February 2003

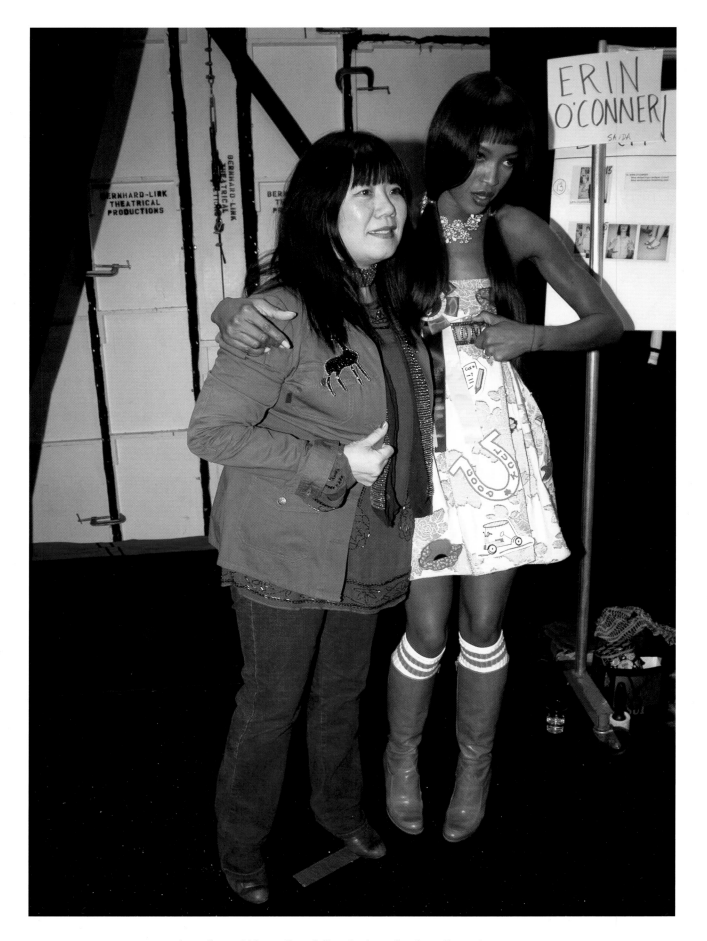

Anna Sui and Naomi Campbell at the Anna Sui show, September 2002

Nian Fish and Anna Sui backstage at the Anna Sui show, September 2002

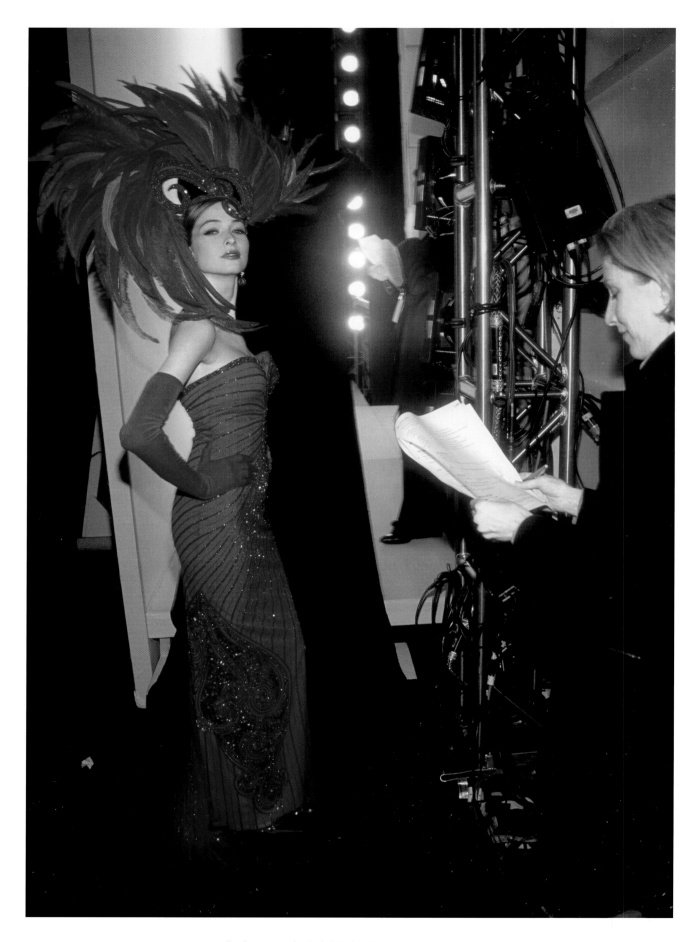

Backstage at the Bob Mackie show, February 2002

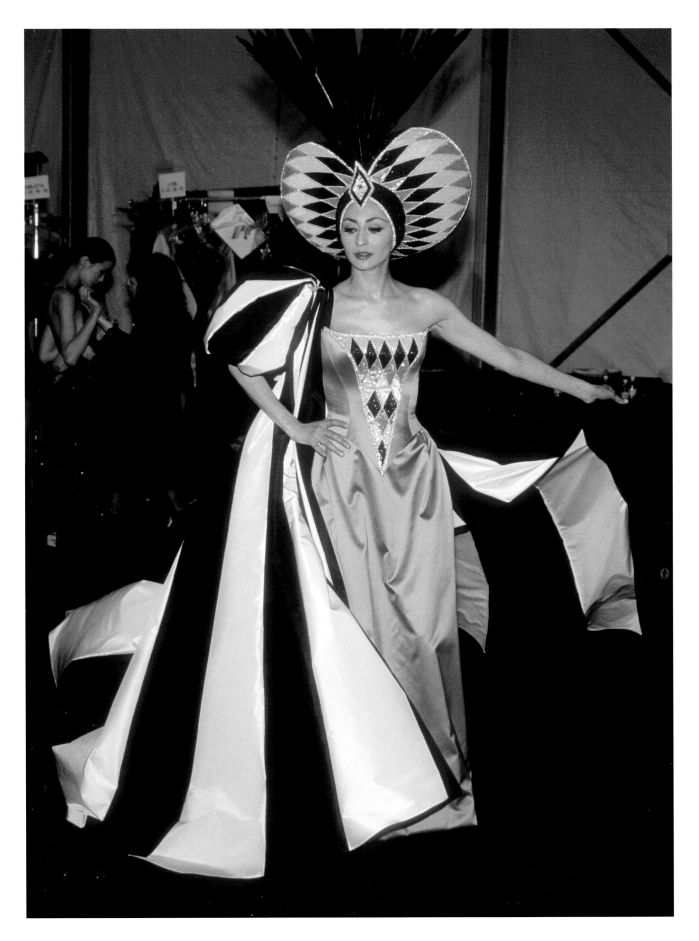

Backstage at the Bob Mackie show, February 2002

Carmen Del'Ofrice at the Isaac Mizrahi show, October 1994

THE TENTS HAVE CHANGED THE WHOLE NATURE OF NEW YORK'S FASHION WEEK: THEY HAVE MADE IT INTO A TINY VILLAGE, A GREAT PARTY, AND A THREE-RING CIRCUS ALL ROLLED INTO ONE.

ANNE MCNALLY

Backstage at the Isaac Mizrahi show, October 1994

I MOVED TO MANHATTAN FROM LONDON IN SPRING OF 1998, RIGHT IN TIME FOR NEW YORK FASHION WEEK. THE SCENE AT BRYANT PARK WAS MESMERIZING, TERRIFYING, AND NOTHING LIKE WHAT I HAD KNOWN IN EUROPE. IN LONDON, ONE WENT TO SHOWS WEARING VINTAGE PAJAMAS, POLE CLIMBERS, SPARKLY TIGHTS. THE GOAL WAS TO LOOK AS ORIGINAL AND INSPIRINGLY DISHEVELED AS POSSIBLE. IN NEW YORK, ALL CHANGE! (CHANGED??) STRIDING UP THE STEPS TO THAT TENTED WORLD WERE ARMIES OF LONG-LIMBED STYLE SOLDIERETTES IN THE SLEEKEST GUCCI TROUSER SUITS, THE HIGHEST SERGIO ROSSI HEELS, AND FUR FUR FUR. AND THIS WAS APRIL! EVERY GIRL HAD THE NEWEST BAG — BAGS SO NEW THEY HAD YET TO SEE THE BOUTIQUE FLOOR, REGISTER, OR SHOPPING BAG. I WAS FASCINATED: THE AUDIENCE FOR THE SHOWS SEEMED TO BE FAR MORE INTERESTING THAN WHAT WAS STALKING THE CATWALKS. THIS WAS THE FASHION INDUSTRY'S RED CARPET.

ONE SEASON LATER, WHEN I BECAME FASHION DIRECTOR OF *NEW YORK* MAGAZINE, I KNEW THAT THIS WEIRDLY GLAMOROUS ARENA DESERVED TO BE COVERED — AS MUCH, IF NOT MORE SO, THAN THE UPCOMING TRENDS. PATRICK AND I SET ABOUT DOCUMENTING WHAT THE FRONT ROW WORE TO WORK, AND IN DOING SO WE MADE STARS OF THOSE WHO HAD PREVIOUSLY STAYED BEHIND THE CAMERA. AND PATRICK SHOT EVERYONE SITTING DOWN, SO THAT THEIR TELLTALE ACCESSORIES — THOSE FENDI BAGUETTES, CHLOE AVIATORS, TODS LOAFERS — COULD TELL THE TALE OF ACCESS AND ACQUISITIVENESS THAT UNDERLIES THIS BUSINESS.

THESE DAYS, OF COURSE, THERE IS AN ENTIRE INDUSTRY THAT REPORTS ON WHAT MY INDUSTRY WEARS TO ENTER BRYANT PARK. YOU CAN'T TAKE YOUR SEAT IN THE FRONT ROW WITHOUT SWATTING AWAY SWARMS OF PAPARAZZI. FUNNY ENOUGH, NOW THE REALLY COOL THING IN NEW YORK IS TO COME WEARING THINGS THAT LOOK LIKE FUNNY PAJAMAS — BUT FROM MARC JACOBS, OF COURSE, IF YOU WANT TO BE IN THE PICTURE.

SALLY SINGER
FASHION NEWS DIRECTOR
VOGUE

Backstage at the BCBG Max Azria show, September 2002

Ester de Jong at the Miu Miu show, October 1996

Backstage at the Bob Mackie show, February 2002

Backstage at the Ghost show, April 1997

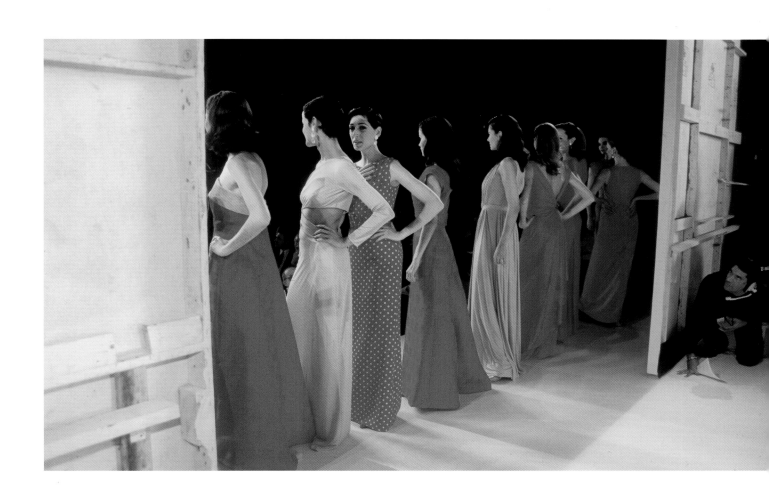

Finale of the Carolina Herrera show, November 1994

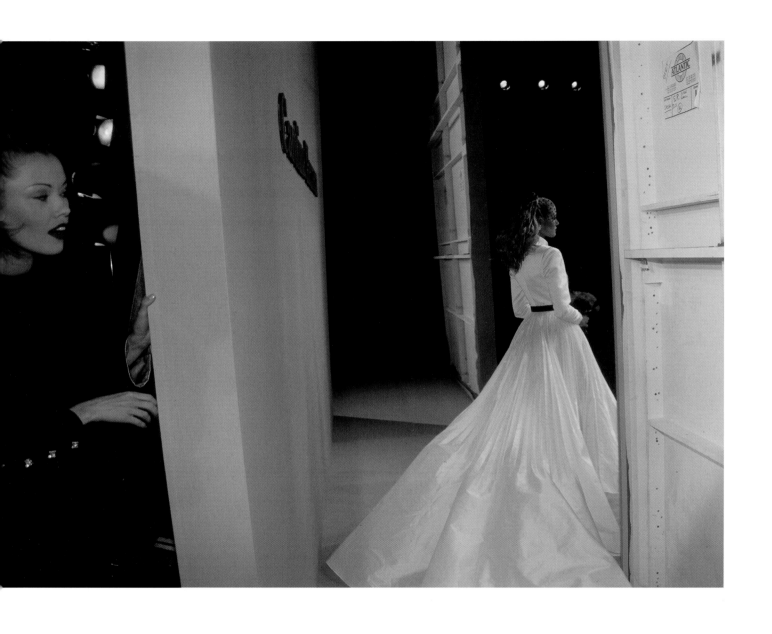

Finale of the Carolina Herrera show, April 1995

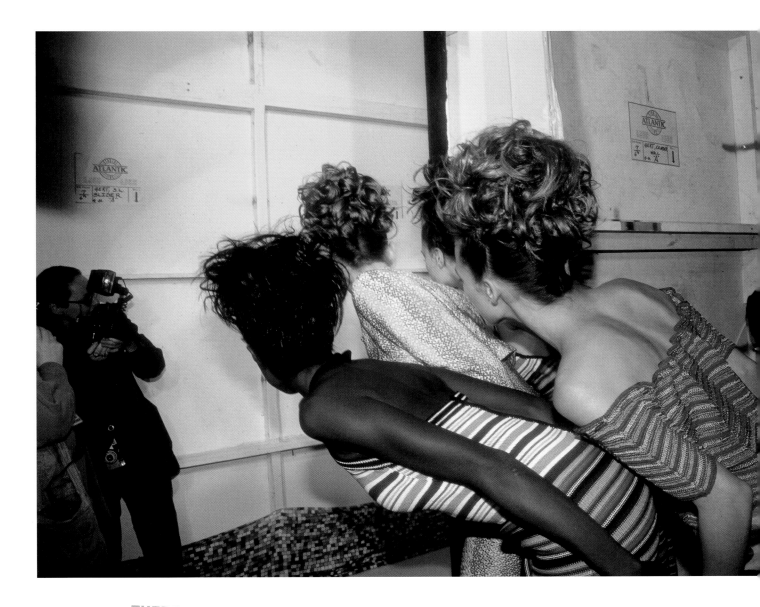

THERE ARE TWO DYNAMIC SIDES TO THE TENTS. I HAVE BEEN ON BOTH. BACKSTAGE EVERYONE IS UNITED AND FOCUSED ON PORTRAYING THE ESSENCE OF THE DESIGNER. HOWEVER, IN THE FRONT ROW, EVERYONE'S CONCERN IS THEIR OWN IMAGE, HOW DO THEY LOOK, WHERE ARE THEY SEATED. I PREFER IT BACKSTAGE.

GIGI MORTIMER

Backstage at the Todd Oldham show, October 1995

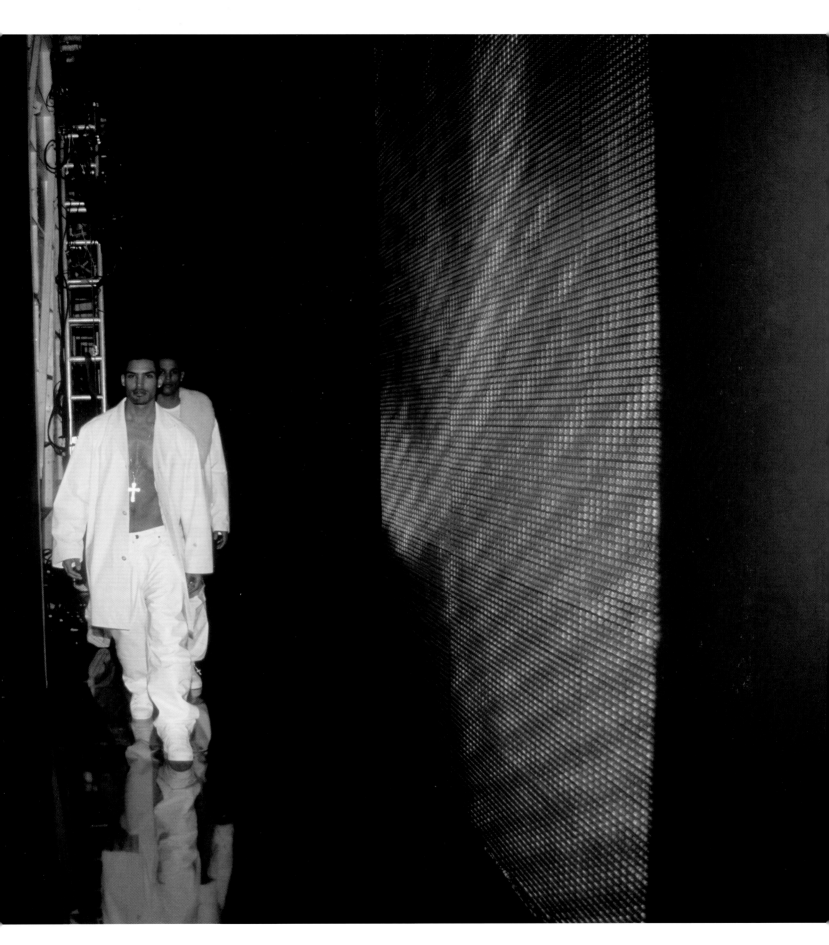

Will Lemay leads the finale at the Sean John show, February 2000

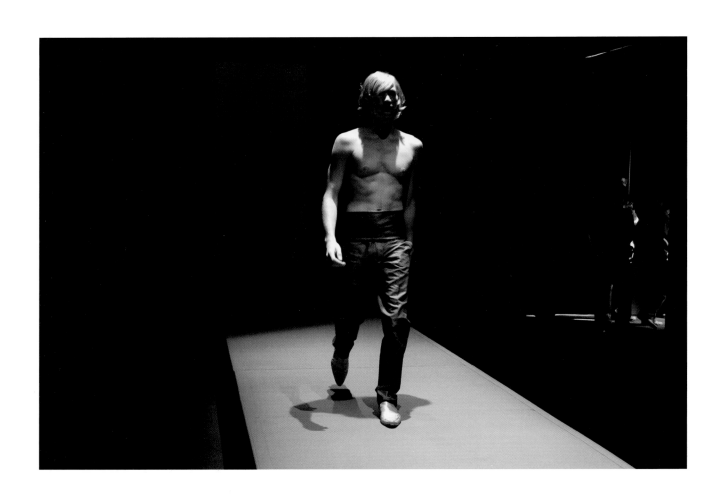

Runway at the GF FERRE show, September 2003

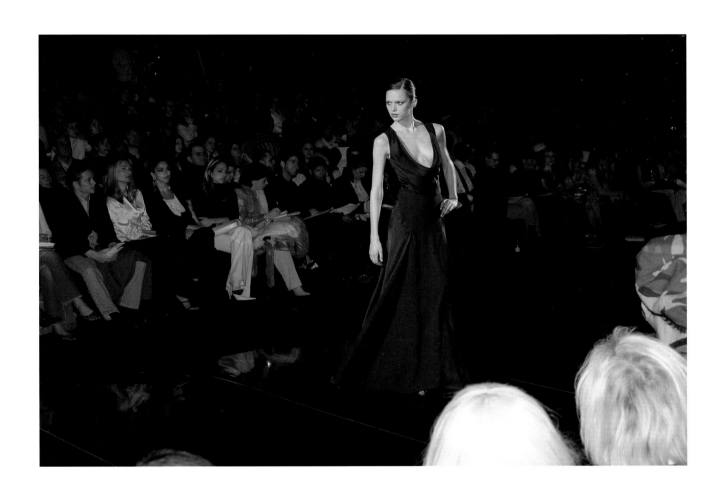

Elise Crombez on the runway at the Luca Luca show, February 2003

AS TEMPTING AS IT MAY BE TO JUST SIT HOME AND WATCH THE SHOWS ON CABLE, IT'S WORTH IT TO ACTUALLY DRAG YOUR BUTT TO THE TENTS AND WITNESS THE STYLE-CRAZED SPECTACLE IN THE FLESH. IT'S FUN TO WATCH THE FASHIONISTAS JOCKEY FOR FIRST ROW SEATS SO THEY CAN TAKE IN THE PARADE DU JOUR OF POUTY LIPS AND FRINGED HEMLINES. NO MATTER HOW MANY TIMES CARNABY STREET AND *STAR WARS* ARE MINED FOR INSPIRATION, IT ALL SEEMS NEW EVERY SEASON, AND SO ARE THE GIFT BAGS, PHOTO OPS, AND AFTER PARTIES FILLED WITH THE SAME PEOPLE AS LAST YEAR. "I'M NOT ONE OF THEM," YOU TELL YOURSELF AS YOU SACRIFICE YOUR LIFE AND TREK TO SHOW AFTER SHOW AFTER SHOW!

MICHAEL MUSTO

Runway at the Anna Sui show, April 1998

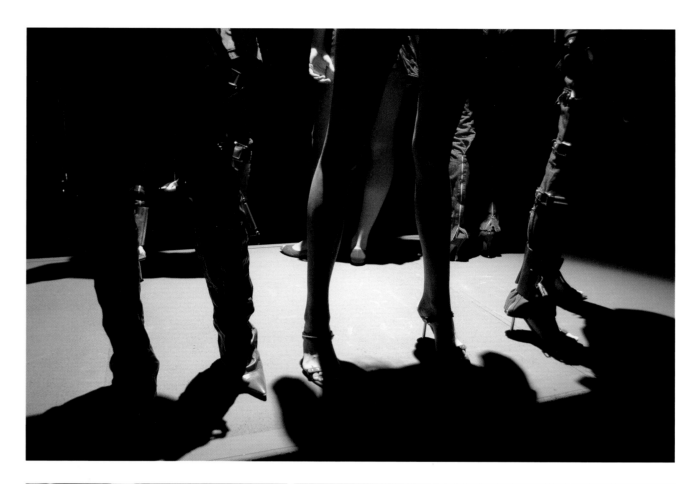

Runway at the GF FERRE show, September 2003
Backstage at the Douglas Hannant show, February 2002

THE TENTS MAKE "ABFAB"
LOOK LIKE A QUAKER MEETING.

SIMON DOONAN
BARNEY'S NY

Backstage at the Narciso Rodriguez show, September 2003

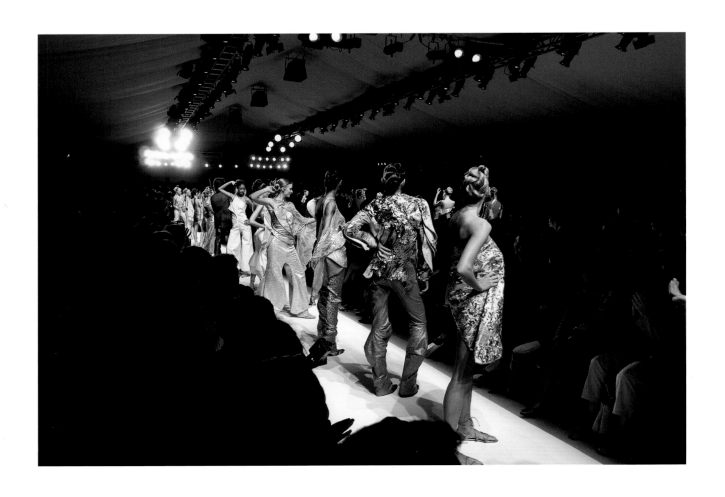

Runway at the AsFour show, September 2003

ABOUT THE TENTS, A FUNNY STORY COMES TO MIND. LATE EIGHTIES OR EARLY NINETIES, WE'RE AT YEOHLEE'S OLD ADDRESS, 202 W 40TH STREET, FIRST SHOW OF THAT DAY, SMALL SPACE, SHORT SHOOTING DISTANCE (AN 85MM LENS BARELY MAKES IT). AS SOON AS THE SHOW ENDS, THE CROWD IS TRYING TO ESCAPE THE RUSHING TO THE ELEVATOR. SOME MAKE IT, THE REST WAITS, AND WAITS, AND WAITS. I EVENTUALLY TAKE THE STAIRS BECAUSE I MUST GO TO THE NEXT EVENT. AS I'M GOING DOWN THE DARK STAIRWELL IT BECOMES QUITE CLEAR THE ELEVATOR WITH THE FIRST LUCKY ONES GOT STUCK SOMEWHERE NEAR THE 4TH FLOOR. IN IT, MICHAEL GROSS, ONE OF MY EDITORS DURING THOSE TIMES. HE NEVER MADE IT TO THE NEXT SHOW. HAH, THE GOOD OLD DAYS!

DAN LECCA
PHOTOGRAPHER

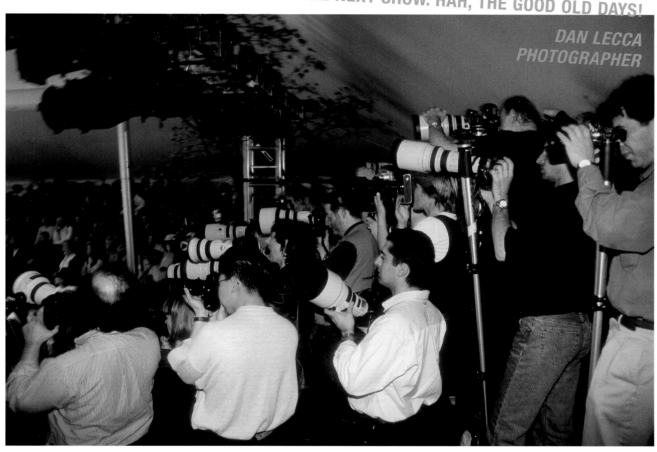

Photographers at the end of the runway at the Liza Bruce show, November 1996

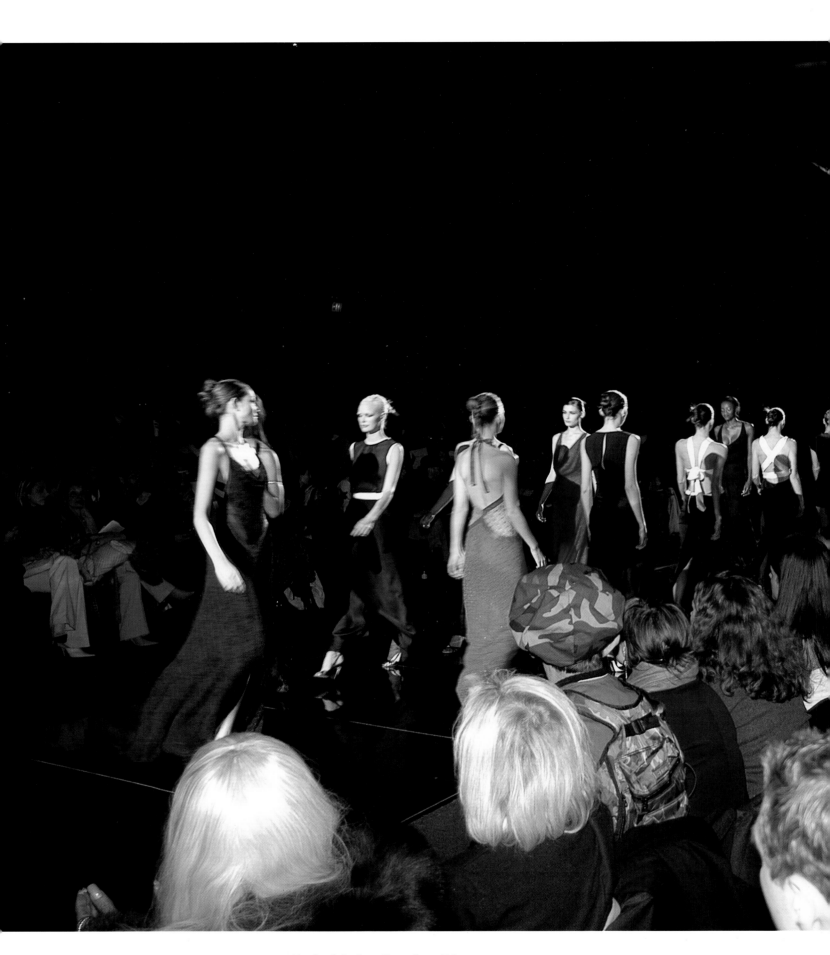

Finale of the Luca Luca show, February 2003

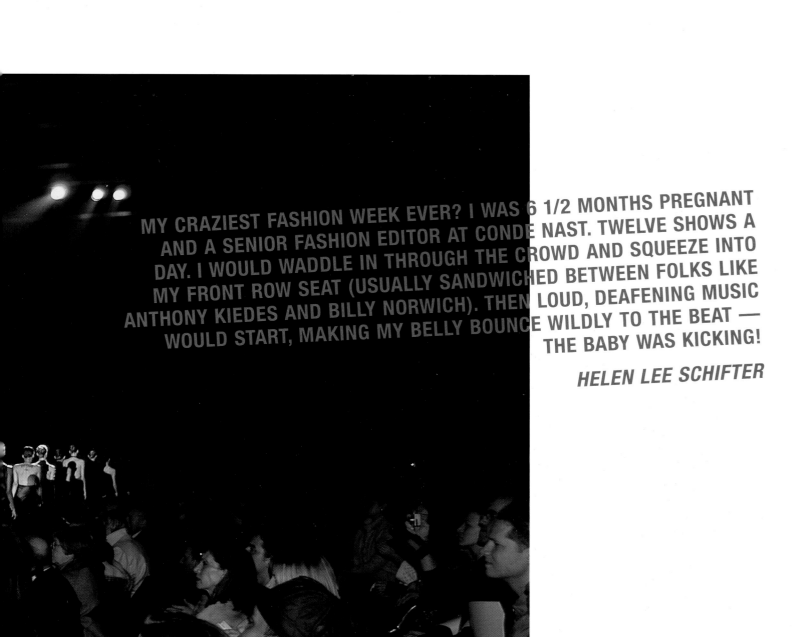

MY CRAZIEST FASHION WEEK EVER? I WAS 6 1/2 MONTHS PREGNANT AND A SENIOR FASHION EDITOR AT CONDE NAST. TWELVE SHOWS A DAY. I WOULD WADDLE IN THROUGH THE CROWD AND SQUEEZE INTO MY FRONT ROW SEAT (USUALLY SANDWICHED BETWEEN FOLKS LIKE ANTHONY KIEDES AND BILLY NORWICH). THEN LOUD, DEAFENING MUSIC WOULD START, MAKING MY BELLY BOUNCE WILDLY TO THE BEAT — THE BABY WAS KICKING!

HELEN LEE SCHIFTER

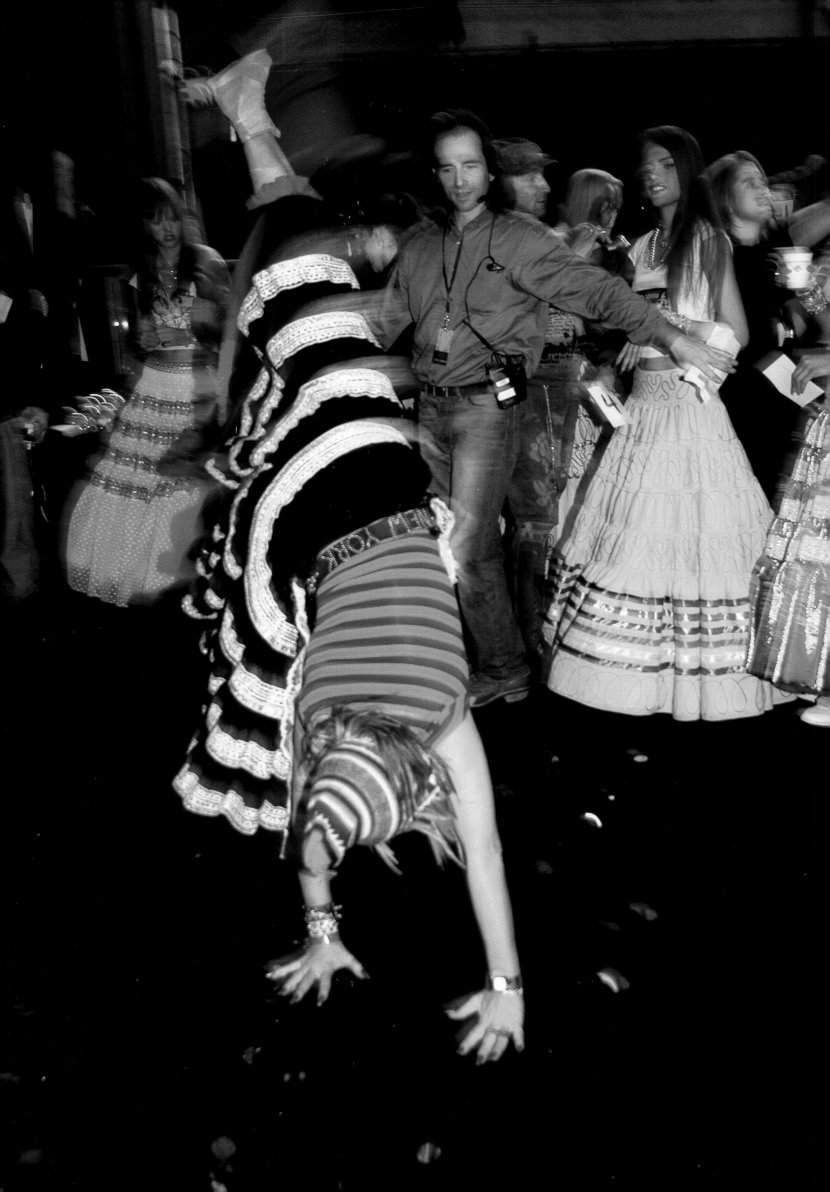

I HAVE GONE TO THE SHOWS ON AND OFF SINCE THE PRE-TENT DAYS OF HALSTON, WILLI SMITH, CLOVIS RUFFIN, SCOTT BARRIE, AND HANDSOME YOUNG CALVIN KLEIN. I SAW THE SHOWS MUTATE FROM CONCLAVES OF THE COGNOSCENTI TO MEDIA MELEES AND ORGIES OF SOCIAL CLIMBING SYCOPHANTS. I SAW THE REAL SUPERMODELS COME AND GO. I SAW FASHION DEVOUR ART AND BECOME A SHOW BUSINESS SIDESHOW.

OVER THE YEARS I ALWAYS ENJOYED THESE RITUALS, BUT THEY TAKE THEIR TOLL. NOW I'M TRYING TO QUIT THE HABIT ALTOGETHER, AS MUCH AS I STILL ENJOY LOOKING AT THE GIRLS AND WATCHING THE SOCIAL DESPERADOS JOCKEY FOR POSITION. IT'S JUST TOO HARD. THE ACTUAL SHOW EXPERIENCE ISN'T USUALLY ALL THAT BAD, EVEN IN OUR DEGRADED STATE OF CULTURE, ALTHOUGH SOMETIMES THERE'S SOME WILD PUSHING AND SHOVING, AND THERE'S ALWAYS WAY TOO MUCH SNOOTY ATTITUDE FROM THE MINIONS WITH CLIPBOARDS AND STOOGES IN HEADSETS. THE PROCESS IS TOO TAXING FOR A PERSON OF MY SELF-INDUCED SENSITIVITY AND OBSOLESCENT SENSE OF DIGNITY.

ONE PROBLEM IS THAT I AM "UNAFFILIATED." IF I CALL AND SAY "THIS IS GLENN O'BRIEN," SOME YOUNG WHIPPERSNAPPERETTE WILL SAY, "WHERE ARE YOU CALLING FROM?" I USUALLY SAY "FROM HOME," EVEN THOUGH THIS HAS NEVER, EVER WORKED. I FIND THAT BEING FREELANCE AND NOT HAVING A PUBLICIST OR A RUTHLESS ASSISTANT, IT'S JUST NOT WORTH THE EFFORT FOR ME TO GO ANYMORE. I HAVE GIVEN UP. I STILL GET INVITED BY SOME OF THE BETTER DESIGNERS, AND MAYBE I'LL SHOW UP NOW AND THEN, BUT ONLY IF I DON'T HAVE TO EXPLAIN MYSELF. I HATE IT WHEN SOMEONE SITS IN MY SEAT AND I HAVE TO HAVE THEM EVICTED AND THEY'RE TOO SHAMELESS TO CARE. AND IF I DON'T HAVE AN ASSIGNED SEAT I'M NOT GOING TO SHOW UP AT ALL. I'M MUCH TOO DISTINGUISHED TO SIT IN ANYTHING PAST THE THIRD ROW.

THERE WERE SOME GREAT MOMENTS, THOUGH. MY FAVORITE WAS A FEW YEARS BACK WHEN I WAS LATE FOR VERSACE AND I WAS TRYING TO GET TO MY SEAT. I FELT SOMEONE PUSHING ME MUCH TOO FORCE-FULLY FROM BEHIND. I WHIRLED AROUND, ALMOST READY TO PUT UP MY DUKES. I LOOKED DOWN AND THERE WAS THE FACE OF MIKE TYSON. HE SMILED AND SAID SWEETLY: "THCYUTHE ME!" OF COURSE I DID.

GLENN O'BRIEN

Betsey Johnson doing a cartwheel backstage at her show, January 2003

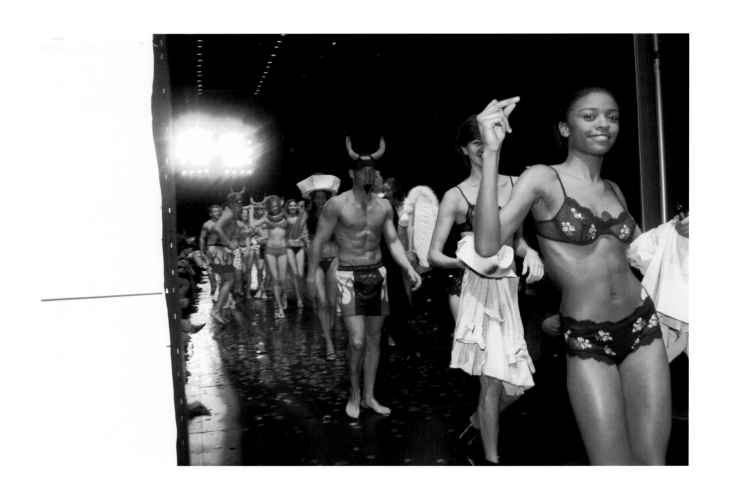

Finale of the Joe Boxer show, February 2003

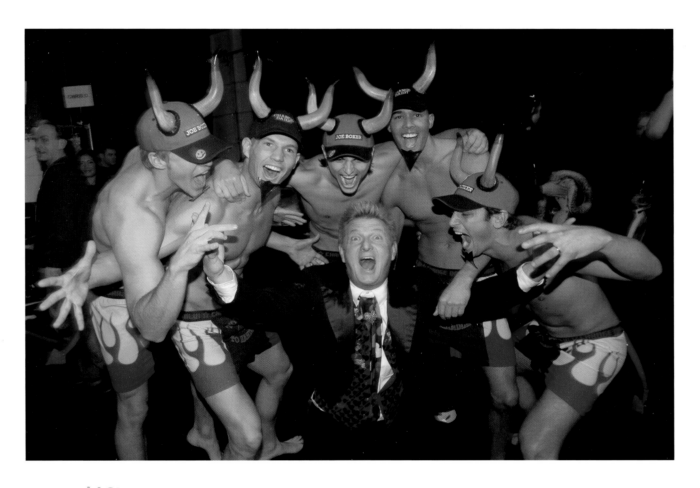

I LOVE BRYANT PARK BECAUSE IT'S LIKE THIS GIANT TEMPORARY DAY CARE CENTER FOR PEOPLE WITH REALLY SHORT ATTENTION SPANS WHO GET TO WATCH IN FIFTEEN MINUTES WHAT SOMEONE HAS TAKEN MAYBE A YEAR AND HUNDREDS OF HOURS TO PUT TOGETHER. ITS PERFECT FOR SOMEONE LIKE ME BECAUSE MY ATTENTION SPAN IS SO BAD I CAN HARDLY SIT THROUGH A BROADWAY SHOW. BRYANT PARK IS LIKE A MINI-BROADWAY WITHOUT THE SINGING, BUT EVERYBODY WANTS TO BE HEARD (OR HERD?).

NICK GRAHAM

Nick Graham with models at the Joe Boxer show, February 2003

Nicole Miller at the end of her show, October 1996

Randy Kemper at the end of his show, October 1995
Bradley Bayou at the end of his show, April 1994

THOSE TENTS — HATED THEM AND LOVED THEM. FASHION WEEK IN NEW YORK WAS QUITE AN EXPLOSION OF IDEAS, CELEBRATED UNDER THOSE TEMPORARY TEMPLES THAT POP UP IN BRYANT PARK TWICE A YEAR.

TODD OLDHAM
DESIGNER

Todd Oldham at the end of his show, October 1994

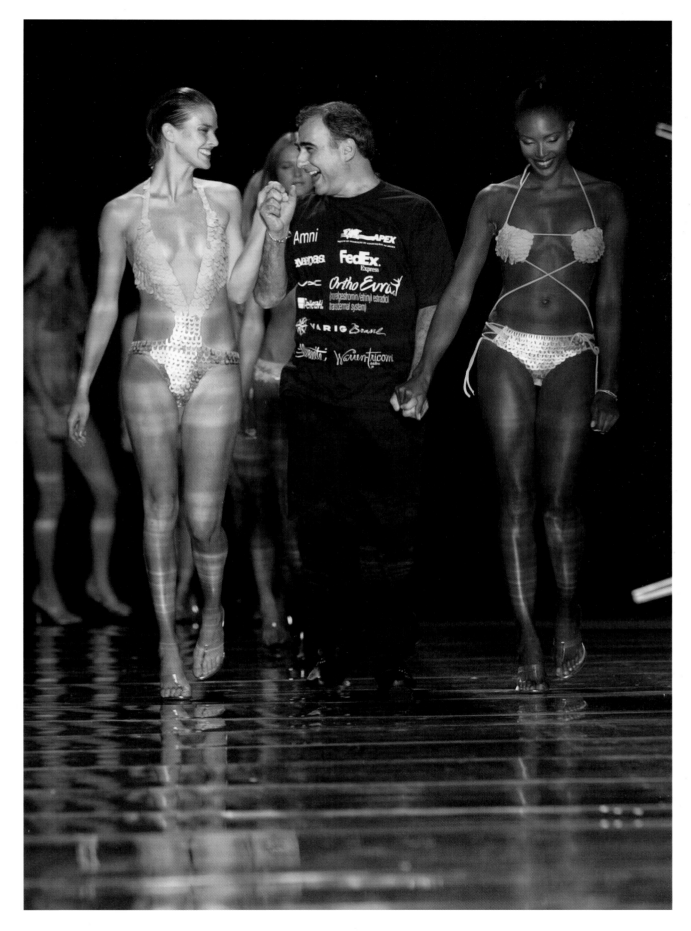

Leticia Birkheuer, Amir Slama, and Naomi Campbell at the end of the Rosa Cha by Amir Slama show,
September 2003

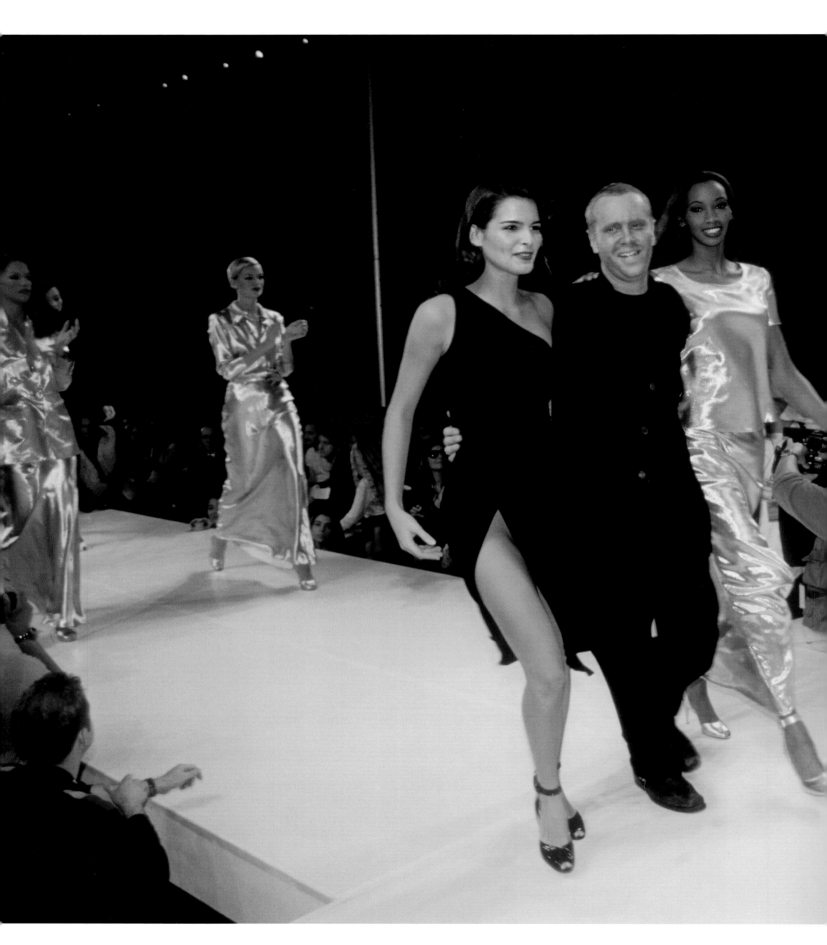

Angie Harmon, Michael Kors, and Beverly Peele at the Michael Kors show, October 1994

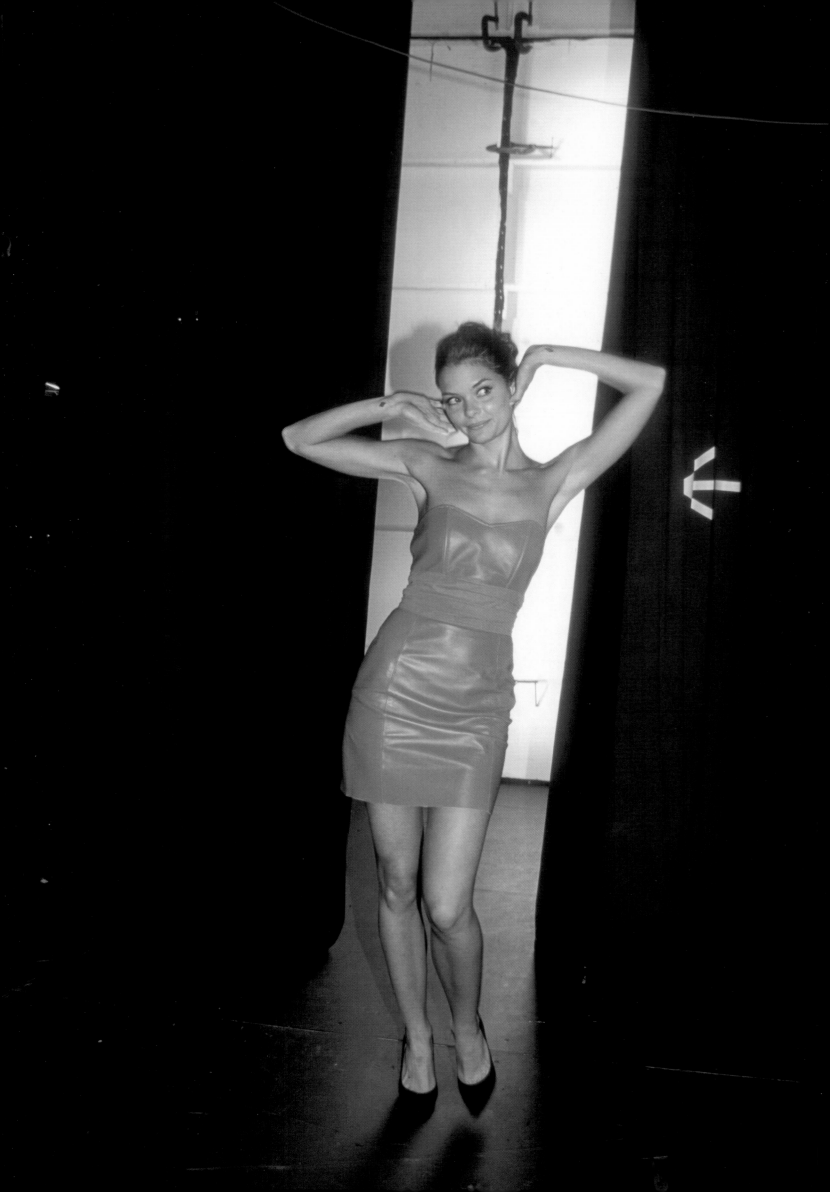

DURING NEW YORK FASHION WEEK, THE TENTS ARE THE EPICENTER OF THE FASHION SYSTEM. THE SCENE LOOKS GLAMOROUS FROM THE VANTAGE POINT OF A TOURIST ON THE PAVEMENT, BUT INSIDE MOST PEOPLE ARE WORKING AT A TREMENDOUS PACE, OFTEN UNDER CONSIDERABLE PRESSURE. IT'S LIKE OPENING 100 BROADWAY SHOWS, EACH OF WHICH LASTS FOR ABOUT FIFTEEN MINUTES.

AT THE SAME TIME, MOST OF THESE PEOPLE KNOW EACH OTHER, SO IT'S LIKE A STRANGE FAMILY REUNION — WITH ALL THE STURM UND DRANG THAT ENTAILS. VISUALLY, IT'S A GOLD MINE.

VALERIE STEELE
F.I.T.

James King at the Halston show, September 2000

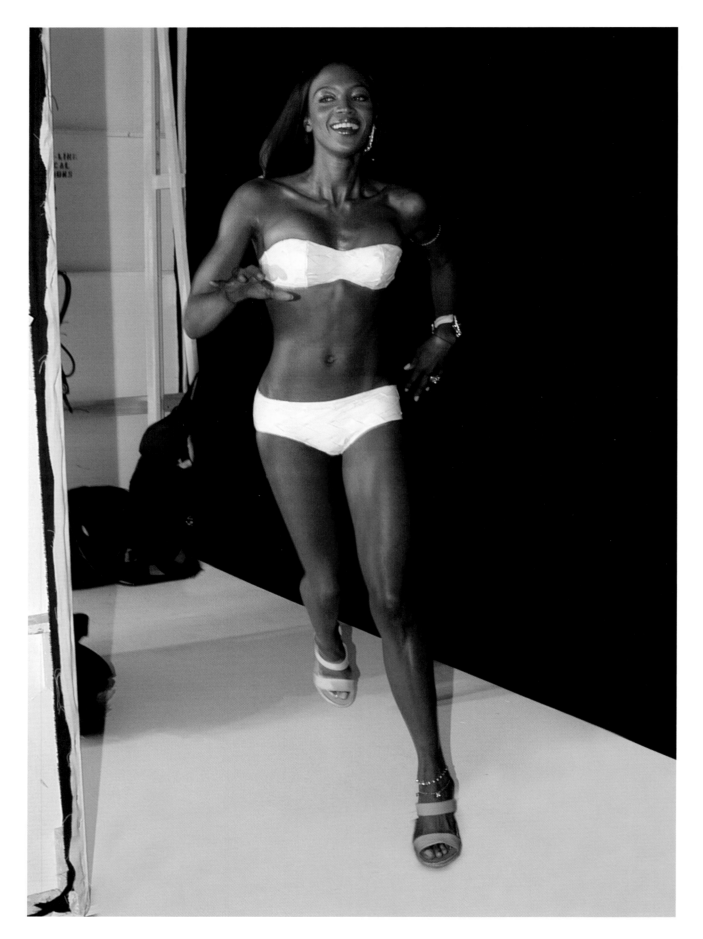

Naomi Campbell at the Rosa Cha by Amir Slama show, September 2002

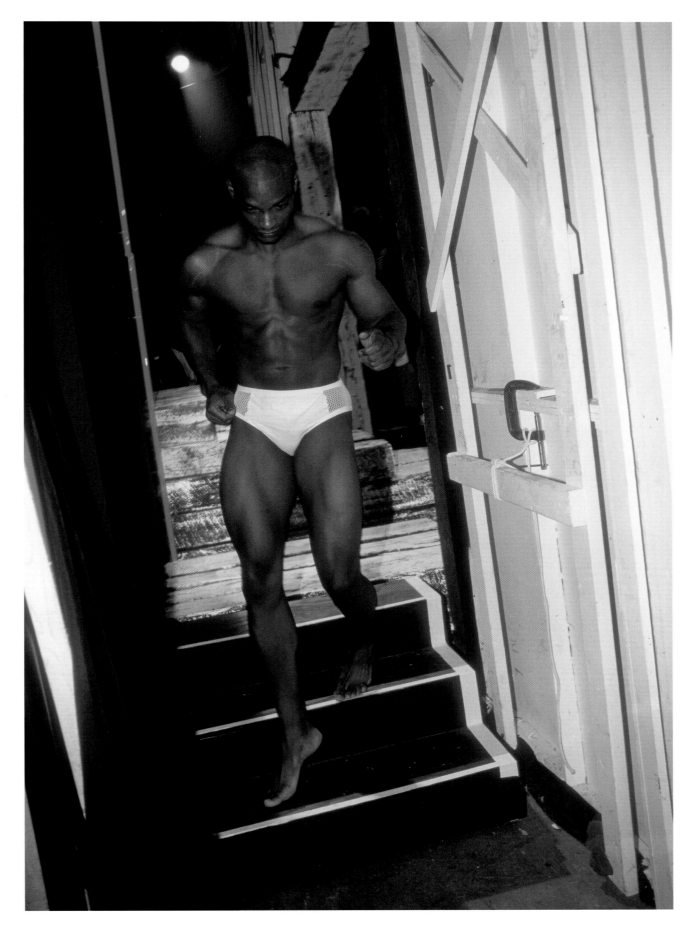

Backstage at the John Bartlett show, July 1997

Jason backstage at the John Varvatos show, September 2002

From top, left to right:
Frankie Rayder at the Tommy Hilfiger show, September 2003
J.R. Gallison at the Gene Meyer show, September 2000
Ryan Locke at the Sean John show, February 2001
Backstage at the Alice Roi show, February 2003

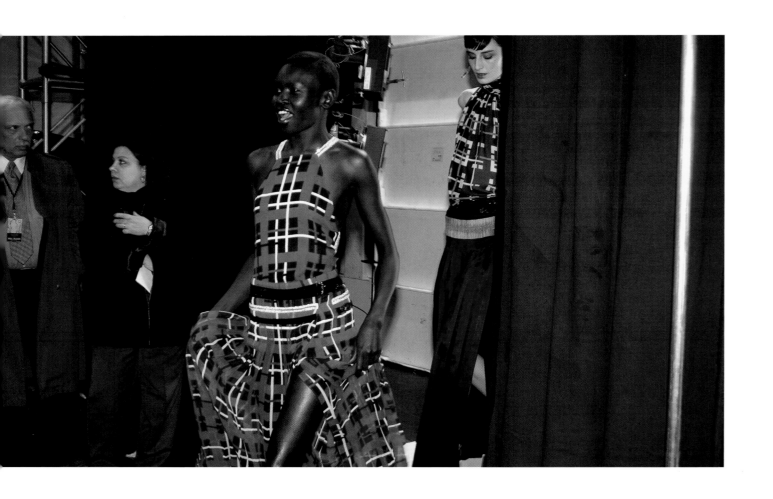

Alek Wek at the Bill Blass show, February 2003

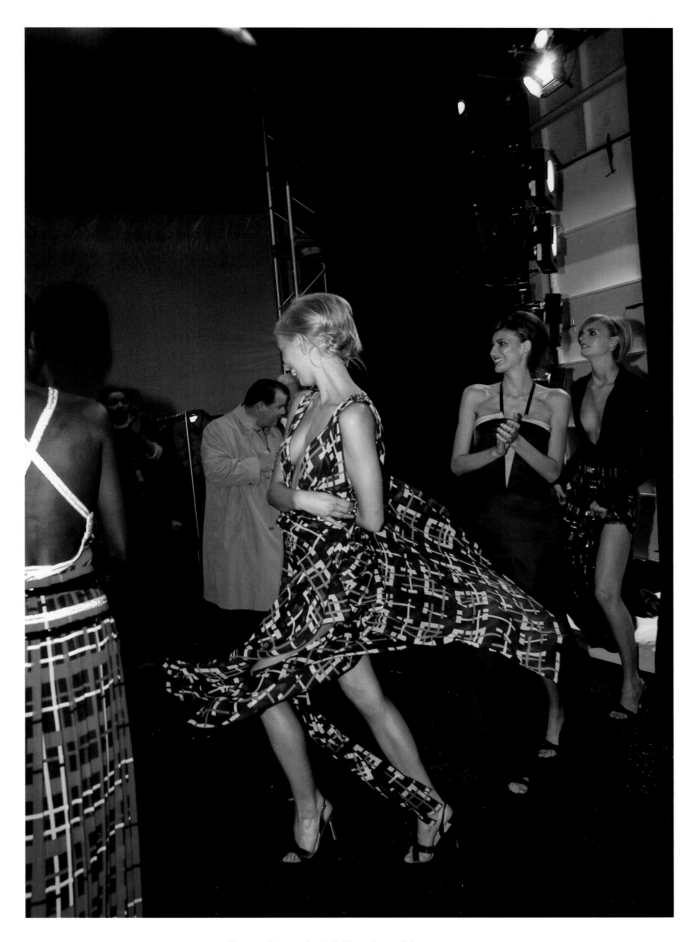

Show ending at the Bill Blass show, February 2003

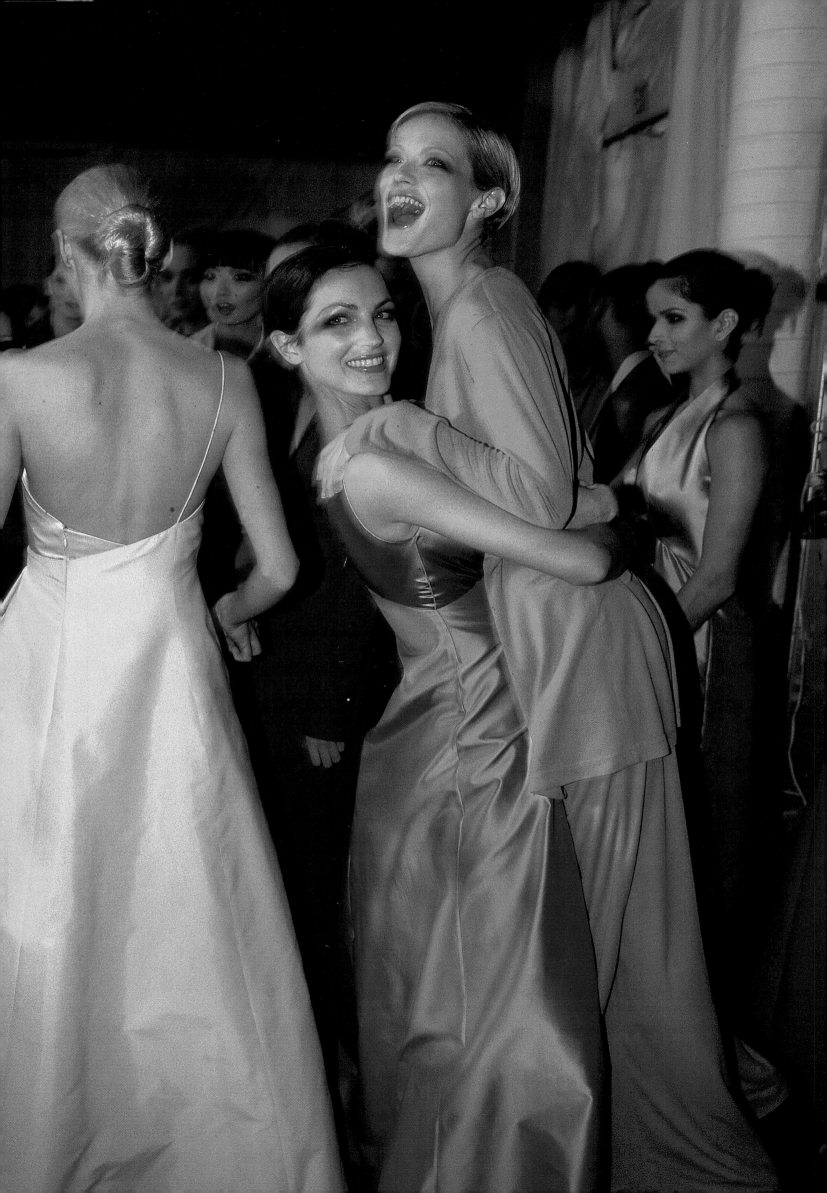

WHAT IS FASHION WITHOUT THE STUDENTS HOVERING AROUND THE TENT ENTRANCE HOPING SOMEONE MIGHT HAVE AN EXTRA INVITATION? I REMEMBER ONCE HAVING AN EXTRA TICKET TO A VERSUS SHOW. I GAVE IT TO A GIRL WHO WAS WATCHING THE CROWD GO INTO THE TENT. HONESTLY, I THINK SHE NEARLY WEPT IN AMAZE- MENT. THE TENT SCENE REMINDS YOU THAT FASHION CAN EVOKE THAT KIND OF PASSION. IT KEEPS YOU FROM GETTING JADED.

ROBIN GIVHAN
FASHION EDITOR
THE WASHINGTON POST

Chandra North and Carolyn Murphy at the Isaac Mizrahi show, April 1996

HI HO...MY BACKSTAGE (BEFORE SHOW) IS ALWAYS THE BIGGEST, BEST PARTY TIME AND PATRICK'S NEVER MISSED CAPTURING THE HAIR, MAKEUP, MODEL FUN ALL THESE YEARS. IT'S TIME TO CELEBRATE!!

THANKS!

XOX BETSEY

BETSEY JOHNSON

Betsey Johnson and Bill Mullen with roses after her show, March 1998

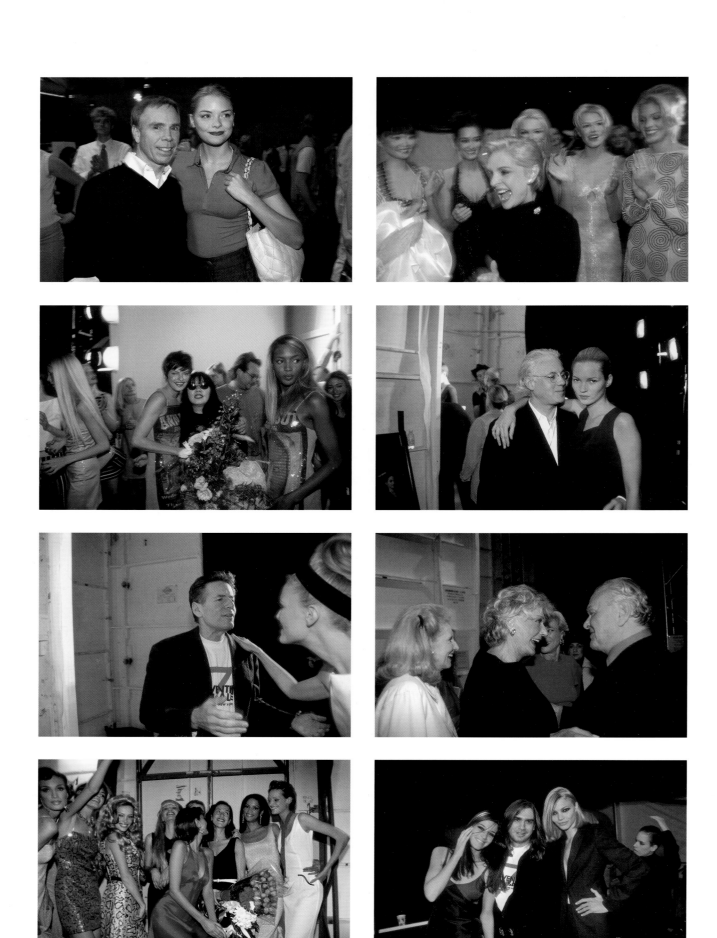

From top, left to right: Tommy Hilfiger and James King at the Tommy Hilfiger show, September 2002
Carolina Herrera and models at her show, March 1996
Linda Evangelista, Anna Sui, and Naomi Campbell at the Anna Sui show, November 1995
Zack Carr and Kate Moss at the Calvin Klein show, April 1996
Calvin Klein at his show, April 1995
Judy Peabody and Pat Buckley congratulating Bill Blass after his show, September 1999
Cynthia Rowley and her models celebrating after her show, October 1994
Mark Eisen and models at his show, April 1995

LIKE GRAND CENTRAL STATION FOR FASHION
COMMUTERS, THE TENTS HAVE WELCOMED US
ALL FAIRLY AND EQUALLY, IRREGARDLESS OF OUR
POINTS OF EMBARKATION. YOU HAVE KEPT US
SAFE, COMFORTABLE, ORGANIZED, WELL-LIGHTED
AND MOSTLY ON TIME — AND ALL AT A CHEAP
TICKET PRICE. THANKS FOR THE RIDE!

JAMES LAFORCE

Narciso Rodriguez celebrating after his show, September 2003

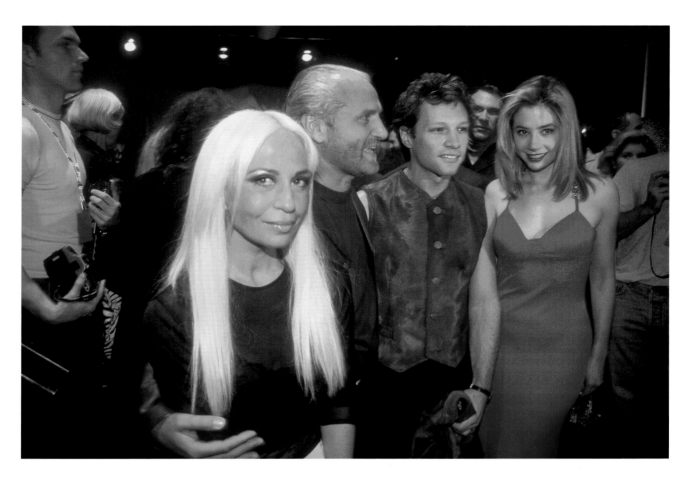

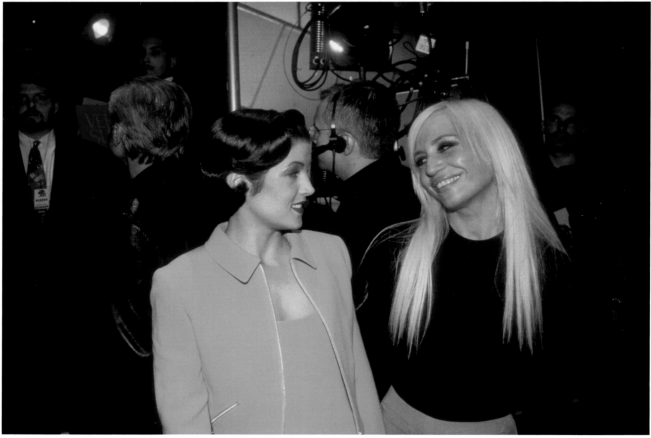

Donatella Versace, Gianni Versace, Jon Bon Jovi, and Mira Sorvino at the Versace show, October 1996
Lisa Marie Presley and Donatella Versace at the Versus show, March 1996

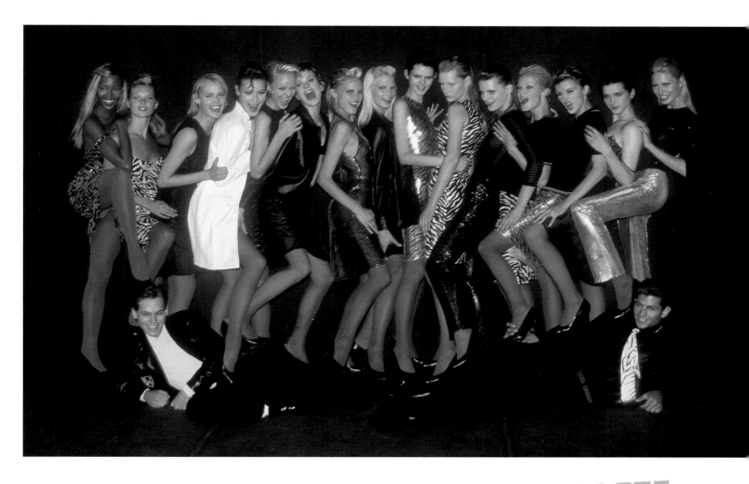

BEING AT THE TENTS IS COMPLETE
PANDEMONIUM, LIKE BEING AT A VERY
ELITE PARTY

KIMORA LEE SIMMONS

Backstage at the Versace show, October 1995

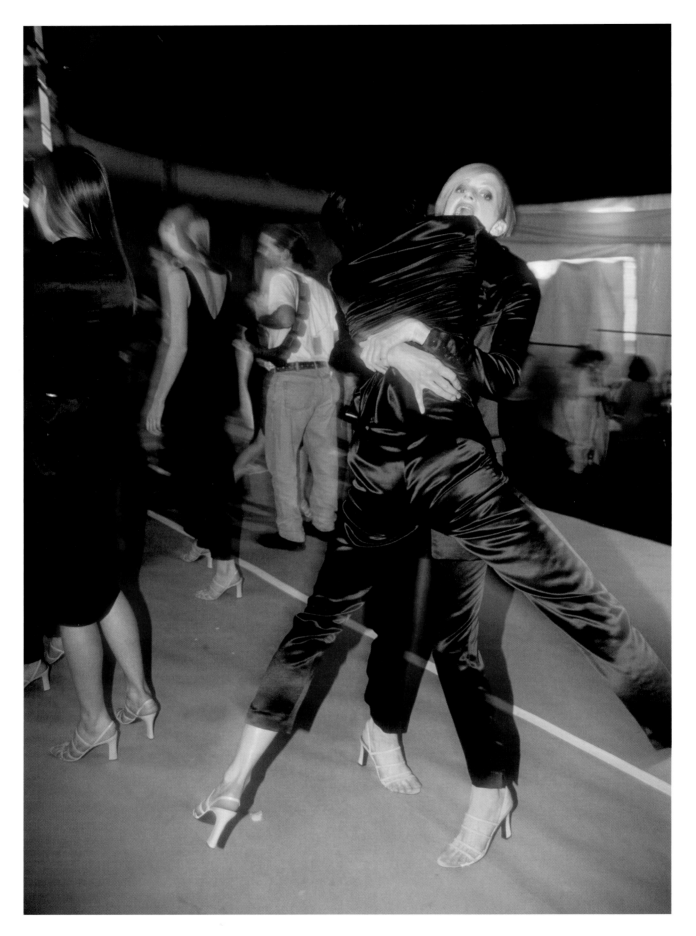

Shalom Harlow and Kristen McMenamy hugging at the Calvin Klein show, October 1994

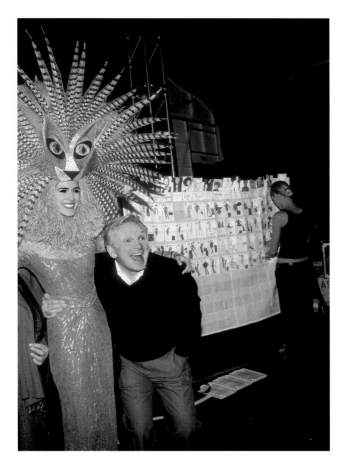

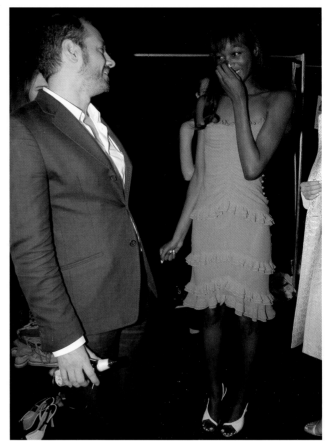

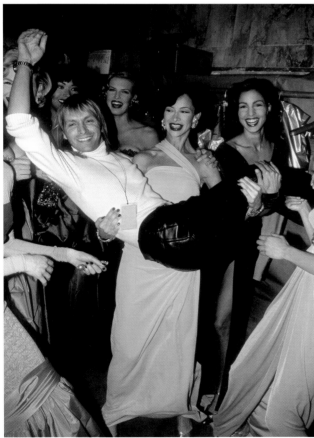

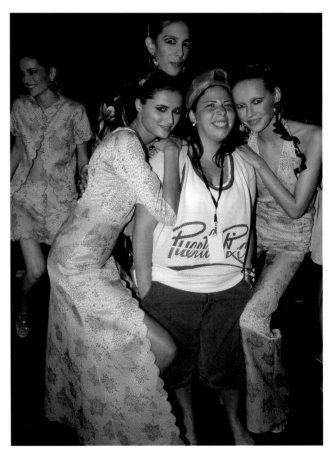

From top, left to right:
Bob Mackie and model after his show, February 2002
Bryan Bradley and Valery Prince at the Tuleh show, September 2003
Models carrying Marc Bouwer at his show, April 1995
Alice Roi with models at her show, September 2002

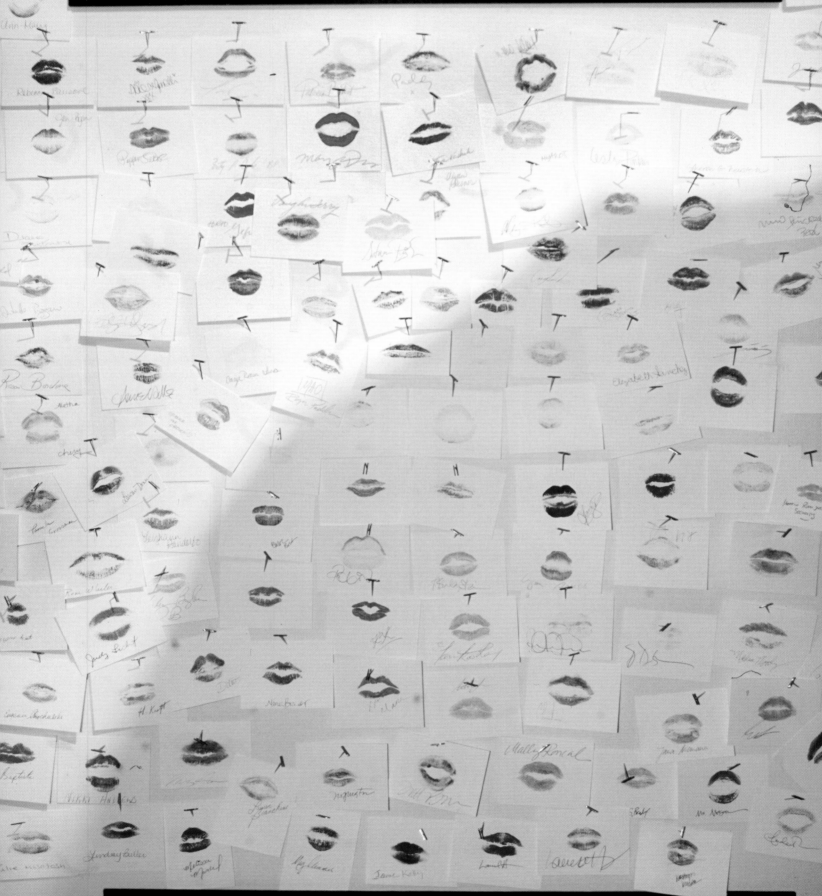

MY FIRST SHOW WAS THEIR
FIRST SHOW. IT WAS EXCITING TO
BE PART OF SOMETHING THAT
HAS BECOME THE ICON OF
AMERICAN FASHION.

CYNTHIA ROWLEY

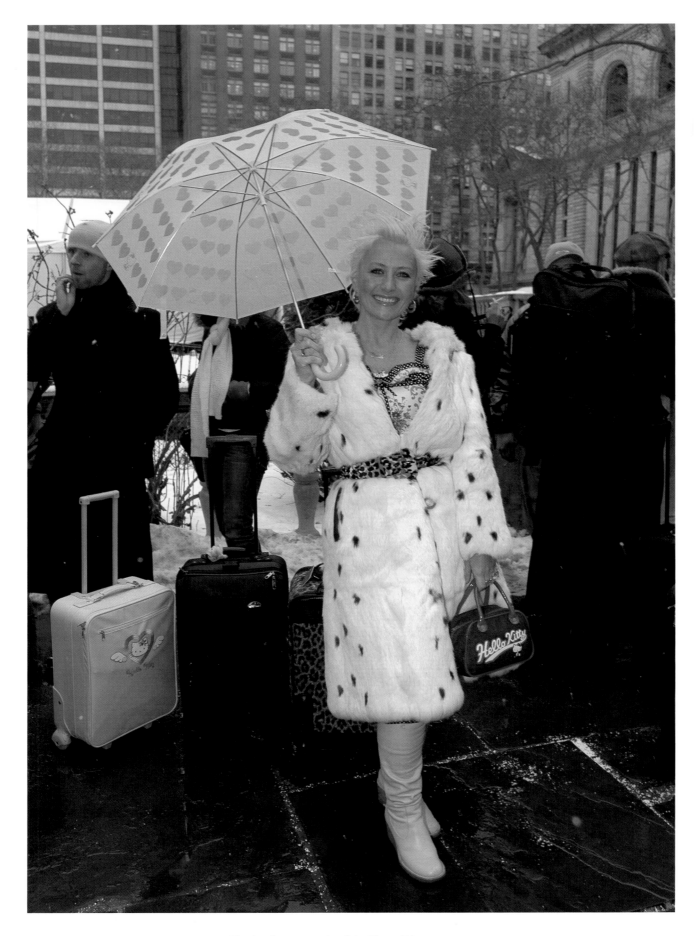

Charlie Green outside of the Tents, February 2003

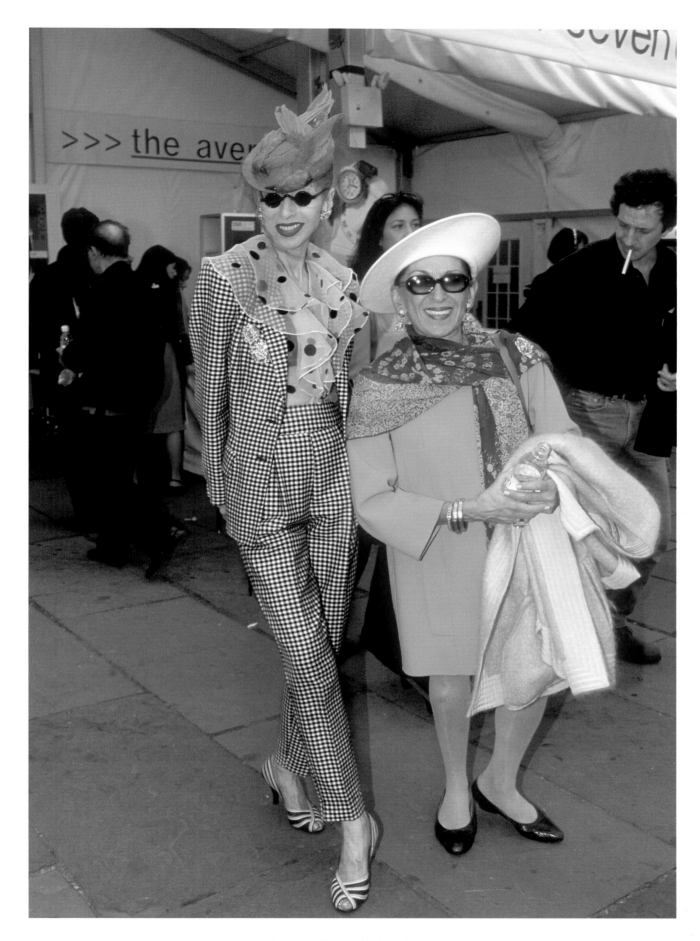

Peggy Cone and fashionable friend, April 1998

Gisele Bundchen leaving the Tents, September 2002

From top, left to right:
Scott Barnhill outside the Tents at the Tommy Hilfiger show, February 2003
Nikki Taylor with a policeman outside the Tents, October 1995
J.R. Gallison at the Diesel StyleLab show, September 2002
Kate Moss and Linda Evangelista inside of the Tents, April 1995

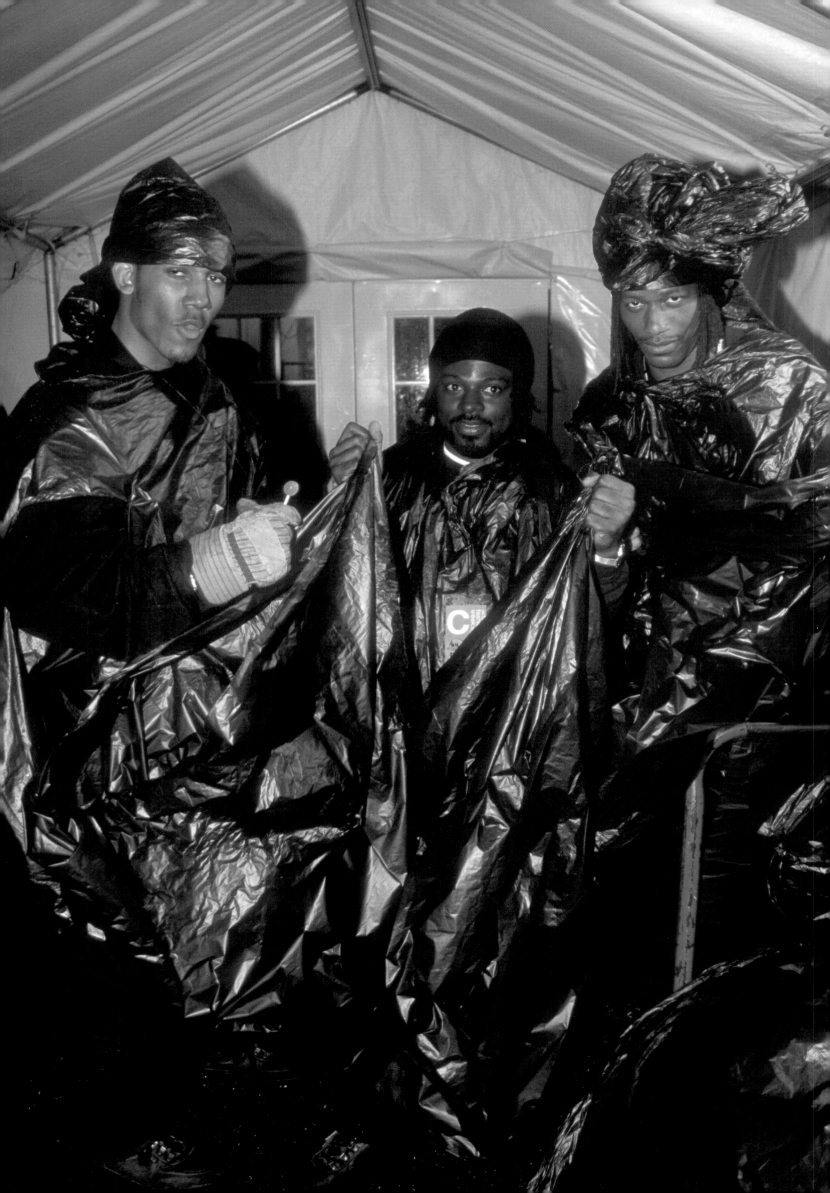

NO BACKSTAGE WOULD BE COMPLETE WITHOUT PATRICK'S INCREDIBLE ENTHUSIASM AND EXCITEMENT. BECAUSE HE TREATS EVERYONE WITH SUCH RESPECT AND DIGNITY, HE HAS BEEN ABLE TO CAPTURE EVEN THE MOST PERSONAL AND NAKED MOMENTS.

JOHN BARTLETT

PATRICK IS A PERMANENT FIXTURE OF FASHION WEEK AND OF THE NEW YORK SCENE. HE SEEMS TO HAVE AN AMAZING TALENT FOR BEING AT THE RIGHT PLACE AT THE RIGHT TIME AND PERFECTLY CAPTURING A MOMENT IN TIME.

TOMMY HILFIGER

PATRICK IS ONE OF THE VERY FEW PHOTOGRAPHERS THAT I'M ALWAYS DELIGHTED TO SEE AROUND.

ELIZABETH HURLEY

PATRICK'S UNPARALLELED ACCESS HAS AFFORDED HIM A UNIQUE PERSPECTIVE ON FASHION, SOCIETY, AND OUR CULTURE OVERALL. HE SEEMS TO BE EVERYWHERE AT THE SAME TIME, IN THE FRONT ROW, BACKSTAGE, AND AT EVERY GLAMOROUS PARTY. WHAT WOULD FASHION WEEK BE WITHOUT PATRICK?

JAQUI LIVIDINI
SENIOR VICE-PRESIDENT, FASHION MERCHANDISING & COMMUNICATIONS
SAKS FIFTH AVENUE

IF YOU'RE WONDERING WHAT THAT TAP-TAP-TAP SOUND IS AT NEW YORK'S BRIGHTEST DO'S...IT'S THE SOUND OF FOLKS TAP-TAP-TAPPING PATRICK MCMULLAN ON THE SHOULDER TO TAKE THEIR PICTURE.

INGRID SISCHY
EDITOR-IN-CHIEF
INTERVIEW MAGAZINE

"One of my favorite pictures," says Patrick,
"Utility responds to fashion: the Ground Crew couture during a major rainstorm at the Tents."
Hefty Bag fashion, April 1998

PAGES 344–345
Postshow mess at the BCBG Men's Show, February 2001

PAGES 346-347
The Tents at the end of Fashion Week, April 1994

INDEX

INDEX

InTents

© 2004 powerHouse Cultural Entertainment, Inc.
Photographs © 2004 Patrick McMullan
Foreword © 2004 Katie Couric
Introduction © 2004 Fern Mallis

Published in the United States by powerHouse Books,
a division of powerHouse Cultural Entertainment, Inc.
68 Charlton Street, New York, NY 10014-4601
telephone 212 604 9074, fax 212 366 5247
e-mail: intents@powerHouseBooks.com
website: www.powerHouseBooks.com

First edition, 2004

Library of Congress Cataloging-in-Publication Data:

McMullan, Patrick.
InTents / photographs by Patrick McMullan ; foreword by Katie Couric ; introduction by Fern Mallis.
p. cm.
ISBN 1-57687-234-3
1. Fashion shows — New York (State) — New York — Pictorial works.
2. Costume design — New York (State) — New York — Pictorial works.
3. Fashion photography — New York (State) — New York.
4. Documentary photography — New York (State) — New York. I. Title.

TT502.M48 2004
746.9'2'097471022 — dc22

2004040099

Hardcover ISBN 1-57687-234-3

Separations, printing, and binding by EBS, Verona

Book design by Pentagram

Special thanks to A Diamond Is Forever

A complete catalog of powerHouse Books and
Limited Editions is available upon request;
please call, write, or see the shows on our website.

10 9 8 7 6 5 4 3 2 1

Printed and bound in Italy

INSIDE BACK COVER
"Bye-Bye" finale at the Betsey Johnson show, September 2003

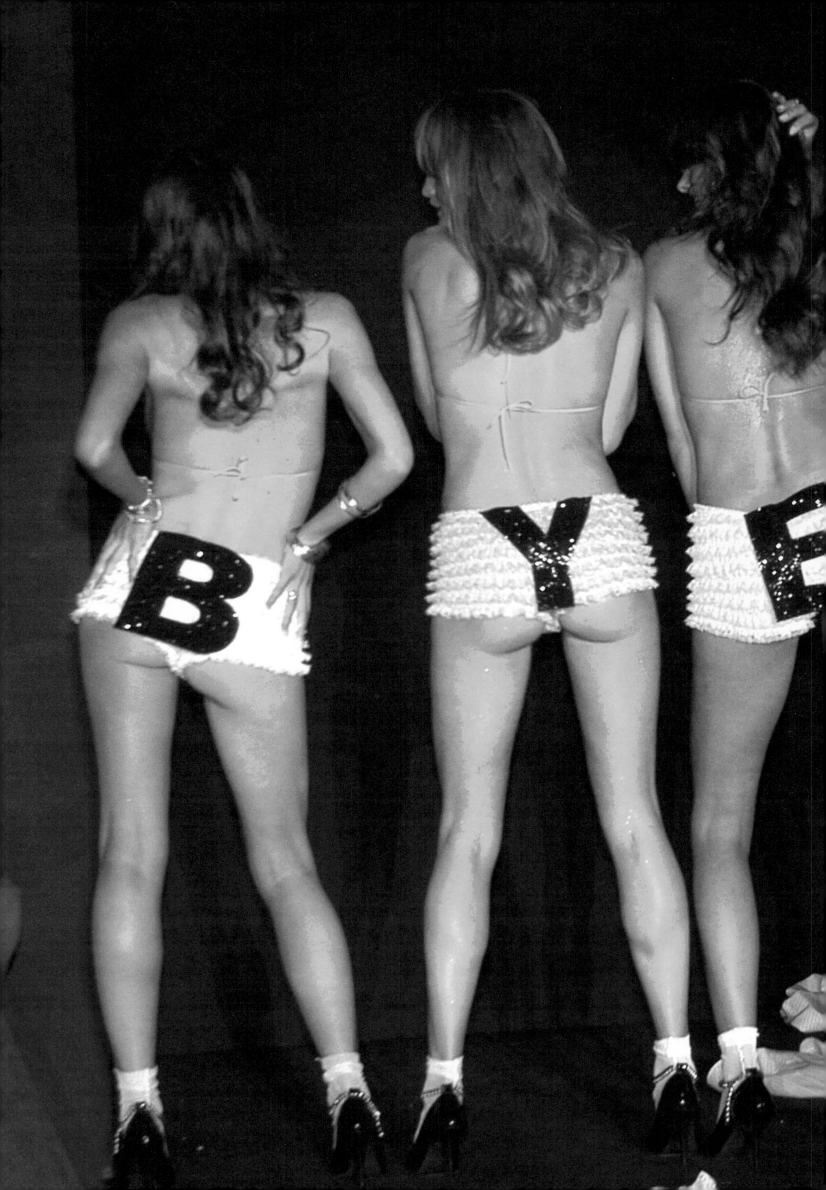